HENRY MOORE

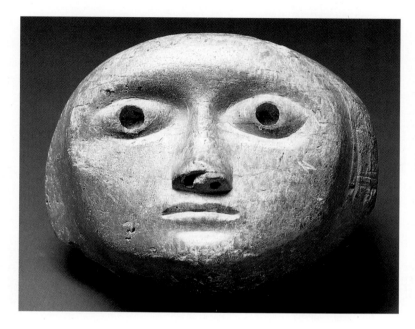

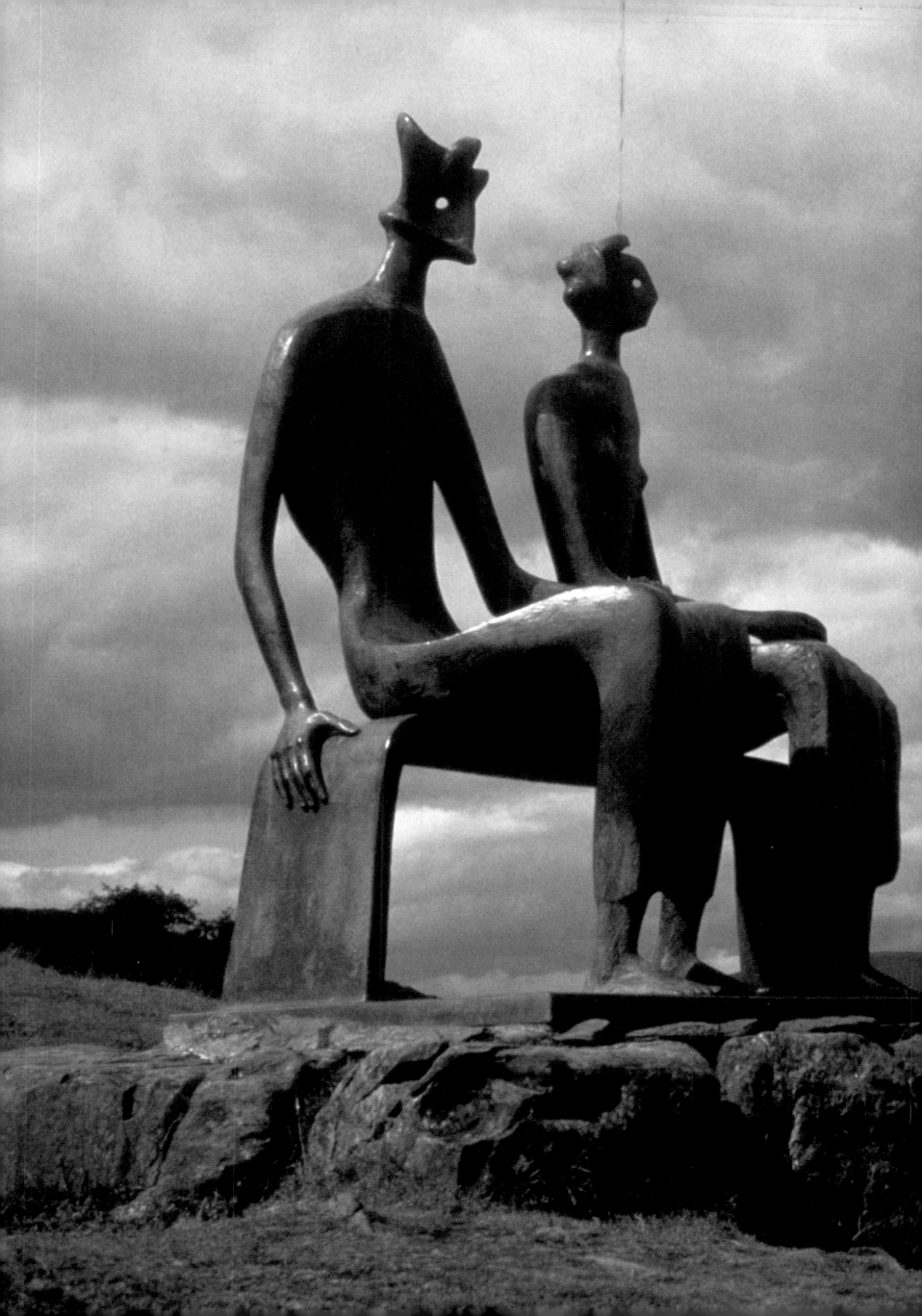

HENRY
MOORE

Doreen Ehrlich

KNICKERBOCKER
PRESS

Published by Knickerbocker Press
276 Fifth Avenue
New York, New York 10001

Produced by PRC Publishing Ltd
Kiln House, 210 New Kings Road
London SW6 4NZ

ISBN 1 57715 071 6

Printed in China

The right of Doreen Ehrlich to be identified as the author has been
asserted by the same in accordance with the Copyright, Designs and Patents Act 1988.

PAGE 1: *Mask*, 1929,
stone, h.5 inches (12.7 cm),
Private Collection
Photo Malcolm Varon
PAGE 2: *King and Queen*, 1952-53,
bronze, h.64 inches (164 cm),
Courtesy of the Henry Moore
Foundation
BELOW: Henry and Irina Moore in
the garden at Much Hadham,
1966.

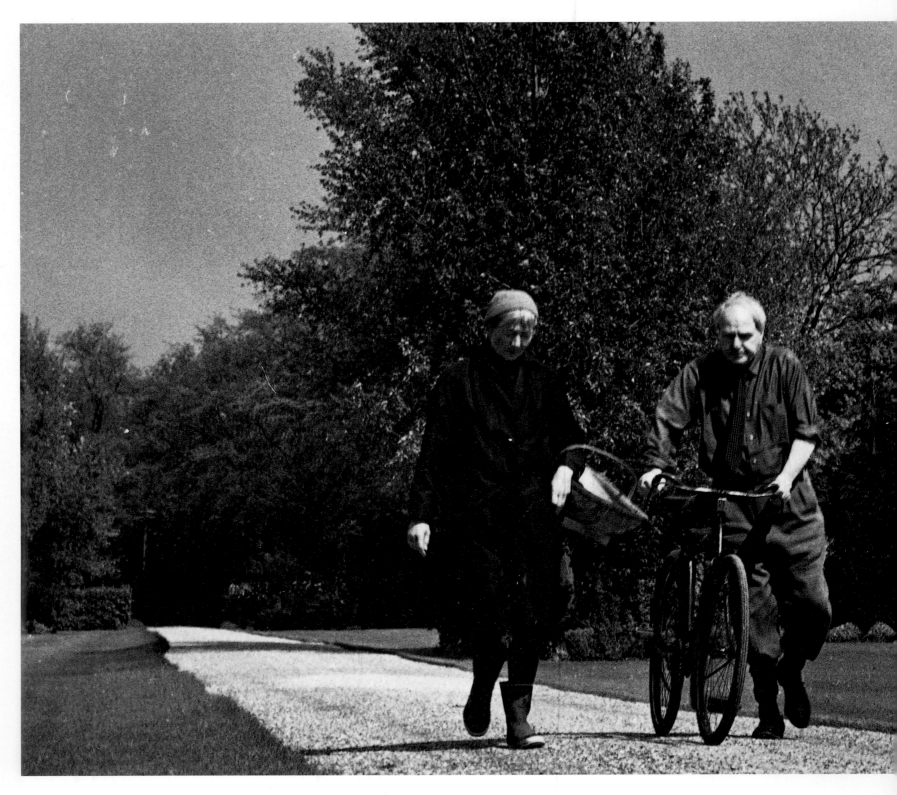

CONTENTS

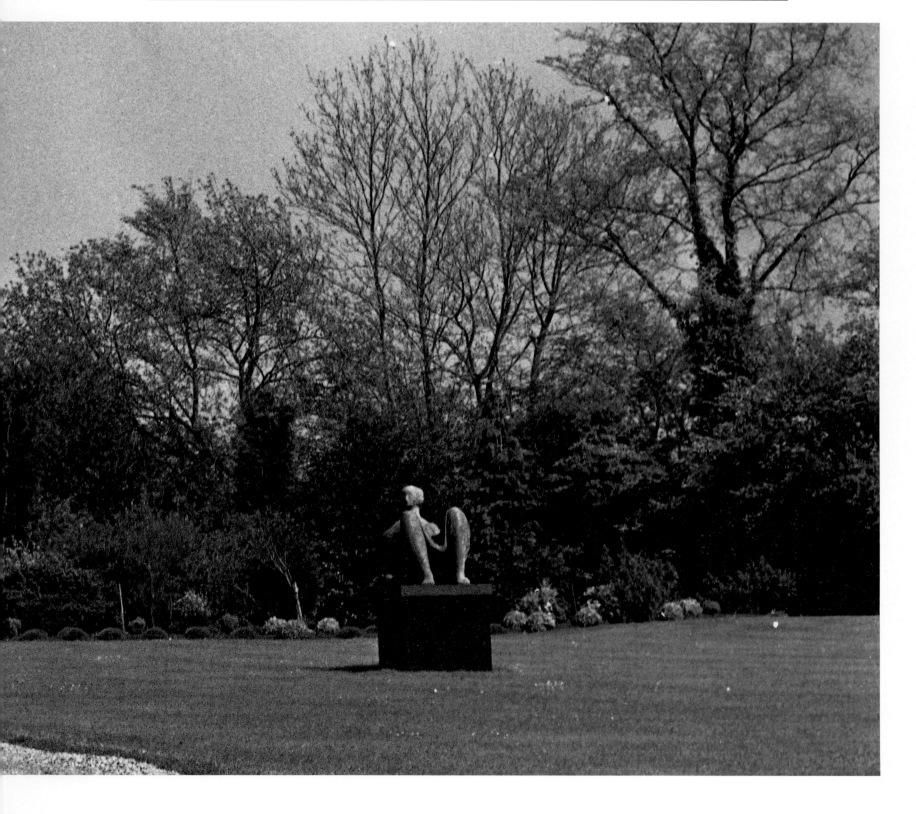

INTRODUCTION

The most famous British artist of the twentieth century, Henry Moore was born in Castleford, Yorkshire, in 1898, and died, aged 88, in 1986. His long life encompassed two world wars; his huge body of work can be found in prominent sites all over the world, from London to Jerusalem, from New York to Japan. He is one of the very few twentieth-century artists whose work is instantly recognizable to a wide public, playing as it does a central role in the settings of such significant buildings as the Lincoln Center, New York and the UNESCO Building, Paris. The universal popularity of Moore's sculptures suggests that the imagery he uses taps into the collective unconscious, transcending national and cultural boundaries.

The circumstances of Moore's birth were modest. Castleford was at that time a mining town of some twenty thousand residents, and the Moores lived in a typical four-room Victorian terrace house of the period, back-to-back with the houses of the next street. Moore's father, Raymond Spencer Moore, worked in the mines, and was himself the son of a farm worker from Lincolnshire. Moore senior was tenacious and independent; he had taught himself the skills needed to become a mining engineer, although an industrial injury affecting his sight prevented him from further advancement. He was determined that his eight children should better themselves by hard work through the education system. His ambitions were realized, as none of them followed him into mining and three were to become teachers, a career for which Henry Moore was also trained, at his father's insistence.

Moore's mother, Mary, the subject of one of her son's finest early drawings, was a key figure in his life and work. In later life, Moore attributed the physical strength and stamina so necessary in a sculptor to his mother, who worked as a laundress in addition to raising eight children: 'she had tremendous physical stamina . . . to be a sculptor, you have to have that sort of energy and that sort of stamina.' He remembered that as a boy

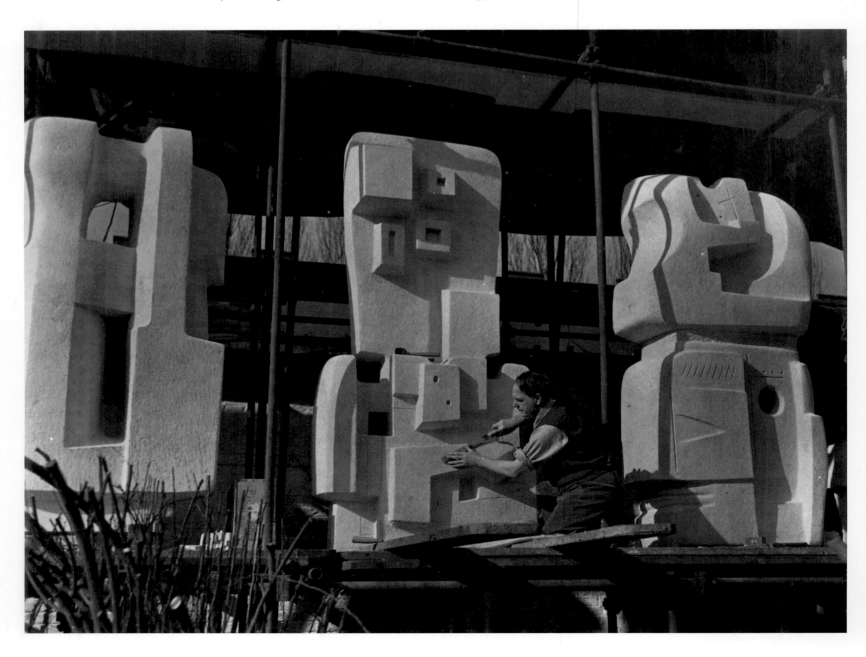

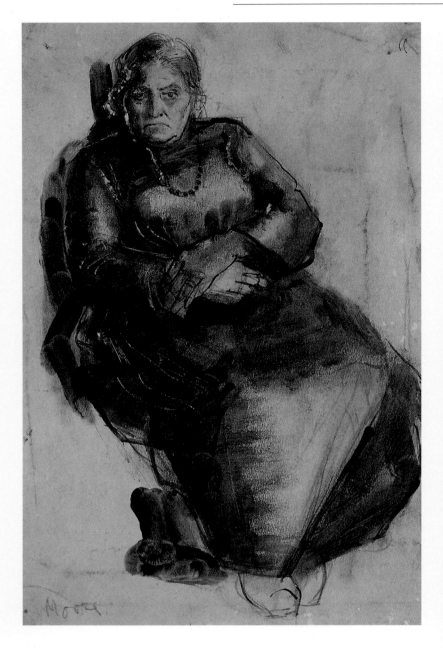

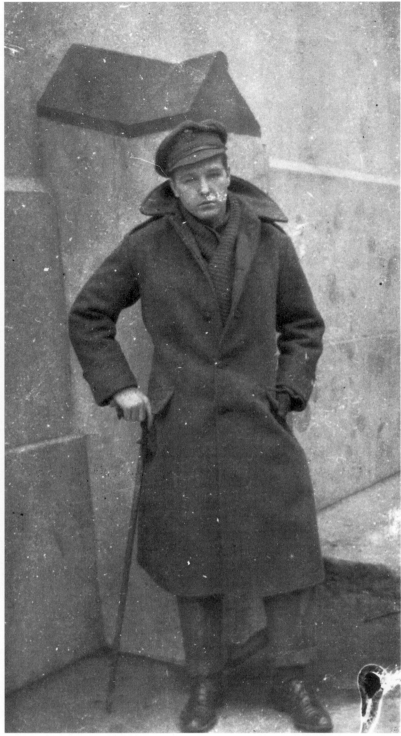

LEFT: Moore working on the Portland stone *Time-Life* screen (1952-53) at Much Hadham.

ABOVE: *The Artist's Mother*, 1927, pencil, pen and ink with finger rub and scraping, $10^{15}/_{16} \times 7^{9}/_{16}$ inches (27.7 × 19.1 cm).

RIGHT: Henry Moore at Castleford in 1918, recovering from the effects of gassing suffered at Cambrai.

he had to massage her back with liniment, adding significantly: 'I suppose I've got a mother complex . . . I could almost have made [her back] without looking at it. The sense of touch, the boniness across the backbone.'

For the Moore children, as for other working-class children of the period, the way out of a seemingly pre-determined way of life was through education. Moore twice failed his entrance examination to the local secondary (later grammar) school, yet on his father's insistence he sat a third time and was successful. The education he received, until he was called up at the age of 18, was to change his life. He was fortunate enough to be taught by two remarkable educators. The headmaster, Thomas ('Toddy') Dawes, was an enlightened and experienced teacher with broad cultural sympathies, who took working groups of young children to study the medieval churches and abbeys in the Yorkshire countryside. It was on one of these occasions, at Methley church, that Moore remembered drawing the carved stone heads that were his first experience of sculpture. In addi-

tion to such Gothic architectural sculpture, many Yorkshire churches contain finely carved medieval tombs, with recumbent figures which were to have echoes in much of Moore's later work.

The prime influence on the young Moore's artistic education, however, and the determining factor in his choice of career, was his art teacher, Alice Gostick. Herself half French, she maintained a keen interest in the wider world of European art, subscribing to such magazines as *The Studio*, which reported the exciting developments in European Modernism, for example the School of Paris, or the current Art Nouveau style in Vienna and elsewhere in Europe. The enlightened teaching at Castleford ensured that art and its making were central to the children's education. Moore found himself among a number of gifted children who were encouraged to see their futures in art; Miss Gostick was to remain an artistic mentor and friend, and her correspondence with Moore continued for over half a century.

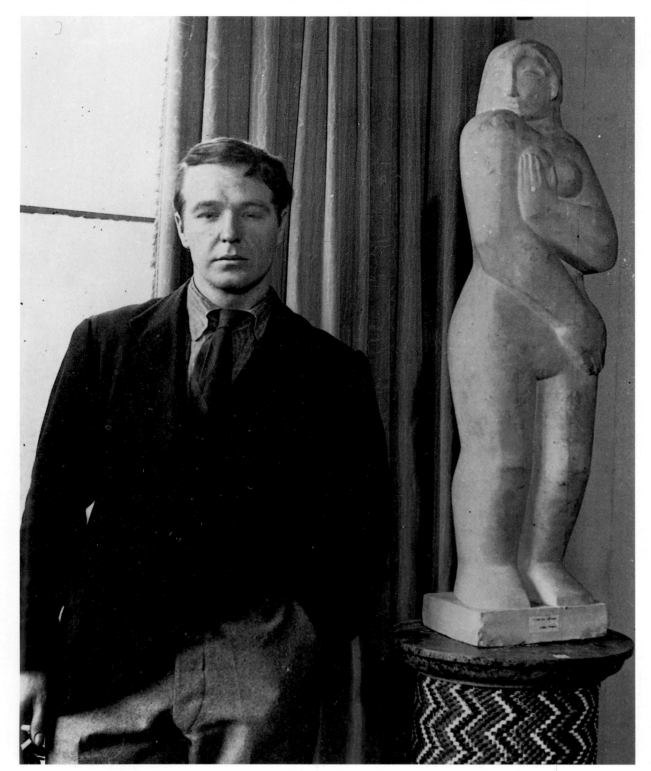

LEFT: Henry Moore in London in the late 1920s, photographed with an early work, *Standing Woman* (1926), since destroyed.

RIGHT: On holiday in Norfolk in 1930; from left to right, Ivon Hitchens, Irina Moore, Henry Moore, Barbara Hepworth, Ben Nicholson and Mary Jenkins (wife of Douglas Jenkins, who took the photograph).

Moore left school aged 16, in the first year of World War I, to become a trainee teacher. He took this practical step on his father's advice, although he found his apprenticeship in local schools a difficult one. When conscription began in 1916, after the terrible slaughter of the volunteer army, Raymond Spencer Moore realized that his youngest son stood a much better chance in a London Regiment, and Henry was soon enlisted in the Civil Service Rifles, the 15th Battalion, the London Regiment.

He received his training near London and was able at the same time to study the sculpture at the British Museum, which was to be of seminal importance in his future work. For what remained of World War I, however, he was to find himself in the thick of the action at the front, as a Lewis gunner. After the tank battle at Cambrai, Moore was invalided out, suffering from the effects of the gas that had been so terrible a feature of the action, and was sent back to hospital in Wales to re-

cuperate. After two years' service, he was promoted to Lance-Corporal, using his teaching skills in a vastly different context as a bayonet drill instructor.

After the Armistice of 1918, Moore was free to leave the army; aged 20, he was ready to take advantage of the educational grants that were being made available to returning servicemen. On demobilization, he returned to Castleford to teach small children, to attend Miss Gostick's pottery class and, in the fall of 1919, to take up a place at the Leeds School of Art, ten miles away. There Moore found himself, along with other mature and determined students marked by their experience of the war, engaged in the traditional disciplines of art school training in England at that time. His long working day was occupied with classes in anatomy, life-drawing, drawing from the antique, and the study of perspective and architecture, while back in Castleford in the evening there were Miss Gostick's pottery classes to complement his drier academic

studies in Leeds, and to compensate for its more uncongenial aspects.

As in other aspects of his life, Moore was fortunate in being in the right place at the right time when he came into the orbit of the Vice-Chancellor of Leeds University, Sir Michael Sadler, the collector and connoisseur of the arts. Sadler owned one of the most avant-garde collections in the country, which included works by Picasso and Matisse and a collection of African carvings. He had known Kandinsky before the war and was a friend of Roger Fry, whose theories on art, together with those of other members of the Bloomsbury Group, were so influential in Britain during this period. Fry had been Curator of Paintings at the Metropolitan Museum of Art, New York, between 1906 and 1910, and was the first to introduce Post-Impressionist painting to Britain, with the two exhibitions he arranged in London in 1910 and 1912.

Moore himself stressed the influence on his later work of Fry's essay on 'Negro Sculpture' in *Vision and Design* in 1921, which he read as a student in Leeds. Roger Fry in turn commented on Sadler's influence on cultural life in Leeds: 'He showed what can be done – but very rarely is – by education.' Moore himself, writing nearly 50 years later, considered that Sadler 'really knew what was going on in modern art.' Among Moore's contemporaries at Leeds School of Art at this time was a student from nearby Wakefield, Barbara Hepworth, four years younger than Moore, who was later to achieve a national reputation as a sculptor second only to his. Barbara Hepworth left Leeds before Moore on that all-important first step to the Royal College of Art in London, on a major scholarship.

A year later, aged 23, Moore followed her to the Royal College in what he was later to describe as 'a dream of excitement.' Moore's scholarship was a generous one and meant that he could concentrate entirely on his development as a sculptor. Unlimited access to the National Gallery, the British Museum, and the Victoria and Albert Museum and its reference library meant that he 'could learn about all the sculptures that had ever been made in the world.'

Moore was one of very few students to choose to work in the Sculpture School, and he was able to have an entire studio and a life model to himself. He was also able to concentrate on life drawing in the School of Painting, taught by Leon Underwood, himself a sculptor. According to Moore, Underwood 'set out to teach the science of drawing, of expressing solid form on a flat surface,' a passion that Moore imbibed and that was to remain with him for the rest of his life, becoming a vital part of his sculptural practice. Moore believed strongly in the importance of visual literacy, and saw drawing as a means to that end, a skill that should be taught seriously as a general part of education, 'to get', as he himself later put it, 'people to use their eyes . . . to understand nature and to get nourishment from the visual arts, sculpture and painting.' This belief remained with Moore throughout his life and is carried on today in the work of the Henry Moore Foundation.

Moore's talents and his Yorkshire roots were to ensure him the encouragement of the remarkable Principal of the Royal College, the painter Sir William Rothenstein. Rothenstein, who took up his post in 1920, was determined that the Royal College should develop beyond its then boundaries as a

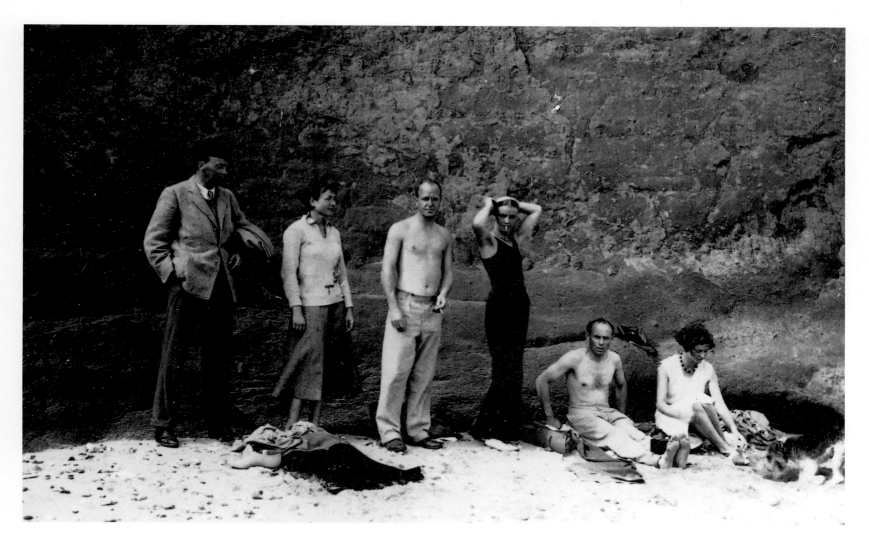

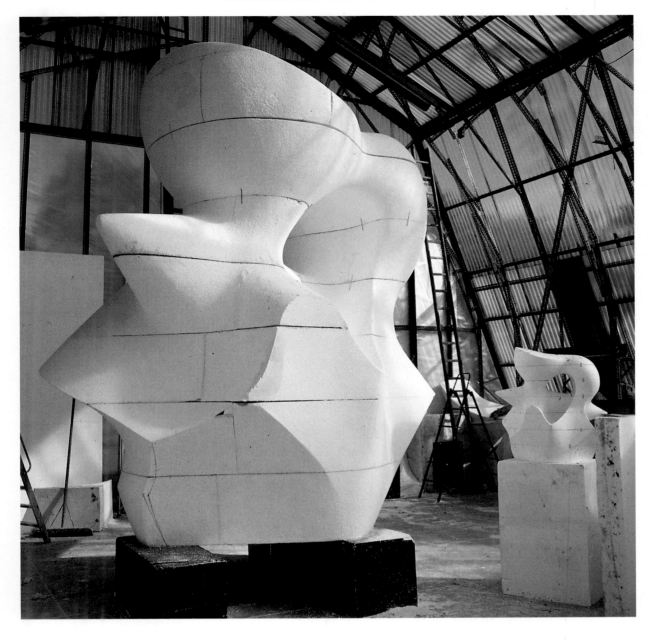

LEFT: Polystyrene model for *Large Spindle Piece* (1968-74).

BELOW: The *Spindle Piece* model in the process of construction.

RIGHT: Moore in his studio working on a polystyrene model.

specialist teacher training college. Rothenstein's family fortune was based on the Yorkshire wool industry. As a young man he had known Rodin and Degas, and he had a wide and influential circle of friends, into which he introduced his student protégés. As a fellow Yorkshireman, whom Rothenstein described in 1939 as 'the most intelligent and gifted among the sculptors,' Moore was to benefit from such contacts. He was never to forget speaking to the Prime Minister, Ramsay MacDonald, at one of the Principal's gatherings: 'Rothenstein gave me the feeling that there was no barrier, no limit to what a young provincial student could get to be or do.'

It could, however, be argued that the major influence on Moore's development as a sculptor at this time was not his more formal studies at the Royal College, but the work that he undertook on his own initiative at the British Museum. He himself considered his time there to be revelatory, and spent two or three hours there at least twice a week. As well as its famed collections of antique classical sculpture, Egyptian antiquities and treasures from Assyria, the British Museum at that time contained what were known as the Ethnographical Galleries, containing sculptures from Mexico, Africa and other non-classical sources, now housed in the Museum of Mankind.

Moore was always ready to acknowledge the lasting foundation his studies of the sculpture in the British Museum gave

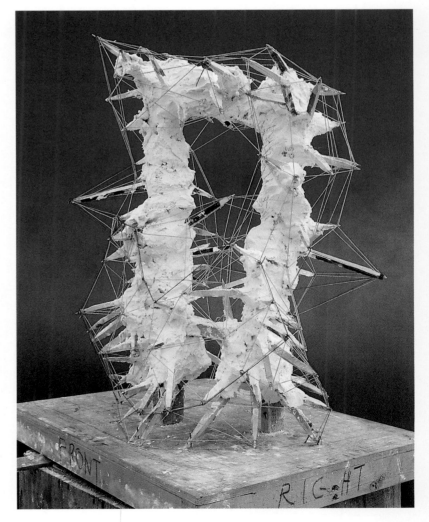

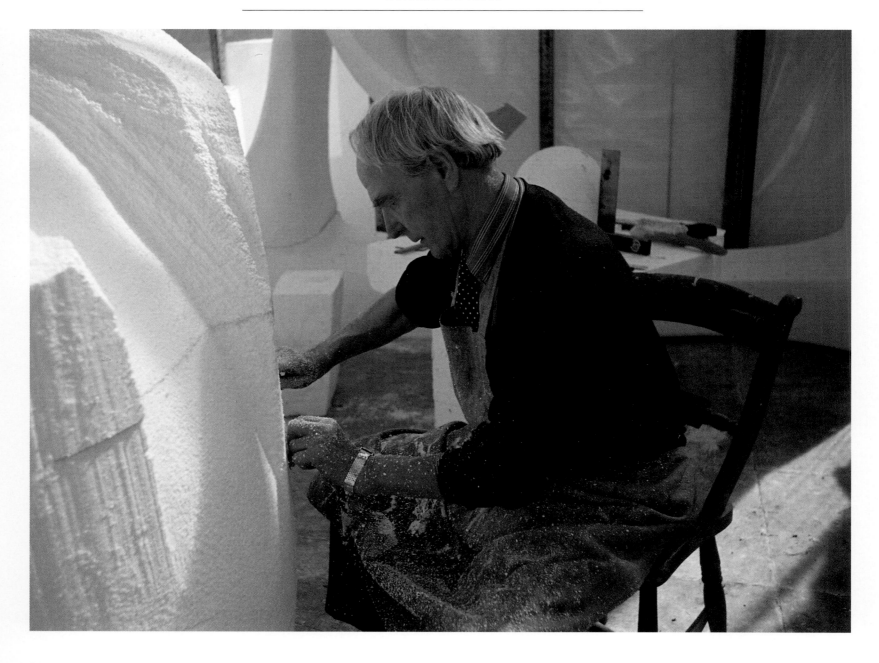

him. His work in the 1920s was particularly influenced by his study of Pre-Columbian sculpture. John Rothenstein (son of William Rothenstein, Moore's Principal at the Royal College, and Director of the Tate Gallery) considered that Moore's 'assiduous' study of Mexican and other ancient sculpture resulted in sculptures which, compared with the originals, 'were little more than exercises – powerful and perceptive, but exercises none the less – in various early stages.' These exercises were vital, however, in enabling Moore to find his own style; vital, too, in strengthening his strongly held belief in 'truth to material.' This was a characteristic of African art much stressed by Roger Fry and was, according to Moore, 'one of the first principles of art . . . the artist shows an instinctive understanding of his material, its right use and possibilities.'

The method by which the British Museum sculptures had been produced, by direct carving, was also a major influence on the young sculptor. This method had been used since ancient times, and during the Renaissance had reached heroic dimensions, for example in the work of Michelangelo. It had gradually fallen out of use since and been replaced by a pointing machine, which could translate the smallest *modello* made by the artist into whatever dimensions were required for the finished result. The majority of monumental stone sculptures in the previous century had either been produced in this mechanical manner or, in the case of such famous works of the period as Rodin's *The Kiss*, carved under the artist's supervision by another sculptor.

Moore comments that 'when I was a student, direct carving as an occupation, and as a sculptor's natural way of producing things, was simply unheard of in academic circles.' During the early part of the twentieth century, however, the pioneer Modernist sculptor Constantin Brancusi, 20 years older than Moore, had made a decisive return to direct carving, and the technique had been used in England by such sculptors as Henri Gaudier-Brzeska (who was killed in World War I at the age of 24), Jacob Epstein, and Eric Gill, whose public carvings had already caused controversy by the time Moore started on his career.

Writing about carving some 40 years later, Moore's comments are revealing: 'I am by nature a stone-carving sculptor, not a modelling sculptor. I like chopping and cutting things rather than building up. I like the resistance of hard material.' When producing the plaster original for a bronze sculpture, he used a process which involved applying the plaster while in a malleable state and then paring it down, once it was hard, with axes, rifflers and graters. This process is still evident on the bronze casts of such works as *Standing Figure: Knife Edge*.

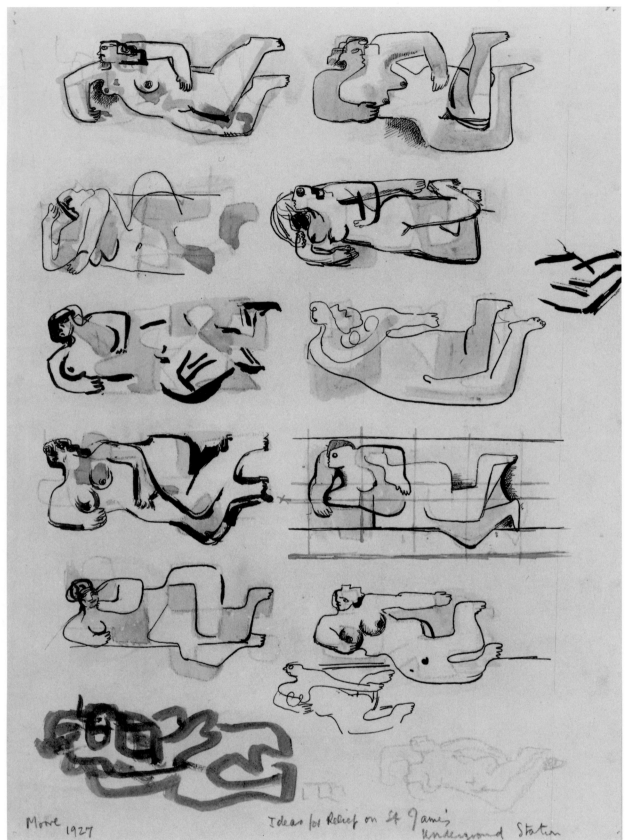

LEFT: Moore's sketch ideas for the relief sculpture *West Wind*, designed for the headquarters of the London Underground Railway, St James's Park, 1928, pen and wash, 14½ × 10½ inches (37.5 × 26.7 cm).

RIGHT: *West Wind* (1928-29), Moore's first public commission and the source of considerable controversy.

As a student, Moore was able to travel to Paris once or twice a year, often with fellow students from Leeds, including his life-long friend Raymond Coxon, Edna Ginesi, who was soon to marry Coxon, and Barbara Hepworth. Rothenstein provided introductions to his own artistic circle in Paris, and the group of friends attended life classes and took up an introduction to visit the Pellerin Collection, which contained the first Cézanne Moore had ever seen. *The Large Bathers* (1898-1905), now in the Philadelphia Museum of Art, had 'a tremendous impact on me. For me this was like seeing Chartres Cathedral.' Moore stressed in particular his admiration for the 'nudes in perspective, lying on the ground as if they had been sliced out of mountain rock.'

The rich and various mix of influences on Moore's work, drawn from both painting and sculpture, was enhanced in January 1925, when he took up a travelling scholarship to Italy. He found the experience painful, as he had to learn 'to mix the Mediterranean approach comfortably with my interest in the more elementary concept of archaic and primitive peoples,' and wrote later that he did not resolve the conflict set up by the experience of seeing work by the major artists of the Renaissance until the Shelter drawings series during World War II. In these drawings Moore's re-appraisal of Renaissance work is clear. The influence of such early Renaissance painters as Masaccio (1401-28) can be seen in the weight and massive monumentality of the figures, qualities present also in the

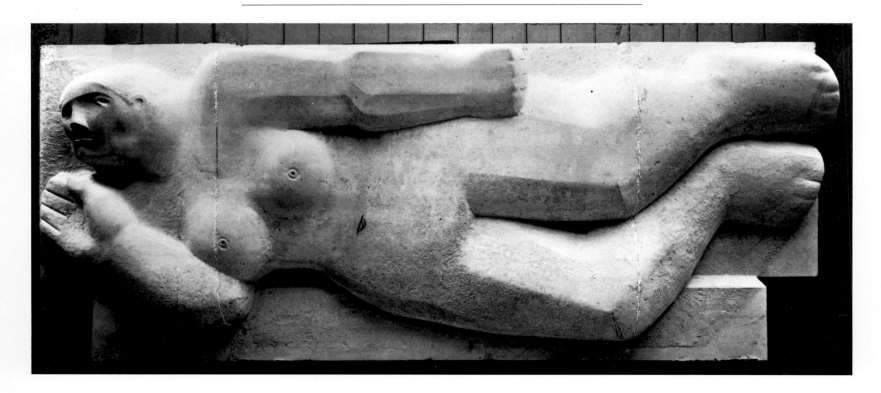

Northampton *Madonna and Child* (1943-44), where the Madonna's hieratic pose and capacious lap are reminiscent of Masaccio's *Madonna and Child* from the Pisa Polyptych (1426), now in the National Gallery, London.

Moore returned in 1924 to teach sculpture part-time at the Royal College on a seven-year contract. The work of an instructor in the Sculpture School occupied only 66 days in the year, and this gave him a secure base from which to pursue his own work for the greater part of the year. He had already exhibited in group shows, but in 1928 came the watershed of his first one-man show at the Warren Gallery. This received a mixed critical response, although Moore was heartened by the support of his fellow artists. Established sculptors such as Jacob Epstein, whose own work continued to attract ferocious criticism, bought several drawings. So virulent was *The Morning*

Post's criticism, however, that Moore's position at the Royal College was put in doubt. Rothenstein's response was to reassure Moore that he knew him to be a good teacher, and that Moore's art was his own affair.

At the early age of 30 Moore became a national figure with his first public commission, *West Wind*, for the new administrative headquarters of London Underground at St James's Park. The architect, Charles Holden, intended sculpture to be an integral part of the design and much controversy attended the sculptural program, the work of seven sculptors. Epstein, who had the major part of the sculptural commission, had recommended Moore for a minor part. The work proved difficult, not least because the reliefs had to be completed *in situ*, some 70 feet up, but the very scale of the commission was vital to Moore's growing confidence as a sculptor. When the carvings

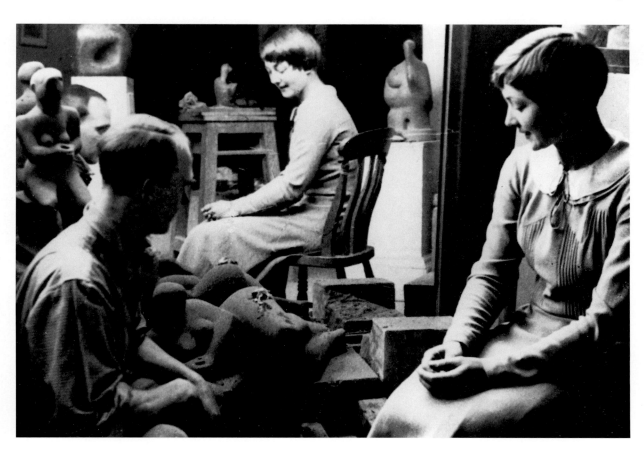

RIGHT: Henry and Irina Moore in the studio at Parkhill Road, Hampstead, in the early 1930s.

were finished the storm broke; Epstein's *Night* was tarred and feathered, and he did not receive another public commission until 1950. Moore's work was also vilified, and once again his position at the Royal College was called into question by *The Morning Post*: 'It is almost unbelievable that men occupying positions of his high responsibility should execute such figures as serious works of art.'

Moore's life and work were nonetheless both entering a highly productive and exciting phase. In July 1929 he married Irina Radetzky, a Russian-born student at the Painting School of the Royal College, and the couple moved to Hampstead in north London, to an area where Barbara Hepworth was already living. Within a year or two the circle was joined by the Yorkshire-born critic Herbert Read, who was to become a highly influential interpreter of modern art, centering his critical studies of contemporary British art on his close friends, Moore, Hepworth, and her second husband, the painter Ben Nicholson. In 1931 Moore held his next one-man show at the Leicester Galleries, with a catalog introduction by Jacob Epstein. Again he found himself the focus of unwelcome press attention, although the works sold well, and several drawings and one small head were bought by a German public collection. These were the first of Moore's works to go abroad, although public collections in England had already started making acquisitions.

The pressure on Moore to resign his teaching appointment was now so extreme that even Rothenstein was forced to acquiesce in his protégé's departure from his post, which still had twelve months of the seven-year term to run. Within a few months of Moore's resignation, he was offered the post of first Head of the new Department of Sculpture at Chelsea School of Art. This allowed him a two-day teaching week in termtime, a time-honored British art school system which enabled distinguished practicing artists to teach part-time, to the mutual benefit of students and artist alike. Moore was now able to divide his time between London and Burcroft, a cottage he had bought near Kingston in Kent. As he was later to write:

Here for the first time I worked with a three- or four-mile view of the countryside to which I could relate my sculptures. The space, the distance and the landscape became very important to me as a background and as an environment for my sculpture.

Throughout his life, Moore stressed the importance of a landscape setting for his work:

I would rather have a piece of my sculpture put in a landscape, almost any landscape, than in, or on, the most beautiful building I know.

Together with Barbara Hepworth, Ben Nicholson and the painter Paul Nash, Moore contributed to the influential exhibitions of avant-garde contemporary art in the 1930s in England, such as the 'Unit One' exhibition in 1934. In 1936 he was one of the organizers of and contributors to the International Surrealist Exhibition in London, where his work

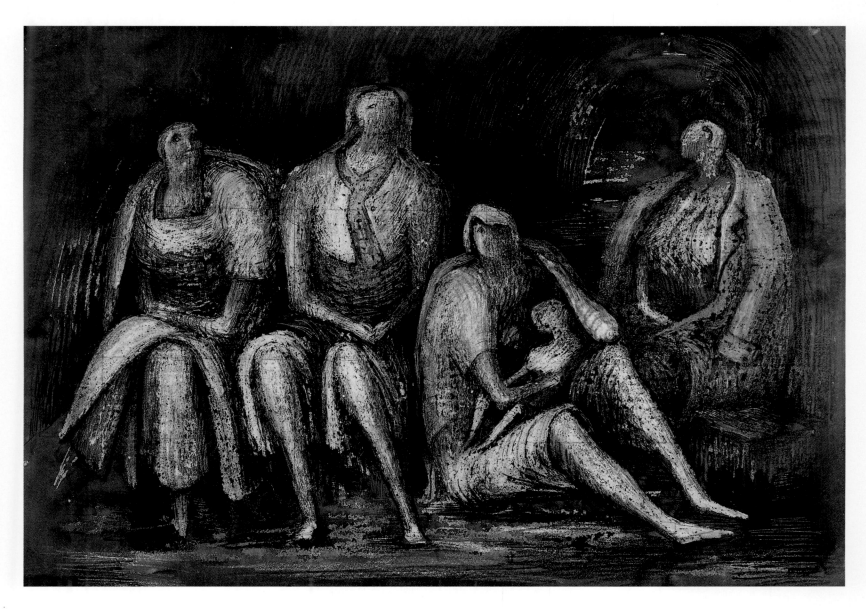

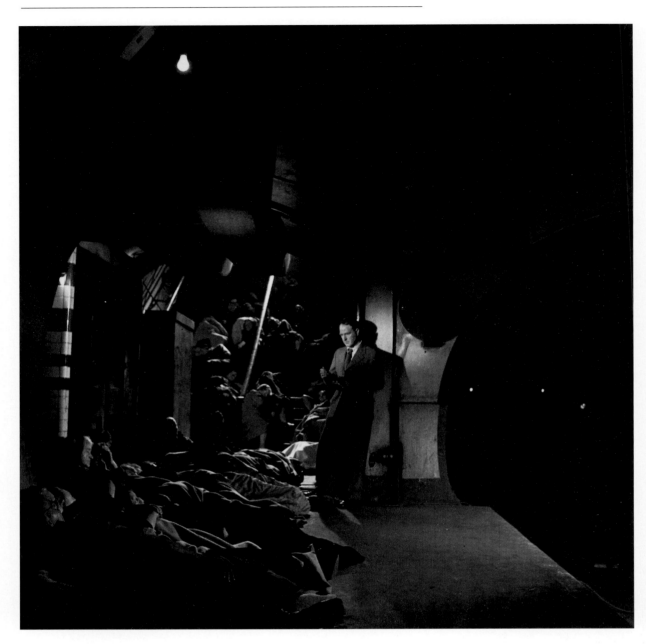

LEFT: *Group of Shelterers During an Air Raid*, 1941, pen and ink, wax crayon, chalk and watercolor, 14 × 21⅝ inches (38 × 55.5 cm).

RIGHT: Moore drawing the crowds who had taken refuge in Holborn Underground Station in September 1940, photographed by Lee Miller.

was exhibited with that of Ernst, Picasso, de Chirico and Duchamp, among others. Surrealism, with its emphasis on the irrational and the dreamlike, and the transformation of natural forms, was to remain an influence on his work.

In 1939, when war was declared, Moore made the decision to resign his teaching post and concentrate on his own work, which was now at a decisive stage in its development. His international reputation was established, while in Britain he was a well-known, even somewhat notorious, figure. In 1941 he was appointed an Official War Artist on the Home Front, and with the series of Shelter drawings found himself, in John Russell's words, 'one of the keepers of the public conscience.' London Underground platforms provided refuge for thousands of people during the nightly bombardments of the Blitz, and for Moore the sleeping figures, forced into burrow-like shelter, were key subjects, observed from life and translated into symbolic images of endurance in adversity. His work was exhibited with that of other war artists and he found popularity with a wider public than ever before.

Although large-scale sculpture proved a practical impossibility during the early years of World War II, Moore was much occupied with drawing in his capacity of Official War Artist. The Shelter drawings were followed in 1942 by a series of remarkable drawings of miners at work, for which Moore returned to his native Yorkshire to visit Wheldale Colliery, Castleford. These drawings have a particular force and private resonance; Moore's confrontation with his subject-matter at this period was significant, for, as he said:

It humanized everything I had been doing. I knew at the time that what I was sketching represented an artistic turning-point for me, though I didn't realize then that it was a professional turning-point too.

Moore's major sculptural work at this time was a unique commission for a *Madonna and Child* for the interior of the Church of St Matthew, Northampton, which came from Canon Walter Hussey, an enlightened patron of contemporary art, who had already commissioned a painting from Graham Sutherland and a cantata from Benjamin Britten. The Northampton *Madonna* is perhaps Moore's most accessible and popular work, and shows a radical rethinking of his approach to Renaissance tradition. It was followed by a reclining figure of similar majestic monumentality, the *Memorial Figure* of 1945-46 for the landscape gardens of Dartington Hall, Devon. This is related both to his earlier carved reclining figures and to the swathed shelter figures of the Blitz drawings, and brings to an end a decisive phase in his work.

At the end of the war Moore was 47 and a major public figure, the best known living artist in Britain and famous abroad. He was the subject of a major retrospective exhibition

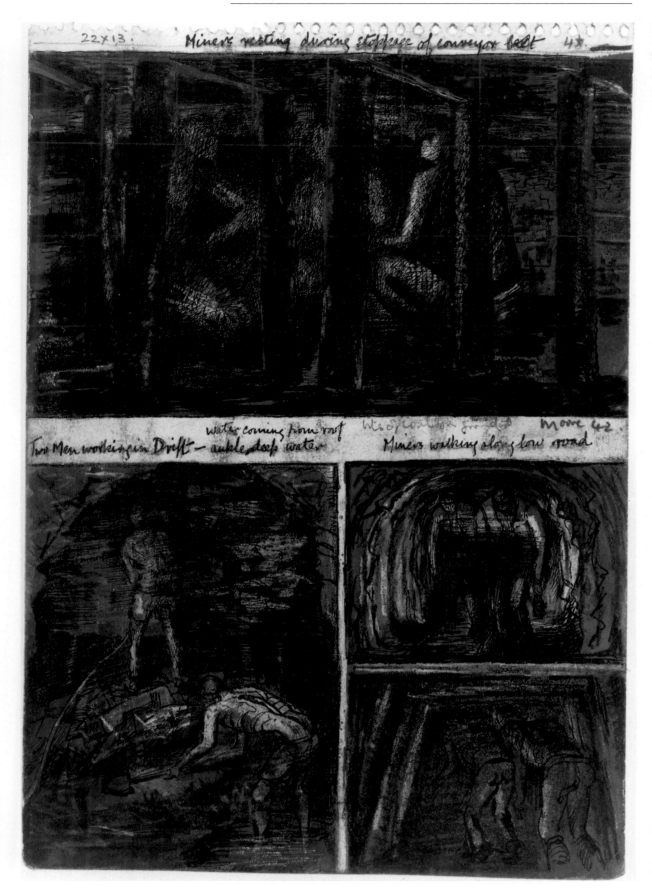

Miners resting during stoppage of conveyor belt

at the Museum of Modern Art in New York in 1946, the winner of the Grand Prize for Sculpture at the Twenty-fourth Venice Biennale in 1948, the recipient of numerous honorary degrees, and a valued member of many national and international committees, on which he served with diplomatic skill. These achievements made him a natural, if unofficial, ambassador for 'Britishness' abroad, while at home, his public manner and photogenic (and, from the 1950s onward, telegenic) qualities contributed to an acclaim seldom accorded to a living British artist and never before to a contemporary sculptor.

Major commissions included two key reclining figures: _Festival,_ for the 1951 Festival of Britain, symbol of Britain's post-war regeneration; and the giant female figure embodying the ideals of UNESCO for their headquarters in Paris. This last was carved from Roman travertine marble taken from a quarry used by Michelangelo. These female archetypes were developed in conjunction with other related sculptures, mothers with children (Moore's only child, Mary, had been born in 1946), family groups, and the large draped reclining figures in bronze of the late 1950s.

Henceforth bronze was to be used for works both large and small, as Moore exploited the potential of a medium in which experimentation with form has infinite possibilities, particularly on a heroic scale, and in which the inevitable risks in-

volved in carving, notably the lack of tensile strength inherent in stone, do not exist. With bronze, the finished work may be scaled up from the original model, and several casts may be produced for varying locations, whereas Moore's earlier large-scale civic works had been unique carvings produced for specific sites. The huge bronze casts of Moore's *Three Piece Reclining Figure No. 1* of 1961-62, for example, are displayed in the very different settings of the garden of Los Angeles County Museum of Art, California; Yorkshire Sculpture Park, near Wakefield, West Yorkshire (on permanent loan from the Tate

Gallery); and the Rochester Institute of Technology, New York.

With sculpture of such heroic scale, Moore was able to:

. . . Satisfy my desire, whereas in earlier days some of my sculptures had to be small in size. You can't make a small piece of sculpture stand outside. It just gets lost . . . it should be over life-size, because the open air reduces a thing in its scale.

Moore also needed to work outside, or as near outside as possible. The commission for another *Reclining Figure*, for the Lincoln Center for the Performing Arts, New York, resulted in a

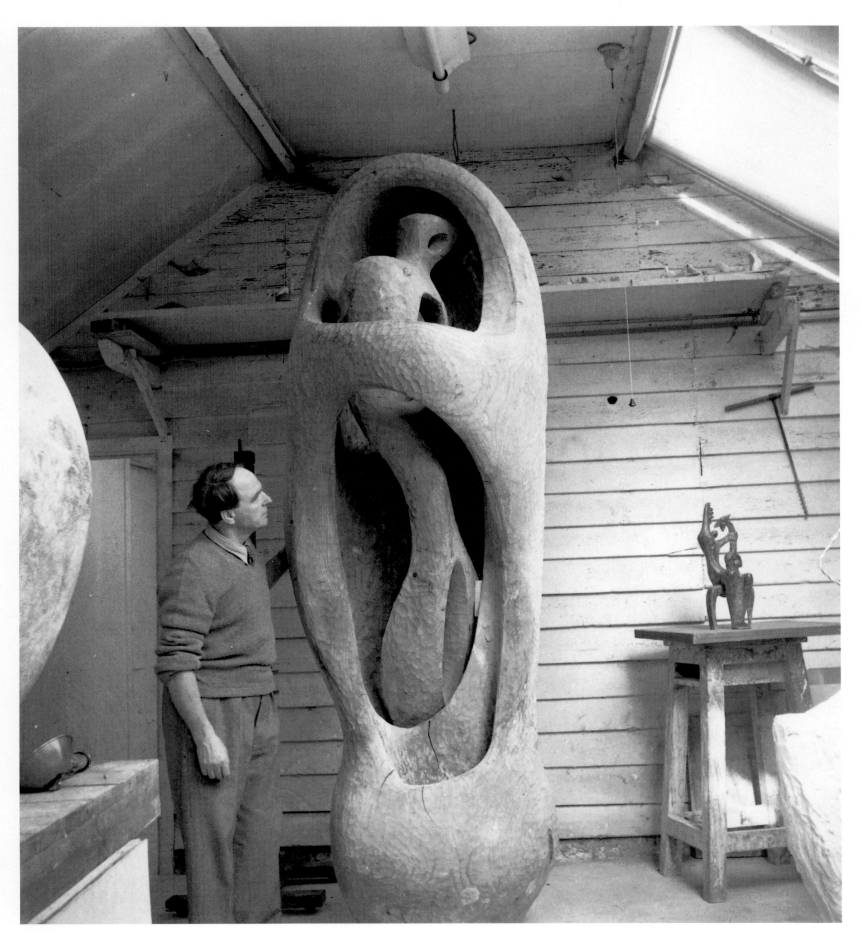

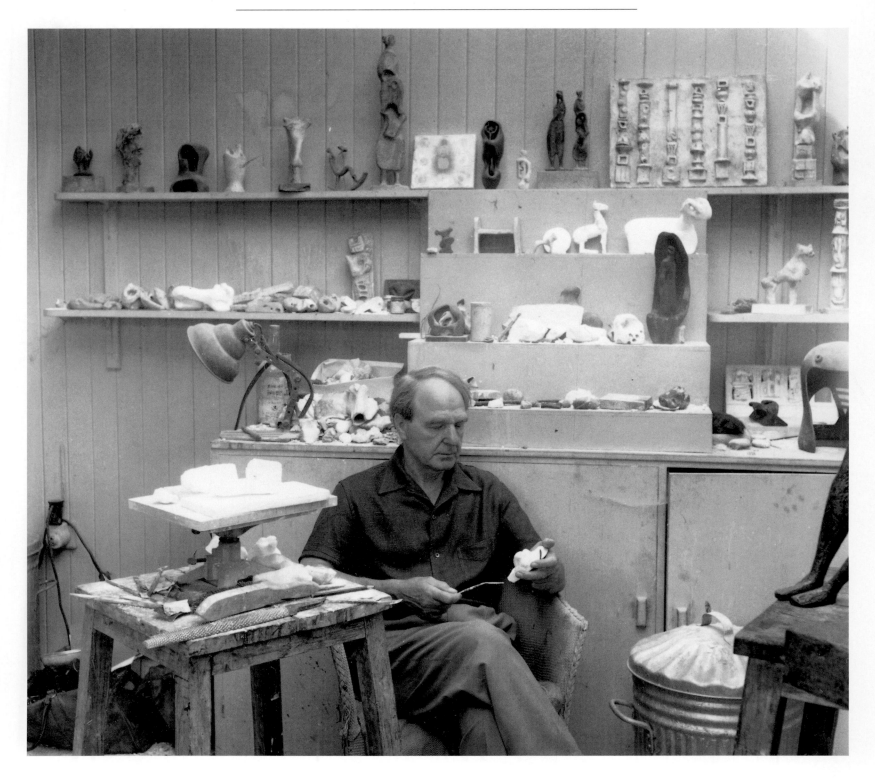

vast piece, 17 feet high and 28 feet long, in two elements. This was twice the size of the UNESCO carving, and the making of the huge plaster from which the cast was made necessitated the building of a special hangar-like studio, consisting of a frame with plastic sheets, which allowed Moore to work outdoors in full light, but protected in any weather.

Moore's reclining figures of the 1950s and early 1960s are perhaps his best known work; they are also important pivotal pieces in his development. The New York figure, for example, is important for reasons other than its huge size and symbolic placing outside the Lincoln Center. From the beginning of his career as a sculptor, Moore's work, like that of Michelangelo and Rodin, had always had as its central concern the human figure. Increasingly Moore began to stress the analogies between the female figure and the natural landscape, even in the work destined for urban or metropolitan settings. After the heroic UNESCO carving, Moore began to push the analogies still further, dividing the figures into sections to stress the rock-like

ABOVE: Moore with some of his many small-scale models in his studio, 1953.

RIGHT: *Sculpture Settings by the Sea*, 1950, ink, watercolor, gouache, colored crayons and white wax on wove paper, 21½ × 15¼ inches (55 × 39.1 cm)

forms, reminiscent of 'a huge natural outcrop of stone . . . which as a young boy impressed me tremendously'. This natural rock formation near Leeds, known as Adel Rock, remained in Moore's memory as a key image, together with the 'slag heaps of the Yorkshire mining villages, which for me as a boy were like mountains . . . they had this triangular, bare, stark quality that

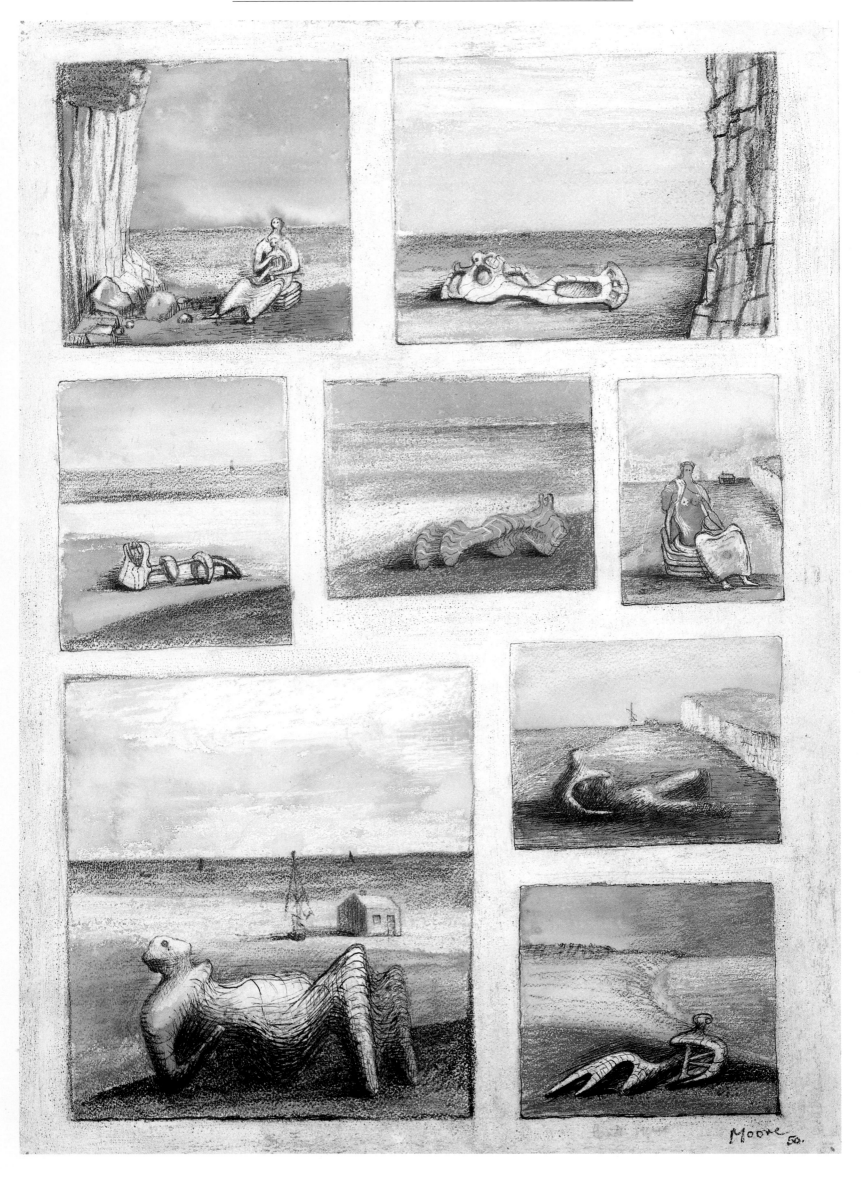

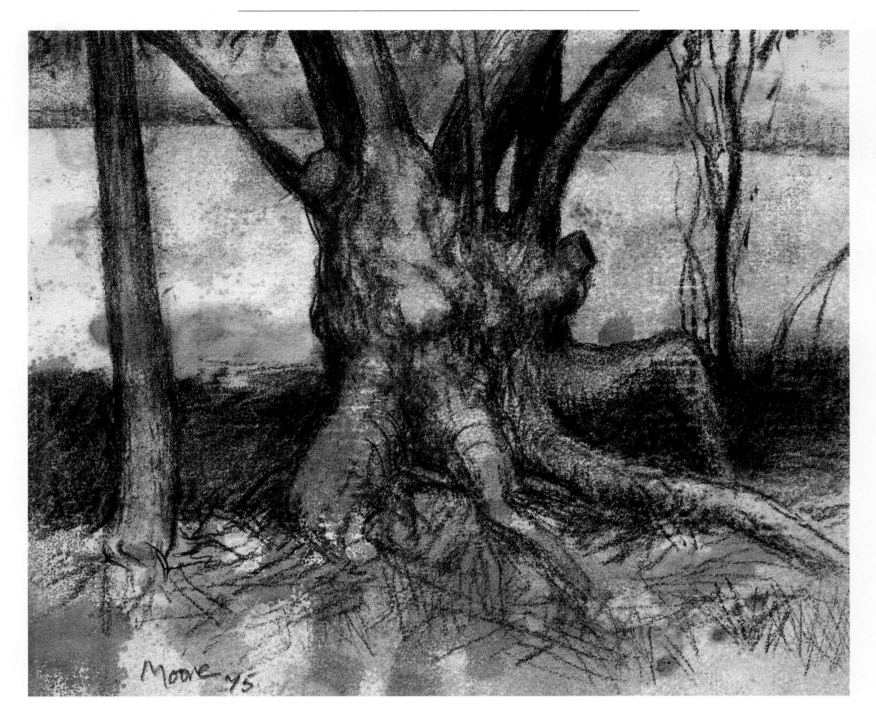

was just as though one were in the Alps. Perhaps those impressions when you're young are what count.'

These boyhood impressions were augmented by his knowledge of Monet's painting *Cliffs at Etretat*, in the collection of the Metropolitan Museum, New York, and, more especially perhaps, Seurat's painting of cliffs and sea, *Le Bec du Hoc*, then in the collection of Moore's friend and early patron, the critic and one-time Director of the National Gallery, Sir Kenneth Clark. Referring in 1962 to the influence of this landscape, Moore commented:

It is this mixture of figure and landscape. It's what I try to do in my sculpture. It's a metaphor of the human relationship with the earth, with mountains and landscape. Like in poetry you can say that the mountains skipped like rams. The sculpture itself is a metaphor like the poem.

The landscape idiom was to remain an important part of Moore's work, particularly in the large works he was asked to provide for open-air public spaces throughout the world in the last decades of his life. The unprecedented international demand for his later work resulted in sculptures which, unlike earlier pieces such as the UNESCO and Lincoln Center reclining figures, were not specifically designed and created for the particular site. Some were adaptations of already existing pieces; in Moore's eightieth year, for example, the National Gallery of Art, Washington, completed its new East Building designed by I M Pei by placing outside it *Mirror Knife Edge*, a unique cast in reverse of the original *Knife Edge Two Piece* of 1962-65.

In the last decades of his life, however, and with the help of assistants, Moore returned to carving. In 1963 he had bought a house in the region of the Carrara Mountains in Italy, where he spent the summer months. It was at Carrara that the marble used by Michelangelo had been quarried. It was here too that Moore's own UNESCO figure had been worked, at Henraux's stone and marble works at Querceta. In 1972 the artist was given the extraordinary honor of a large retrospective exhibition of his work at Forte di Belvedere, in a superb setting overlooking the Renaissance city of Florence.

Forty years after the Northampton *Madonna and Child*, Moore supervised the artisans at Henraux in a process now beyond the octogenarian sculptor's strength, the carving (in Roman travertine marble rather than English Horton stone) of another *Madonna and Child*, for St Paul's Cathedral, London.

LEFT: *Trees VII*, 1975, wash offset, charcoal, black conté, 10⅓ × 7¼ inches (21.3 × 26.5 cm)

RIGHT: *Sheep Grazing in Long Grass 1*, 1981, ballpoint, charcoal, wax crayon, chinagraph, watercolor wash, 13⅞ × 9⅞ inches (35.5 × 25.4 cm)

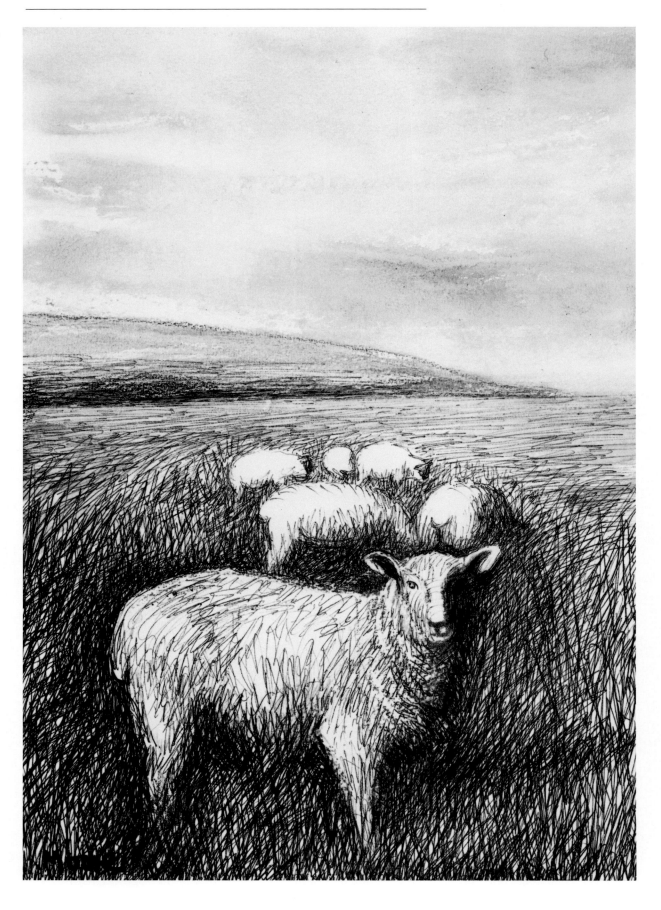

This was Moore's final exploration of the mother and child theme that had been an obsession since his very earliest work, the Portland Stone *Mother and Child* of 1922 (now lost). The St Paul's *Madonna and Child* is a near-abstract piece, one that Moore wrote should 'give the feel of having a religious connotation.'

Of the two outstanding themes in his work, the mother and child and the reclining figure, Moore had claimed when sculpting the Northampton *Madonna* that the mother and child was 'a more fundamental obsession.' In a working life that can be seen to have its own symbolism, it is particularly appropriate that the last work of Britain's most famous sculptor should have

been commissioned for Wren's St Paul's, which was regarded after World War II as symbolic of London's survival during the Blitz. London appears to have had a particular meaning and resonance for Moore, from his Blitz work in the shelters as Official War Artist to his gift of the huge bronze *The Arch* in 1980, sited in Kensington Gardens. This was the nearest landscape setting to the Royal College of Art, to which he had come 'in a dream of excitement' as a student some 60 years before.

In his lifetime Moore was a generous donor of his own work. Gifts that he made to institutions included donations of over 100 sculptures, some 70 drawings and an almost complete set of graphics to the Henry Moore Sculpture Centre at the Art

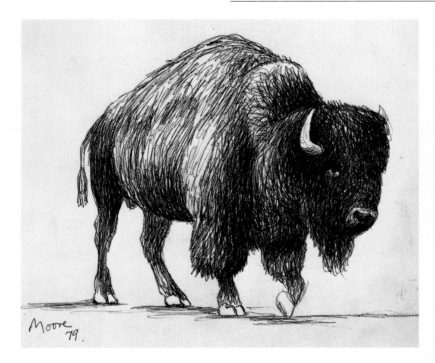

ABOVE: *Bison: Three-quarter View Facing Right*, 1979, charcoal, chalk, ballpoint pen, 7 × 8⅜ inches (17.8 × 21.3 cm).

RIGHT: *Landscape with Bonfire IX*, 1975, pencil, watercolor, pastel, black chalk, 10¾ × 12⅞ inches (27.5 × 33 cm).

Gallery of Ontario, Canada, and 36 sculptures to the Tate Gallery in London on the occasion of his eightieth birthday in 1978. The buildings and studios surrounding Hoglands, the seventeenth-century farmhouse at Much Hadham in Hertfordshire which Moore had bought during World War II, plus 70 acres of land acquired over the years, remain the center of Moore activity. Here the Henry Moore Foundation was established in 1977 to direct what was by then an international concern, which included charitable and educational work on a large scale. Five years later HM The Queen opened the Henry Moore Centre for the Study of Sculpture, now part of the Henry Moore Institute, in Leeds. Interest in Moore's work continues unabated and the site at Much Hadham holds key representative sculptures from every period, many on view and sited according to the sculptor's wishes. Future plans for the Foundation envisage an extension of its research and educational activities to include building a study center, library and gallery on the site.

A long court case brought by Moore's only child, Mary Moore Danowski, against the Foundation over rights of ownership to many important works was decided in favor of the Foundation in the final week of 1993. It is now clear that the Much Hadham sculptures will remain *in situ* in the environment in which their creator worked a seven-day week until his eighties. Despite, or perhaps because, of Moore's international status, Much Hadham has become a uniquely fitting place in which to honor the life and work of Britain's most famous sculptor.

BEGINNINGS, 1923-39

Moore's earliest work is deeply influenced by the Mexican sculptures he had seen at the British Museum when he was a student at the Royal College of Art in London. Moore admired such sculpture for:

Its 'stoniness', by which I mean its truth to material, its tremendous power; without loss of sensitiveness, its astonishing variety and fertility of form – invention, and its approach to a full three-dimensional conception of form, make it unsurpassed in my opinion by any other period of stone sculpture.

The creative influence of such work is strong in Moore's sculpture of the 1920s. The *Mask* of 1929, with its 'male' left-hand side and 'female' right-hand side, and the female half-figures with clasped hands both have the vitality so admired by Moore in Mexican sculpture. His first *Reclining Figure* of the same year also derives from Mexican art, yet it radically transforms its probable source, an eleventh- or twelfth-century Toltec-Maya rain god, from a male to a female figure, and retains the original shape of the block of Brown Hornton stone from which it was carved. Moore's belief in 'truth to material' can clearly be seen in such a vital piece of direct carving, demonstrating, in Moore's own words, the importance of the sculptor's:

Understanding and being in sympathy with his material so that he does not force it beyond its natural constructive build, producing weakness; to know that sculpture in stone should look honestly like stone.

The elmwood *Reclining Figure* of 1935-36 is less representational and uses the natural wide grain of the wood to emphasize the pose. In a radical departure from the earlier reclining figure, Moore hollows out the thorax area, so that the figure has more in common with organic and landscape forms and less with the angular and block-like shapes of ancient Mexican carvings. Organic forms are also used in the small alabaster *Four-Piece Composition: Reclining Figure* of 1934, which is made up of dismembered parts, anticipating the huge two- and three-piece reclining figures of the 1960s. The forms may be seen to relate to the pebbles weathered by the sea which Moore had begun to collect at this period. The major work of the 1930s, however, is the Green Hornton stone *Recumbent Figure* of 1938. Commissioned by the architect Serge Chermayeff for the garden of his long, low house, with its fine view of the South Downs in Sussex, this gave Moore his first opportunity to design a sculpture for a particular landscape setting. The head of this figure is more naturalistic than the earlier pieces; the sculptor 'became aware of the necessity of giving outdoor sculpture a far-seeing gaze. My figure looked out across a great sweep of the Downs and her gaze gathered in the horizon.' The universality of the form and its seeming prescience give the figure, even when divorced from its original setting and placed in a gallery, a presence and power hitherto unknown in Moore's work.

RIGHT:
Figure, 1923
Verde di prato, h.15½ inches (39.4 cm)
Private Collection
Photo Malcolm Varon

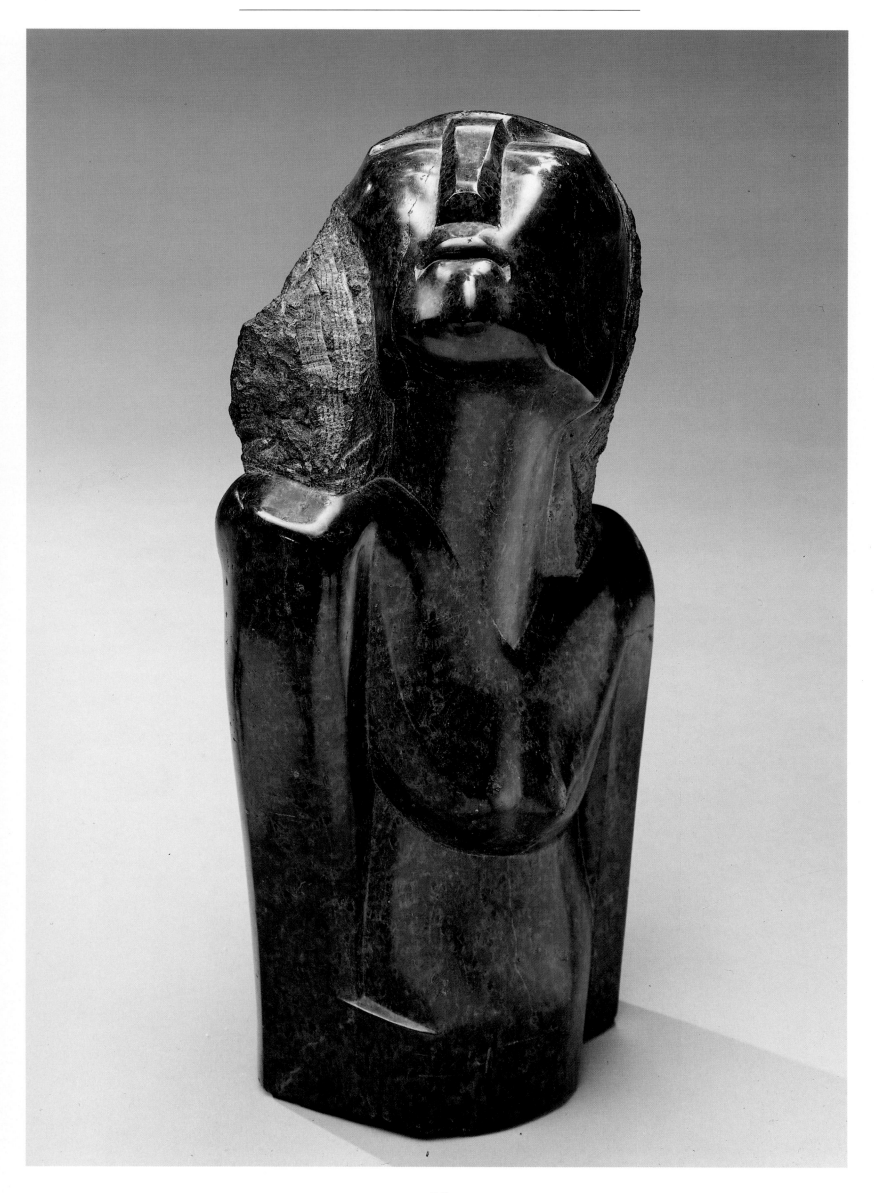

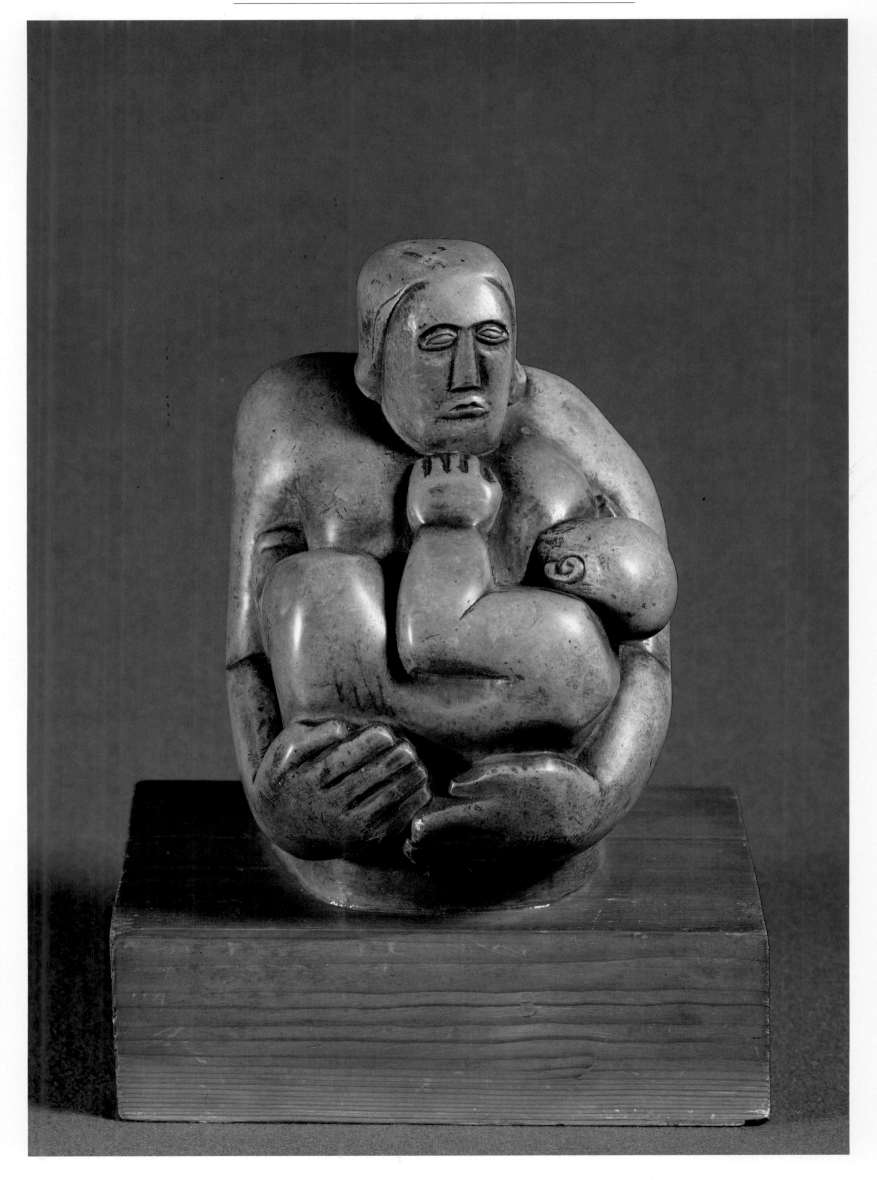

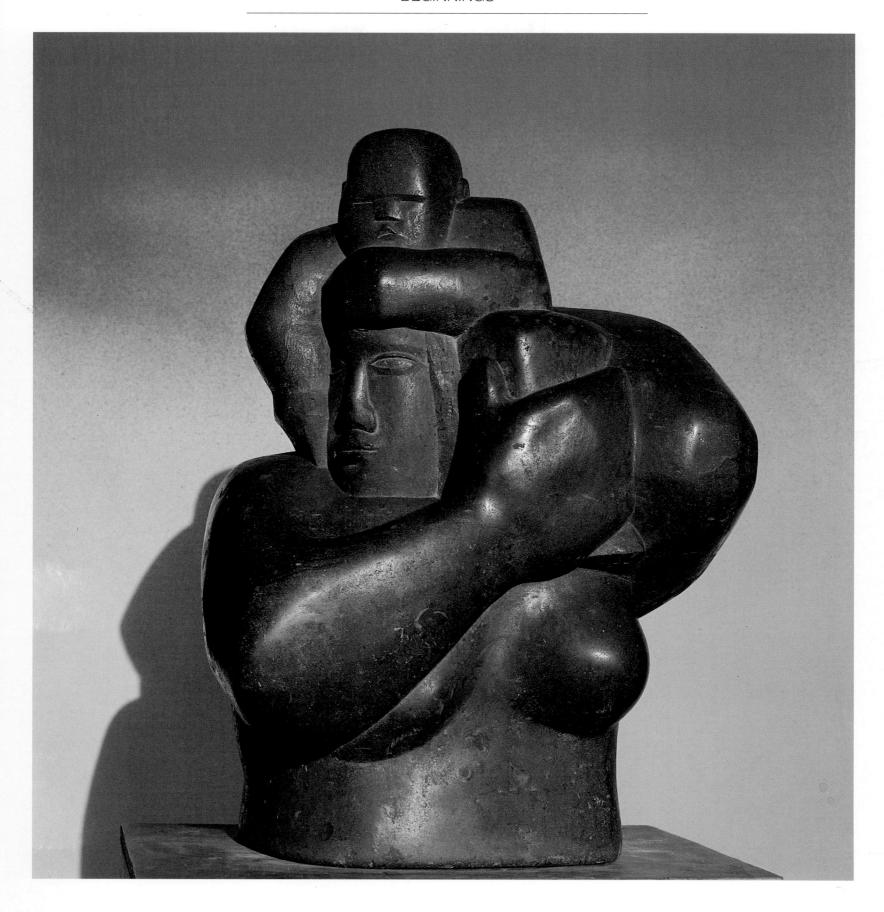

LEFT:
Maternity, 1924
Hopton-wood stone, h. 7¾ inches (19.7 cm)
By permission of the Henry Moore Centre for the Study of
Sculpture, Leeds City Art Galleries

ABOVE:
Mother and Child, 1924-25
Hornton stone, h.25 inches (63.5 cm)
City Art Gallery, Manchester, photo courtesy of the Henry Moore
Foundation

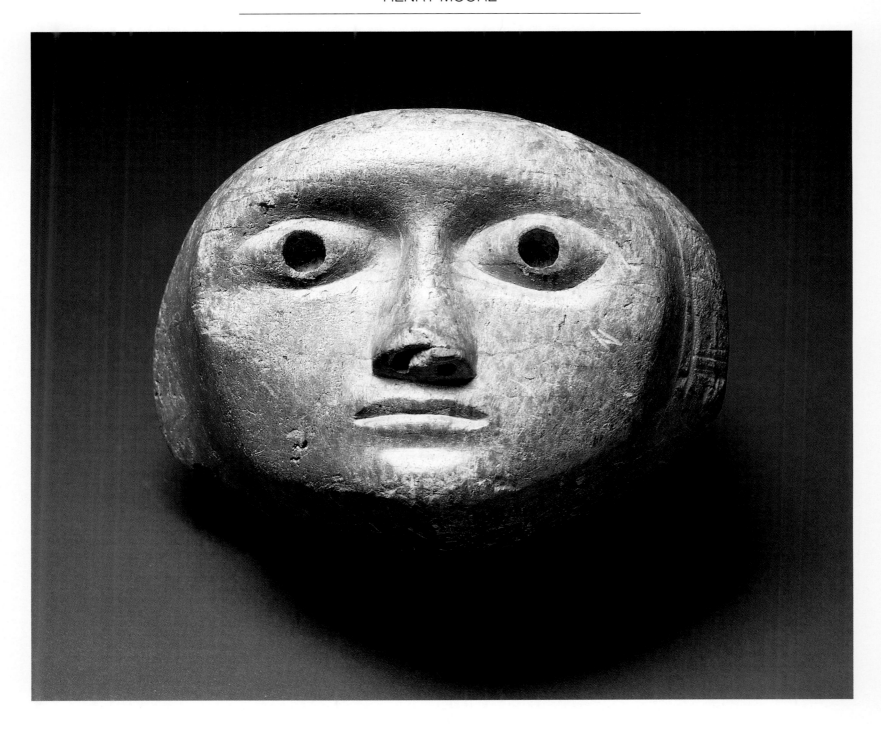

Mask, 1929
Stone, h.5 inches (12.7 cm)
Private Collection
Photo Malcolm Varon

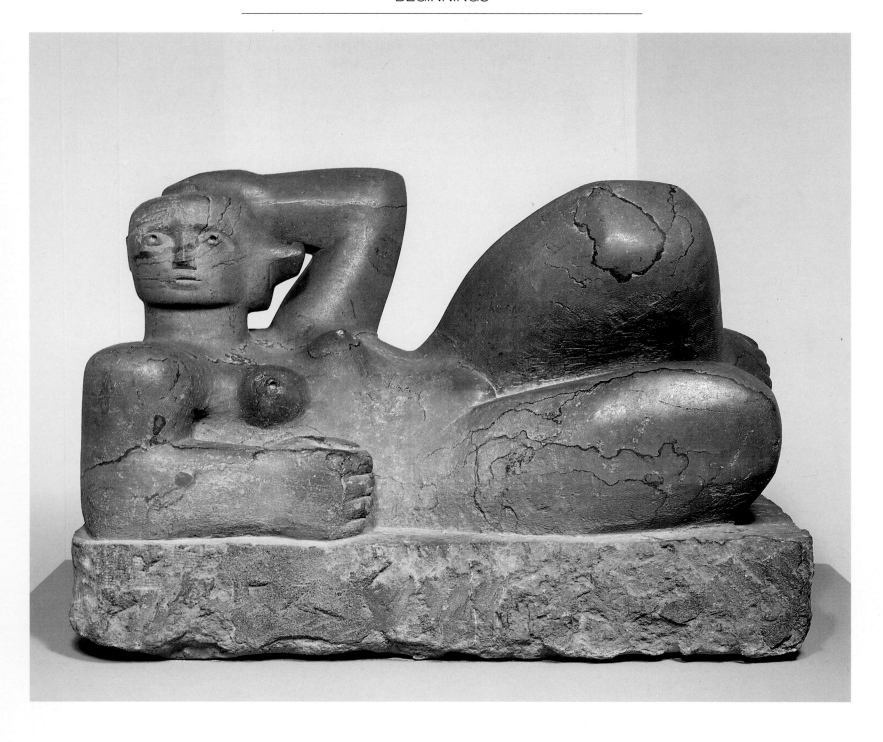

Reclining Figure, 1929
Brown Hornton stone, l. 33 inches (84.5 cm)
By permission of the Henry Moore Centre for the Study of
Sculpture, Leeds City Art Galleries

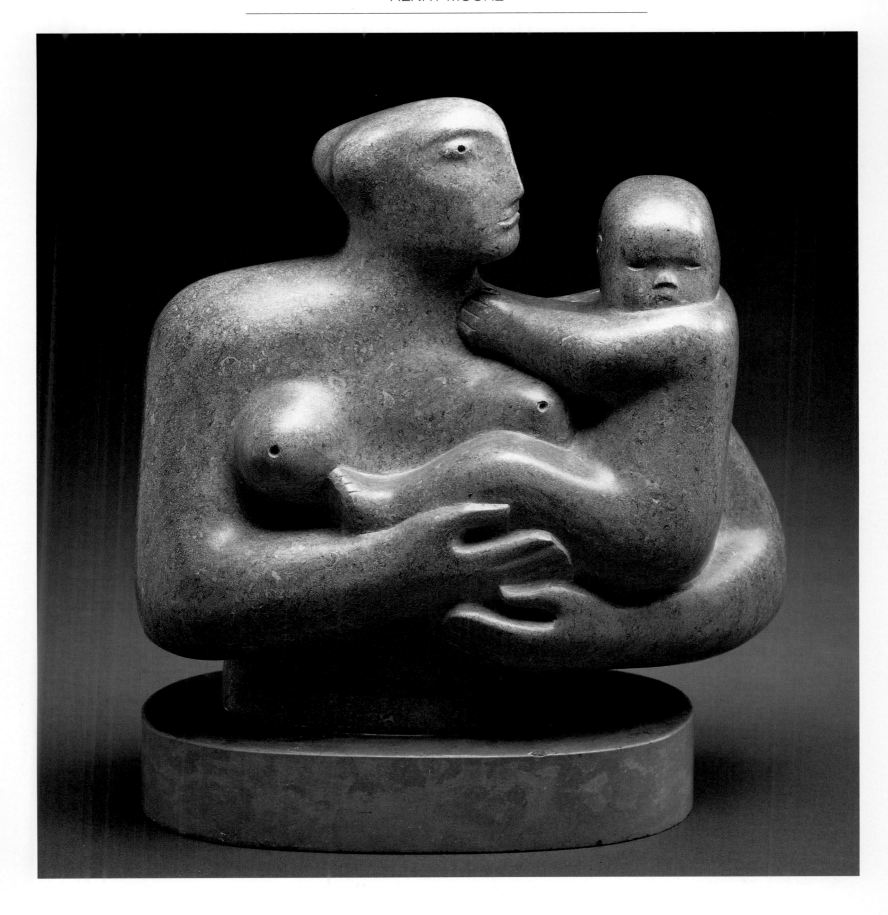

Mother and Child, 1930
Ancaster stone, h.10 inches (25.4 cm)
Private Collection
Photo Malcolm Varon

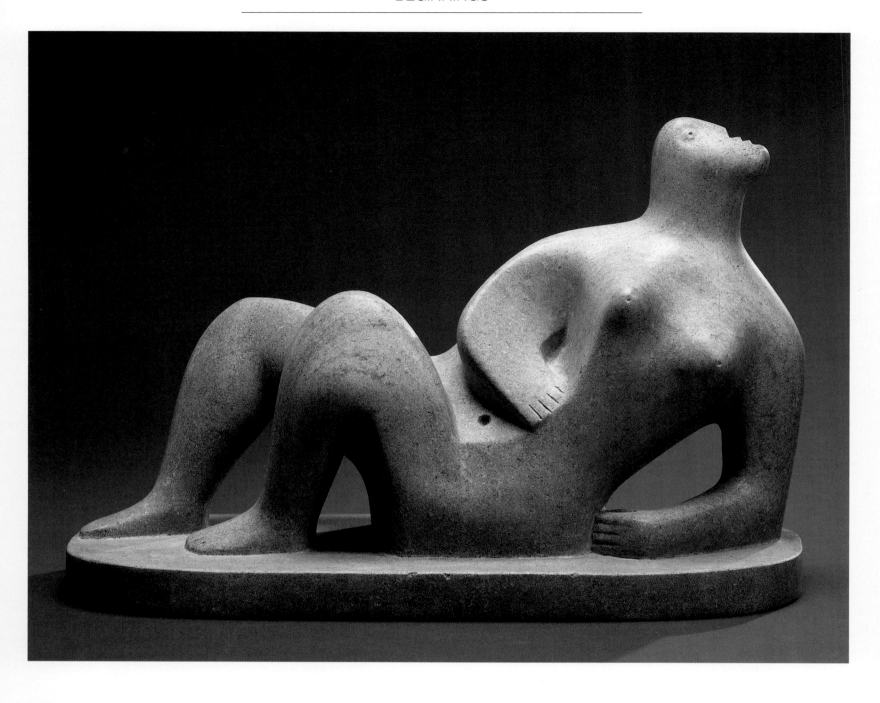

Reclining Figure, 1930
Ancaster stone, l.21 inches (53.3 cm)
Detroit Institute of Arts, Founders Society, Purchase, Friends of
Modern Art Fund

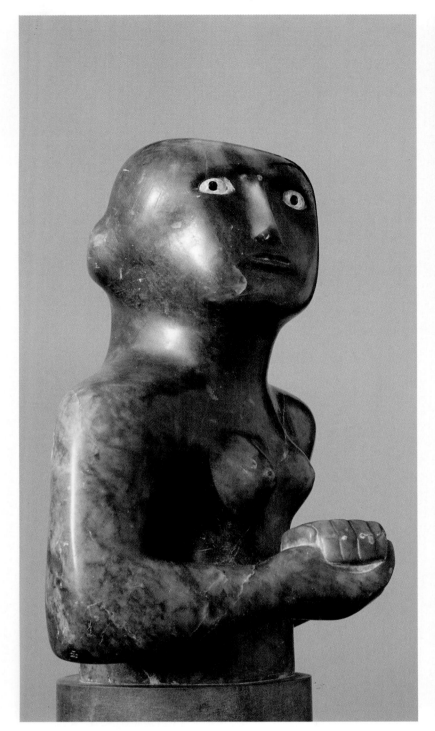
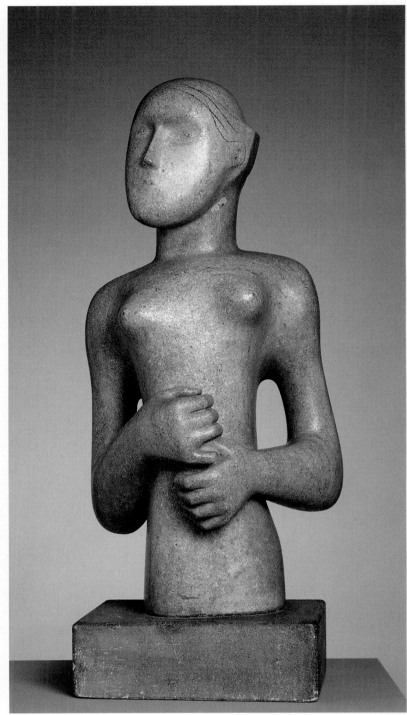

ABOVE LEFT:
Girl with Clasped Hands, 1930
Cumberland alabaster, h.16½ inches (41.5 cm)
The British Council, London, photo courtesy of the Henry Moore
Foundation

ABOVE RIGHT:
Girl, 1931
Ancaster stone, h.29 inches (74.2 cm)
Tate Gallery, London

RIGHT:
Half-Figure, 1932
Terracotta, h.5 inches (12.8 cm)
Tate Gallery, London

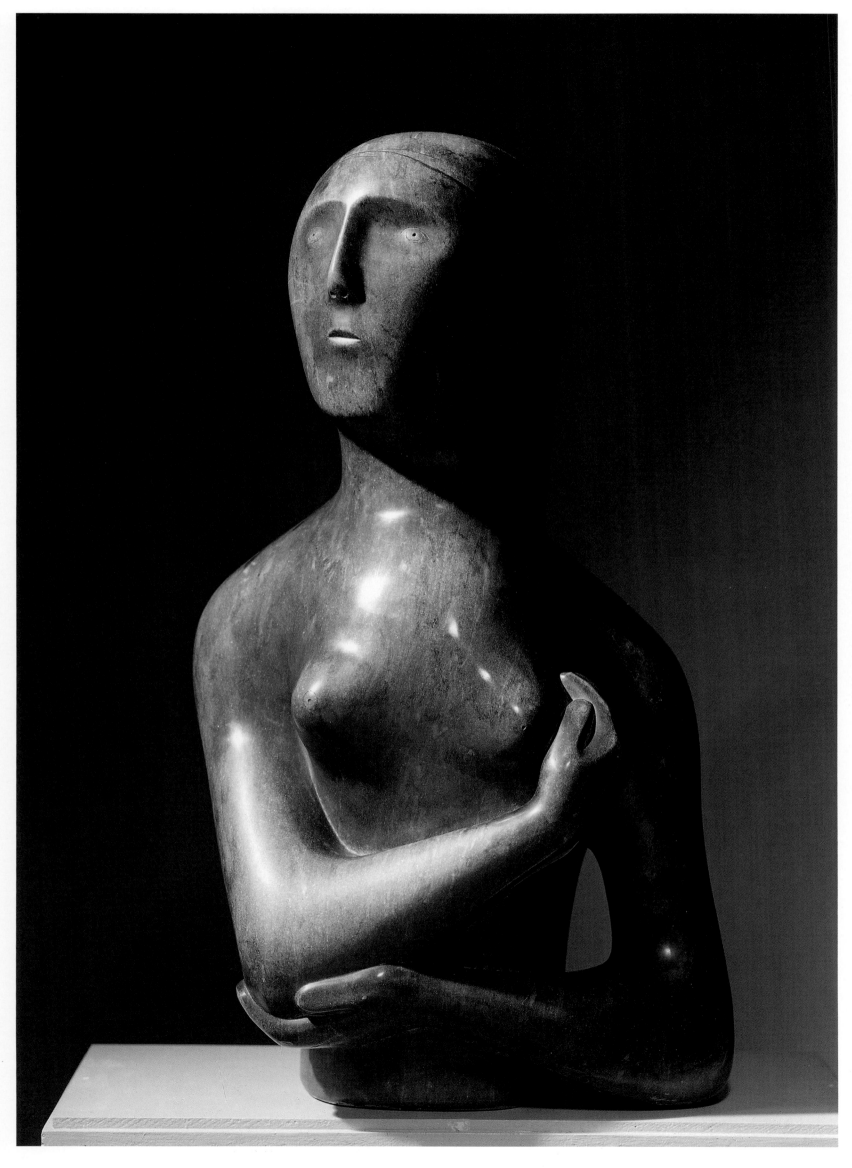

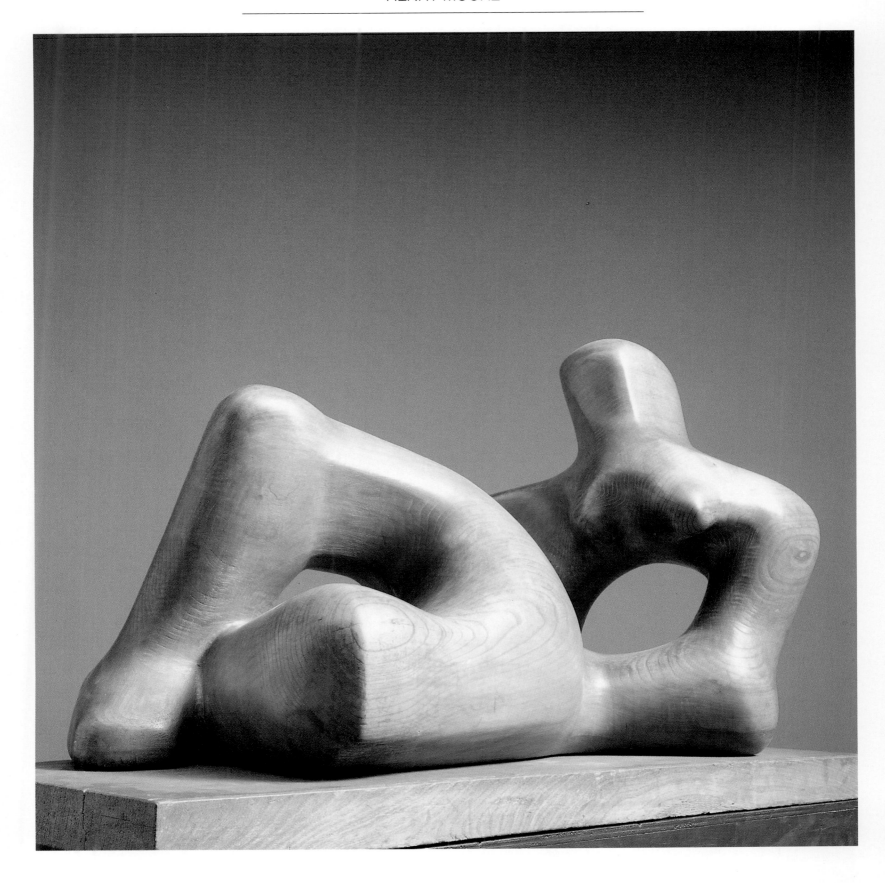

Reclining Figure, 1936
Elmwood, 1.42 inches (106 cm)
Wakefield Art Gallery, photo courtesy of the Henry Moore
Foundation

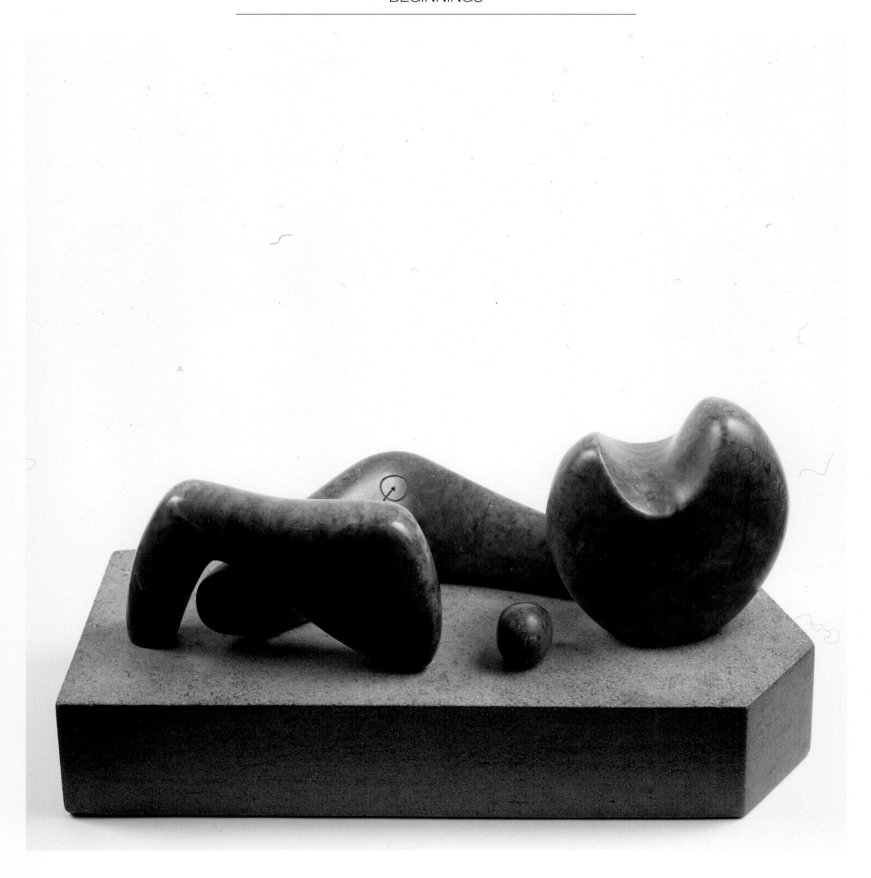

Four Piece Composition: Reclining Figure, 1934
Cumberland alabaster, 1.20 inches (50.8 cm)
Tate Gallery, London

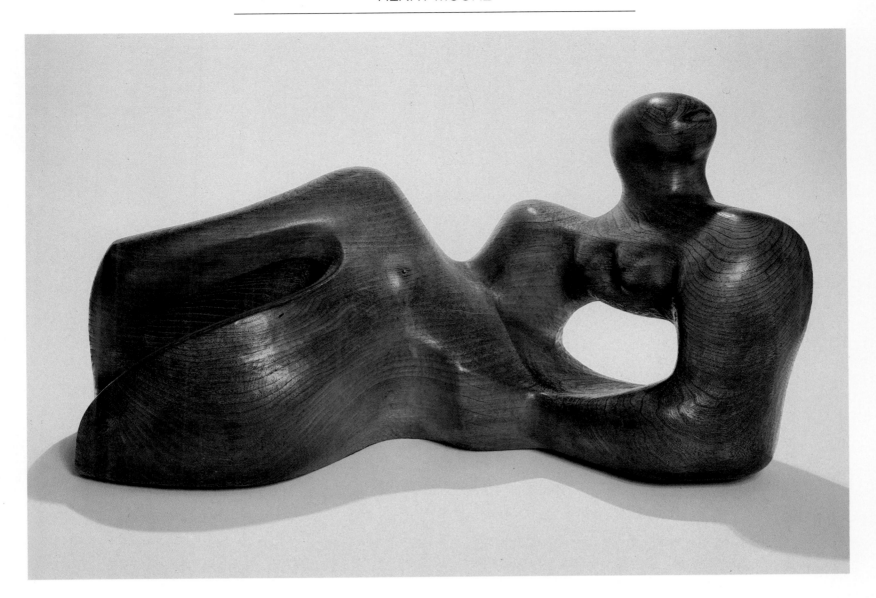

Reclining Figure, 1935-36
Elmwood, 19 × 35 × 15 inches (49 × 90 × 38 cm)
Albright-Knox Art Gallery, Buffalo, Room of Contemporary Art
Fund, 1939

Two Forms, 1936
Hornton stone, h. 42 inches (126.7 cm)
Philadelphia Museum of Art, Gift of Mrs H. Gates Lloyd

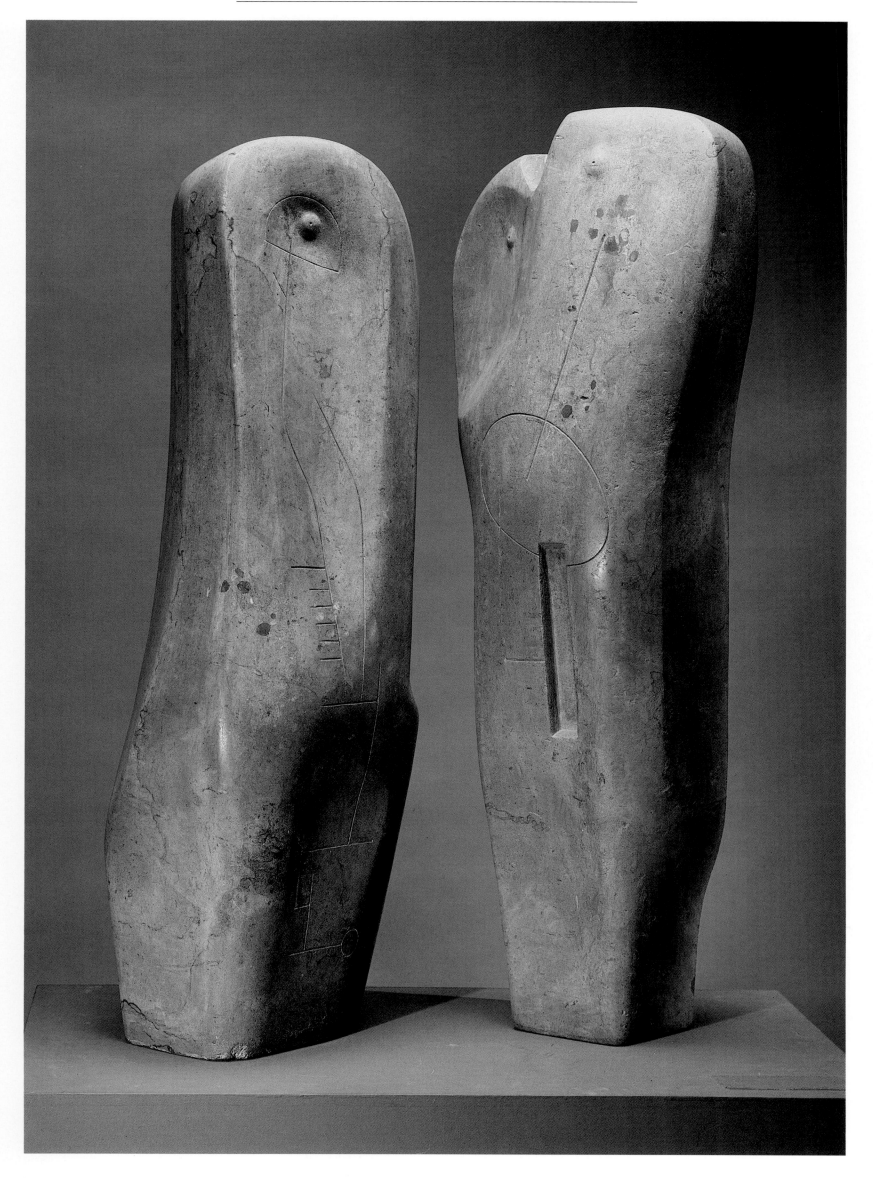

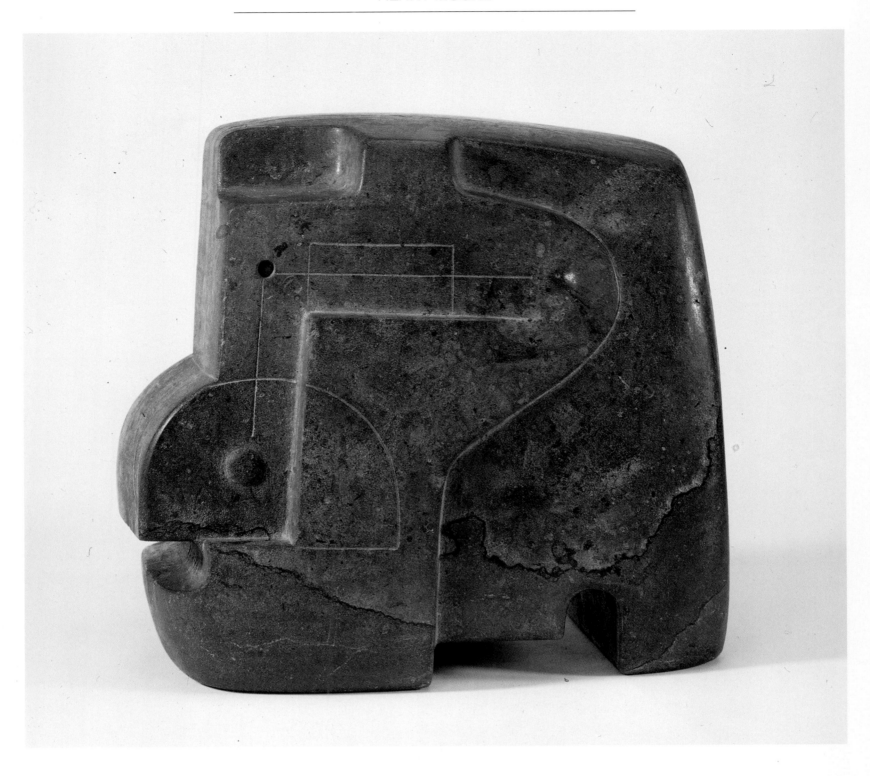

Square Form, 1936
Green Hornton stone, 1.16 inches (41 cm)
Robert and Lisa Sainsbury Collection, University of East Anglia,
Norwich

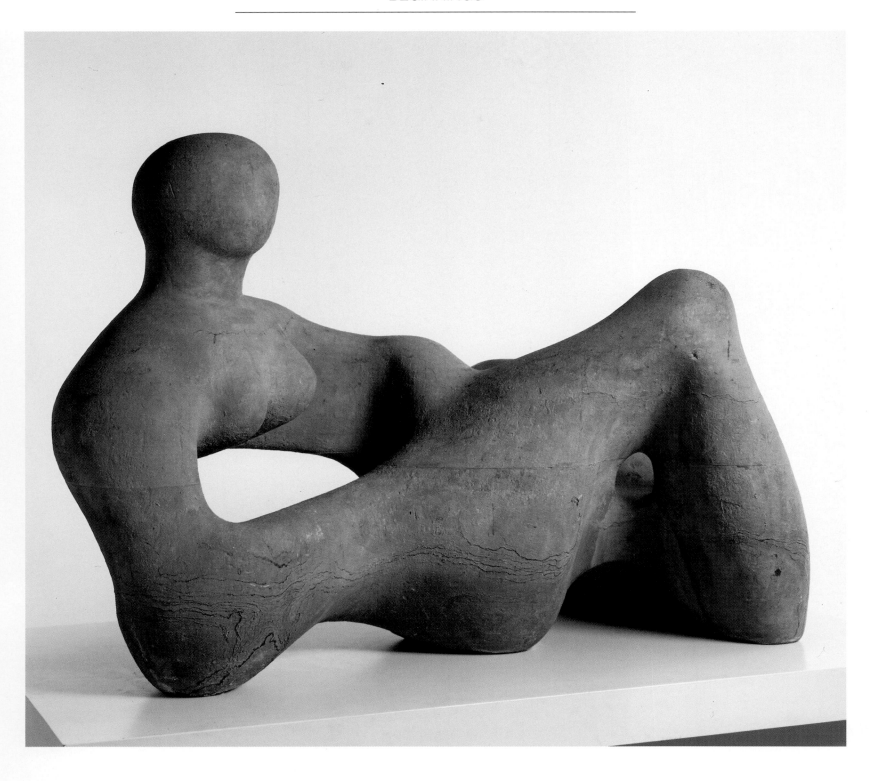

Recumbent Figure, 1938
Green Hornton stone, 1.55 inches (139.7 cm)
Tate Gallery, London

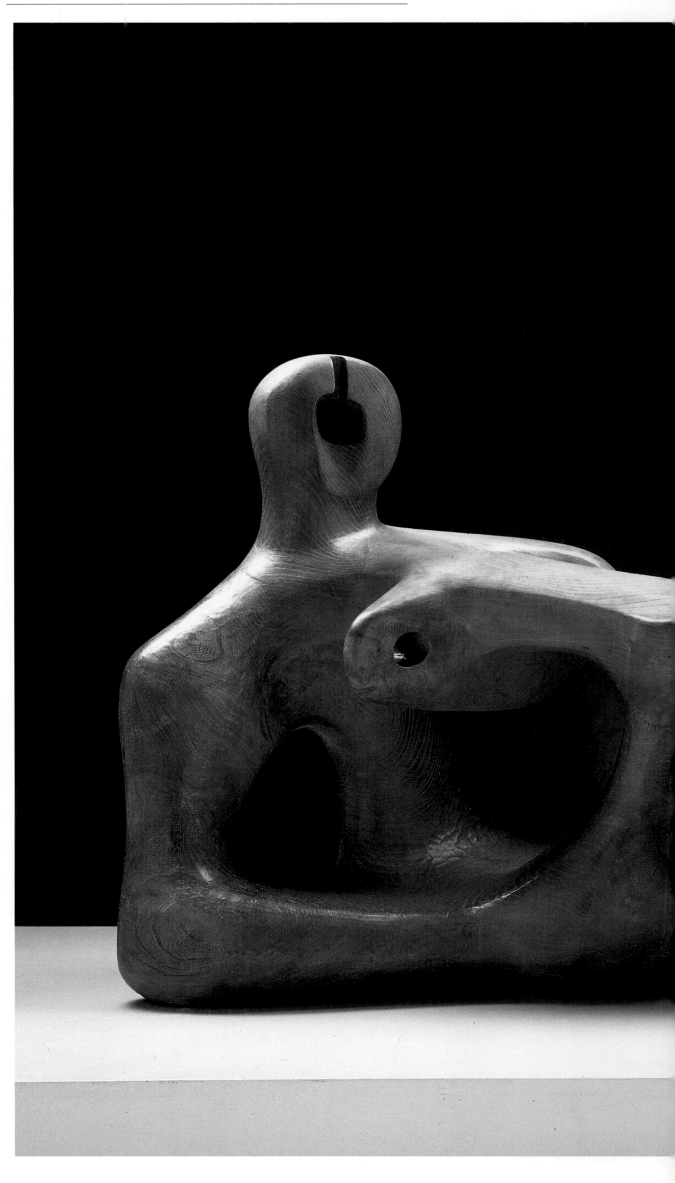

Reclining Figure, 1939
Elmwood, 1.78½ inches
(201 cm)
Detroit Institute of Arts, Gift
of the Dexter M. Ferry Jr.
Trustee Corporation

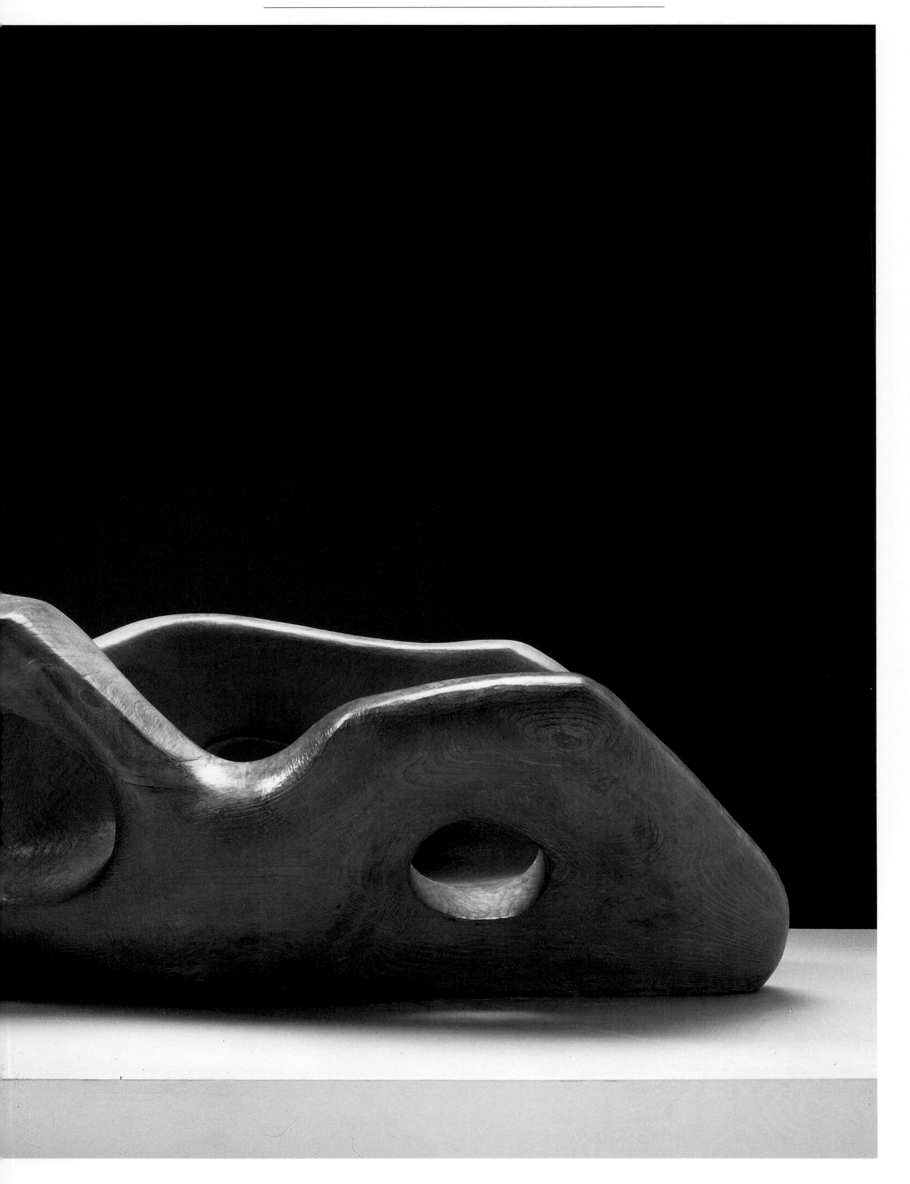

THE WAR AND FAME, 1940-55

Moore's work during the war period took a decisive turn toward a greater humanity. The artist himself described the Shelter drawings as an artistic and professional turning point. His work as Official War Artist on the Home Front, which included both the Shelter series and a later group of drawings of miners at work, brought him new popularity, with a wider public than ever before. Moore's London studio had been bombed early in the war and, for this and other reasons, large-scale sculpture was a practical impossibility for several years.

In 1943, however, he was commissioned to carve the *Madonna and Child* for the Church of St Matthew, Northampton, his first full-length exploration of a theme which had preoccupied many artists, including Michelangelo, throughout the history of Christian art. The mother and child theme had also long interested Moore, more specifically in its domestic aspect, but he now strove to achieve a different ideal, in his own words:

An austerity and nobility, and some touch of grandeur (even hieratic aloofness) which is missing in the everyday Mother and Child idea.

Moore's studies of swathed human forms for the Shelter drawings of the war years found echoes in the monumental draped reclining *Memorial Figure* in the landscape gardens at Dartington Hall, Devon. Perfectly attuned to its superb setting, the figure appears to watch over the surrounding hills. This idea of sculptural forms as witnesses or watchers relates both to eighteenth-century English ideas of the 'spirit of the place' and to the more recent and terrible war-time memories of millions, when the sky contained the threat of aerial bombardment. Whether consciously or not, Moore embodied this concept in such key post-war groups as the Darley Dale stone *Three Standing Figures* (1947-48) for Battersea Park, London, and the bronze *King and Queen* of 1952-53.

Moore explained that the *King and Queen* 'has nothing to do with present-day Kings and Queens but is more connected with the archaic or primitive idea of King.' The cast on the Glenkiln estate in Dumfries, Scotland, has a particularly powerful and timeless relationship with the surrounding landscape, as the figures sit on a hillside facing a lake. Moore acknowledged that the warrior sculptures from the 1950s 'may be emotionally connected . . . with one's feelings and thoughts about England during the crucial and early part of the last war.' The *Warrior with Shield* was the first 'single and separate male figure that I have done in sculpture and carrying it out in its final large scale was almost like the discovery of a new subject matter; the bony, edgy, tense forms were a great excitement to make.'

RIGHT:
Maquette for Madonna and Child, 1943
Bronze, h. 7¼ inches (18.4 cm)
Tate Gallery, London

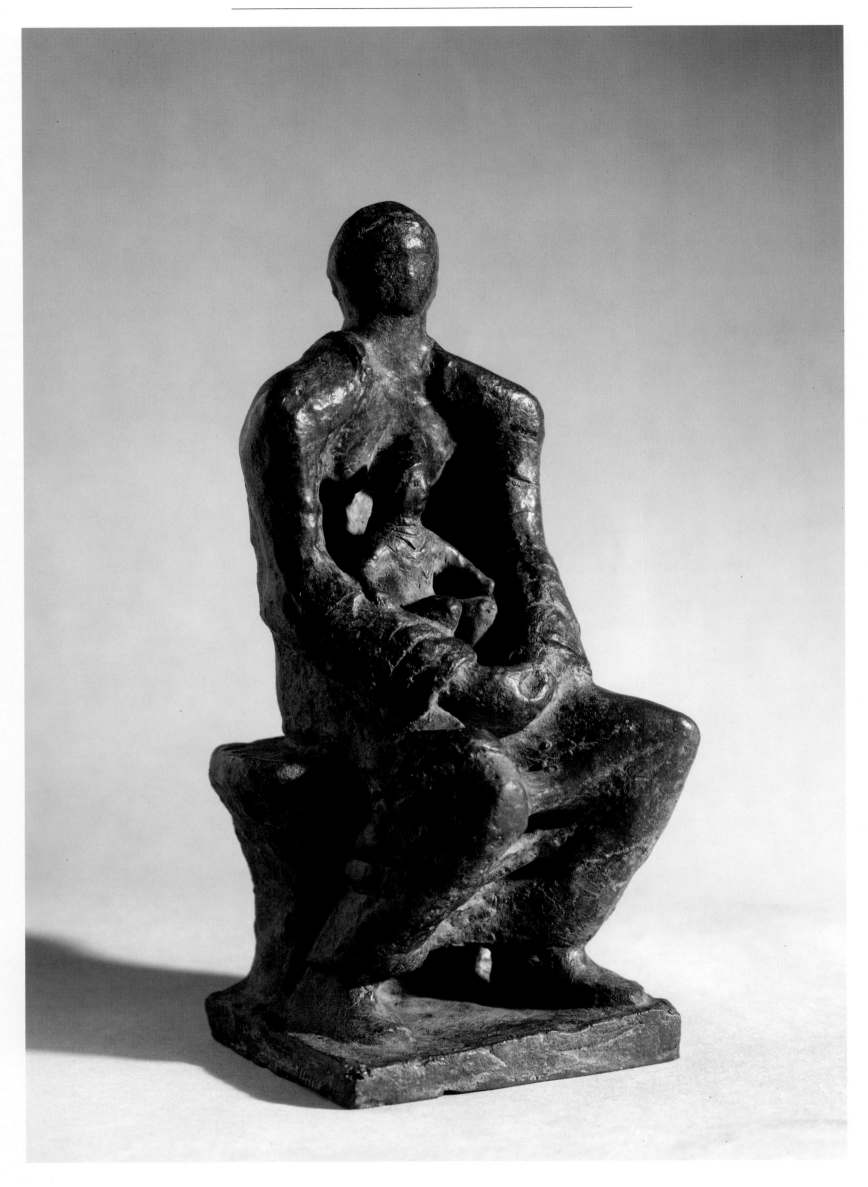

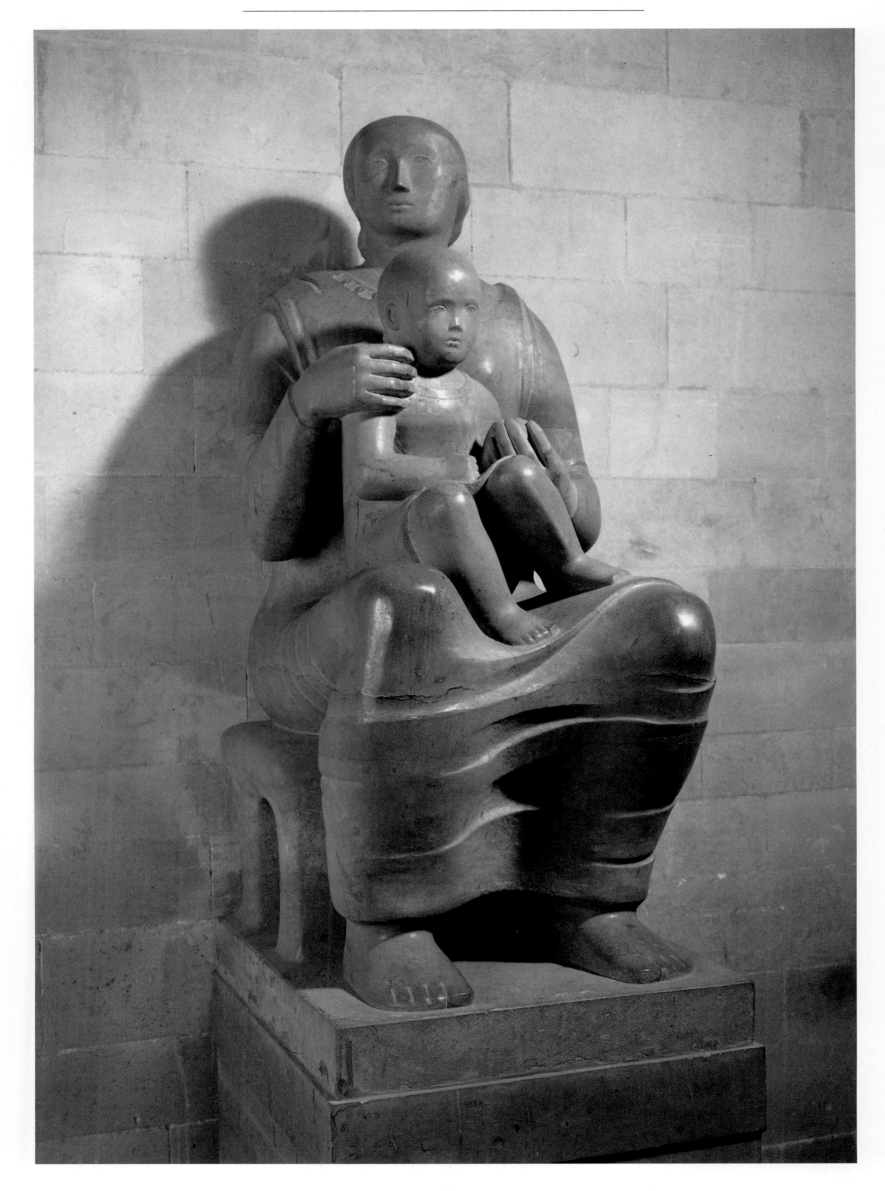

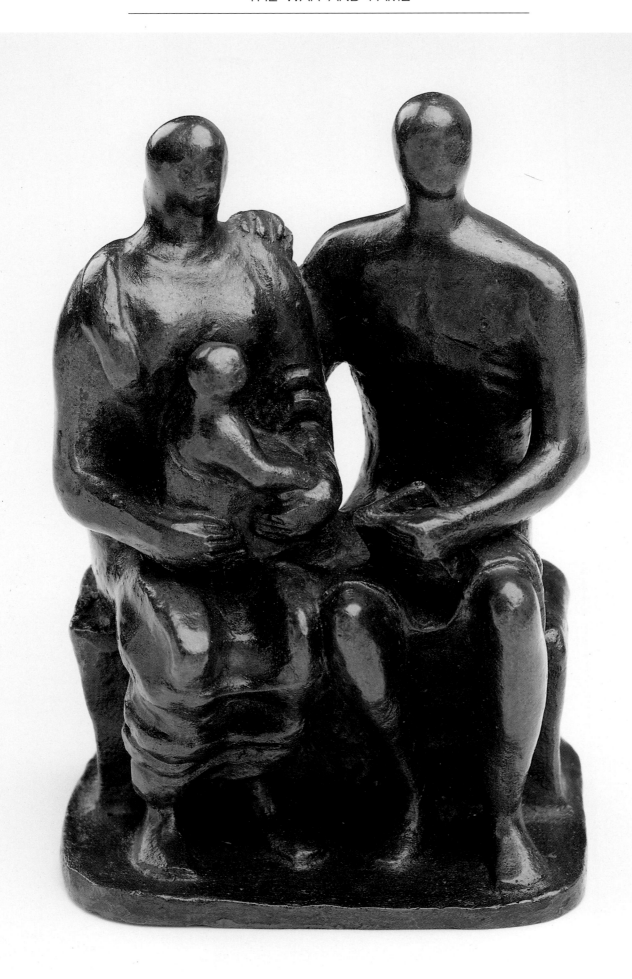

Madonna and Child, 1943-44
Hornton Stone, h.59 inches (150 cm)
Church of St Matthew, Northampton,
photo courtesy of the Henry Moore Foundation

Family Group, 1944
Bronze, h.5½ inches (14 cm)
San Diego Museum of Art, Bequest of Earle W. Grant

45

Memorial Figure, 1945-46
Hornton stone, 1.56 inches
(142 cm)
Dartington Hall, Totnes

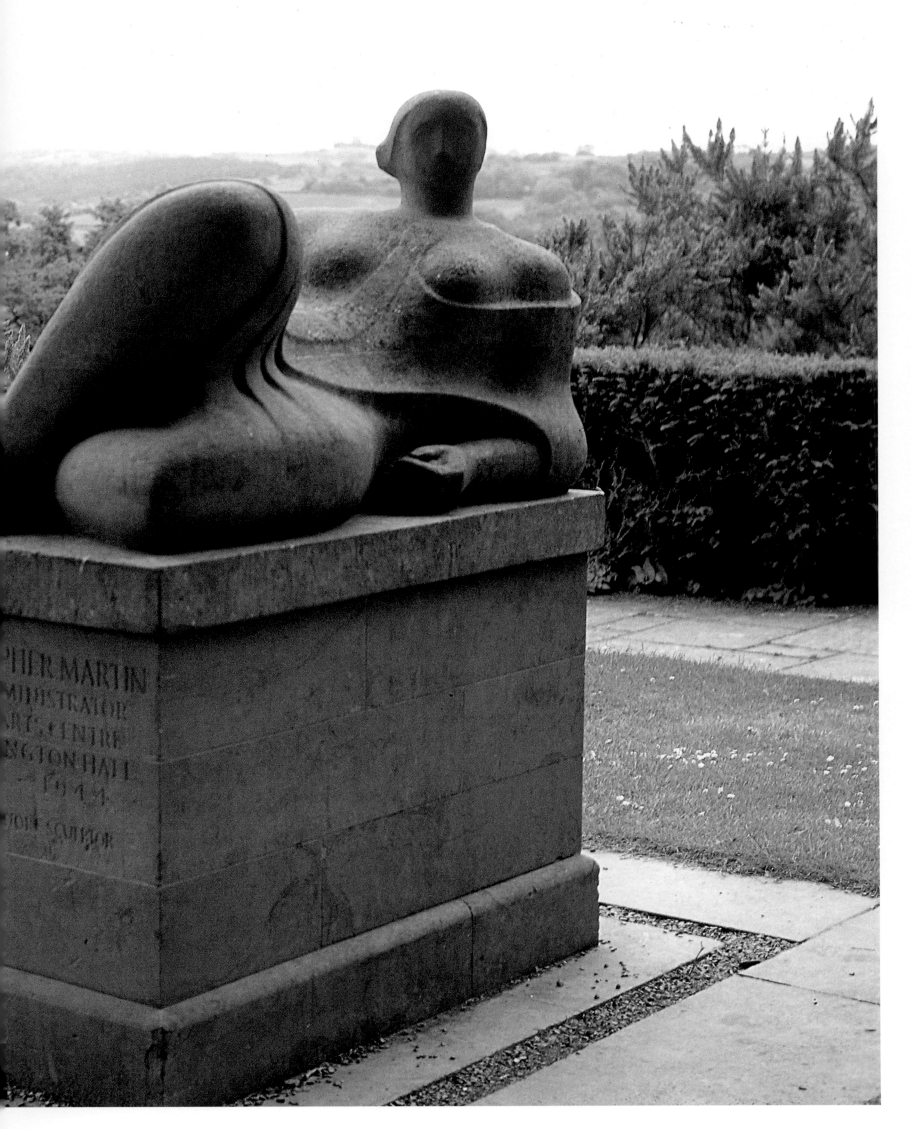

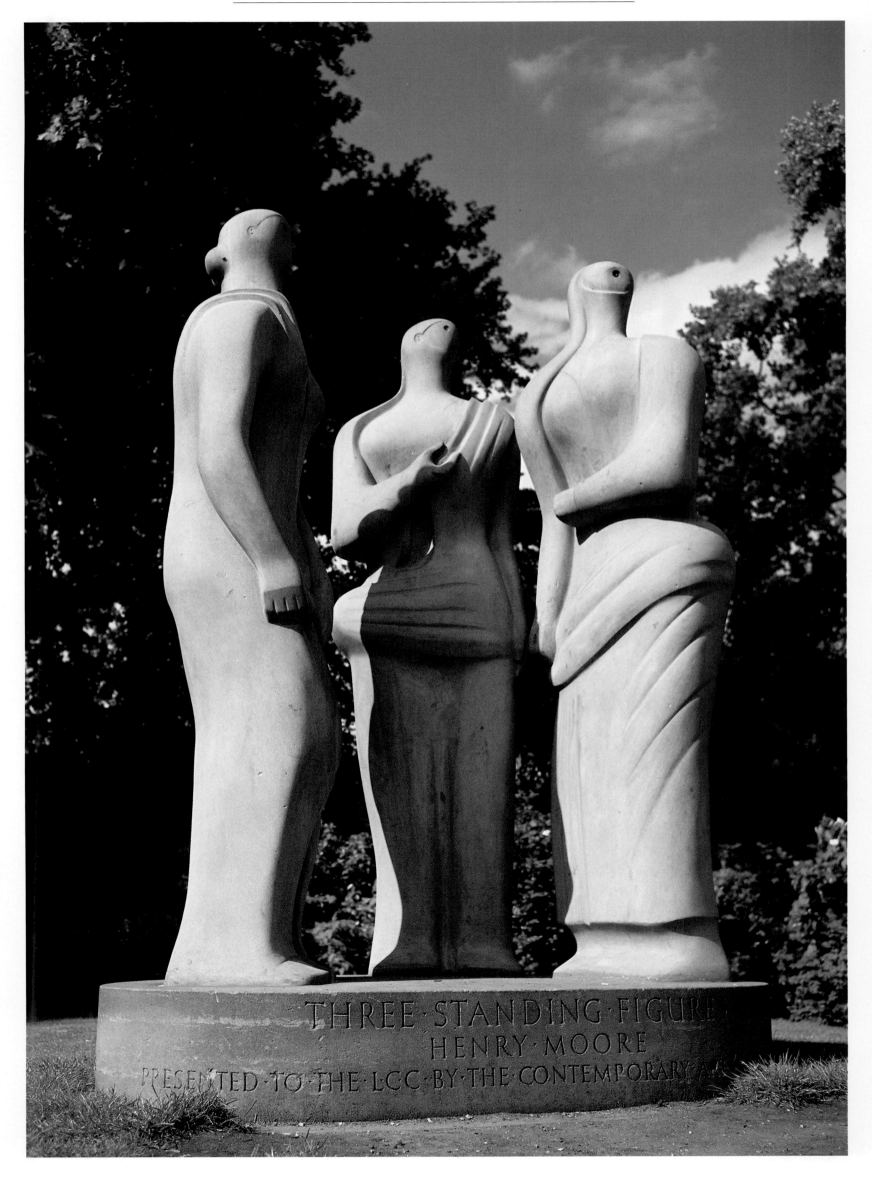

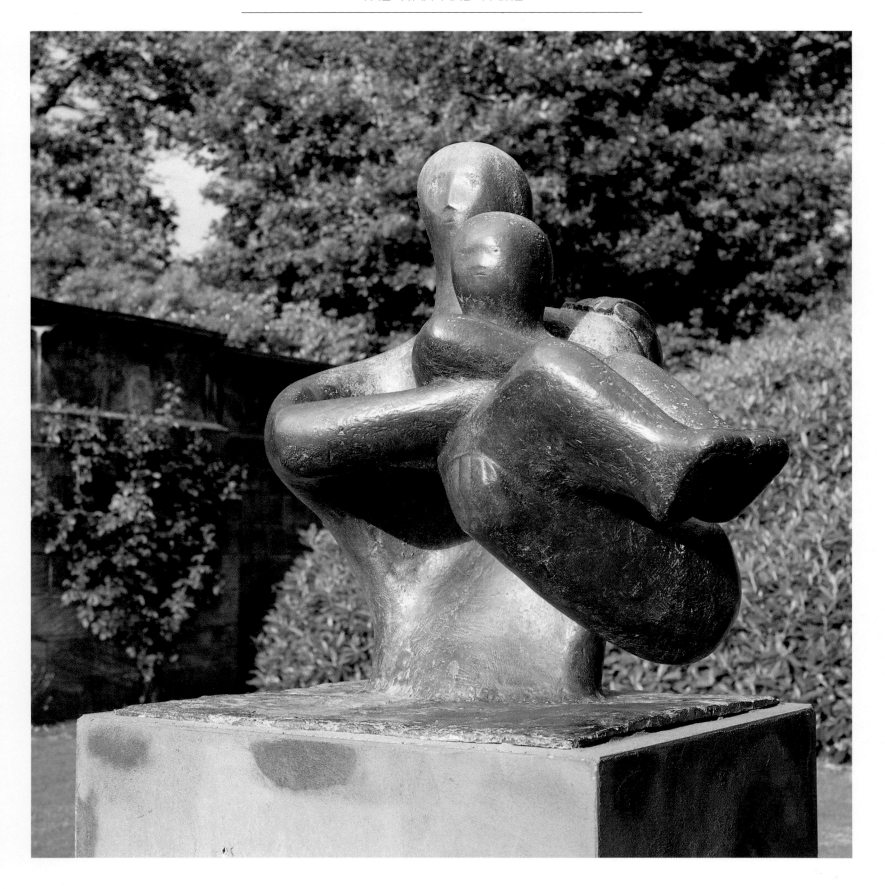

LEFT:
Three Standing Figures, 1947-48
Darley Dale stone, h. 84 inches (213 cm)
London Borough of Wandsworth, Battersea Park, London,
photo courtesy of the Henry Moore Foundation

ABOVE:
Mother and Child, 1949
Bronze, h. 32 inches (81 cm)
Courtesy of the Henry Moore Foundation

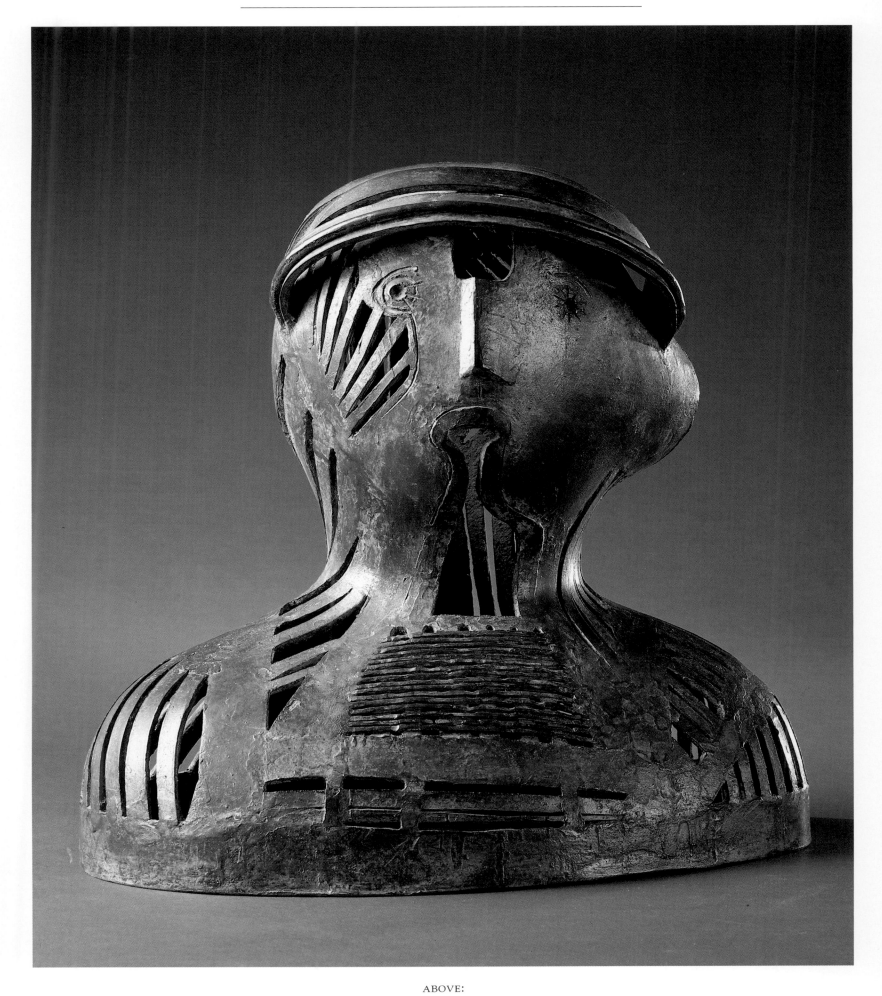

ABOVE:
Openwork Head and Shoulders, 1950
Bronze, h.17½ inches (44.5 cm)
Private Collection
Photo Malcolm Varon

RIGHT:
Helmet Head No.1, 1950
Lead, h.12¾ inches (33 cm)
Tate Gallery, London

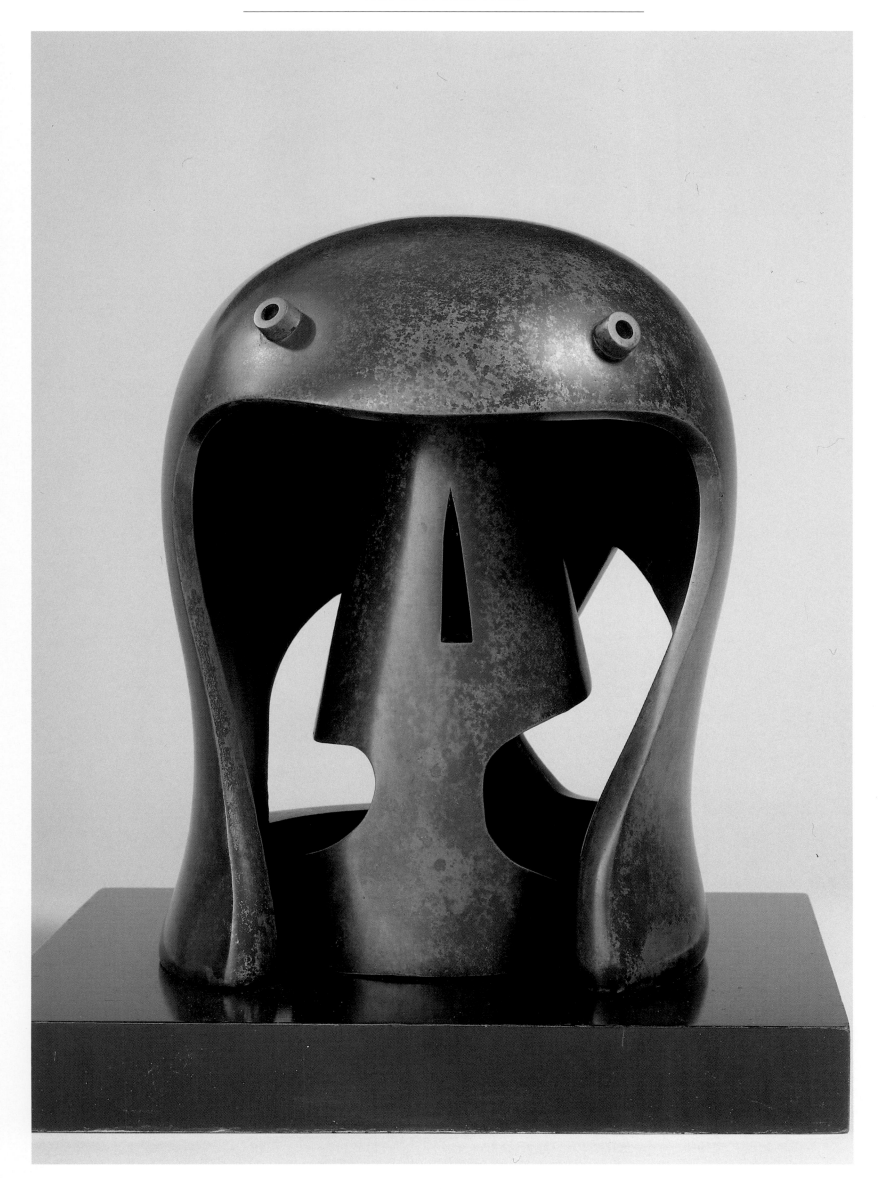

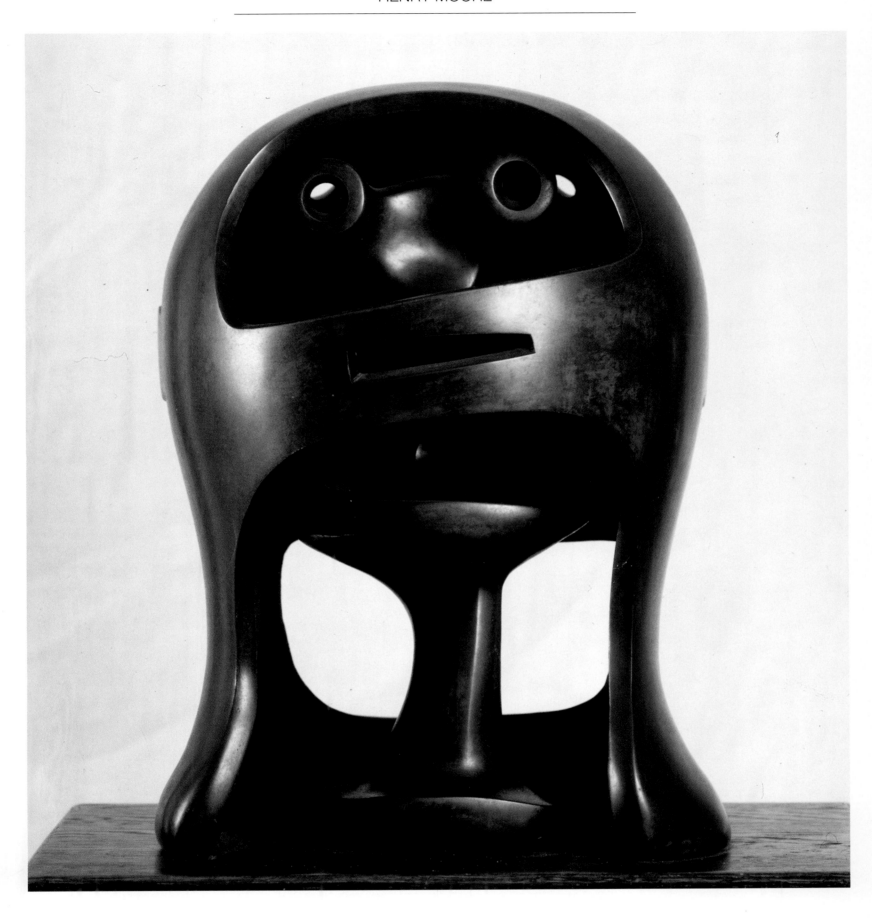

Helmet Head No. 2, 1950
Lead, h.13½ inches (34.3 cm)
Museo d'Arte Moderna, Ca'Pesaro, Venice

52

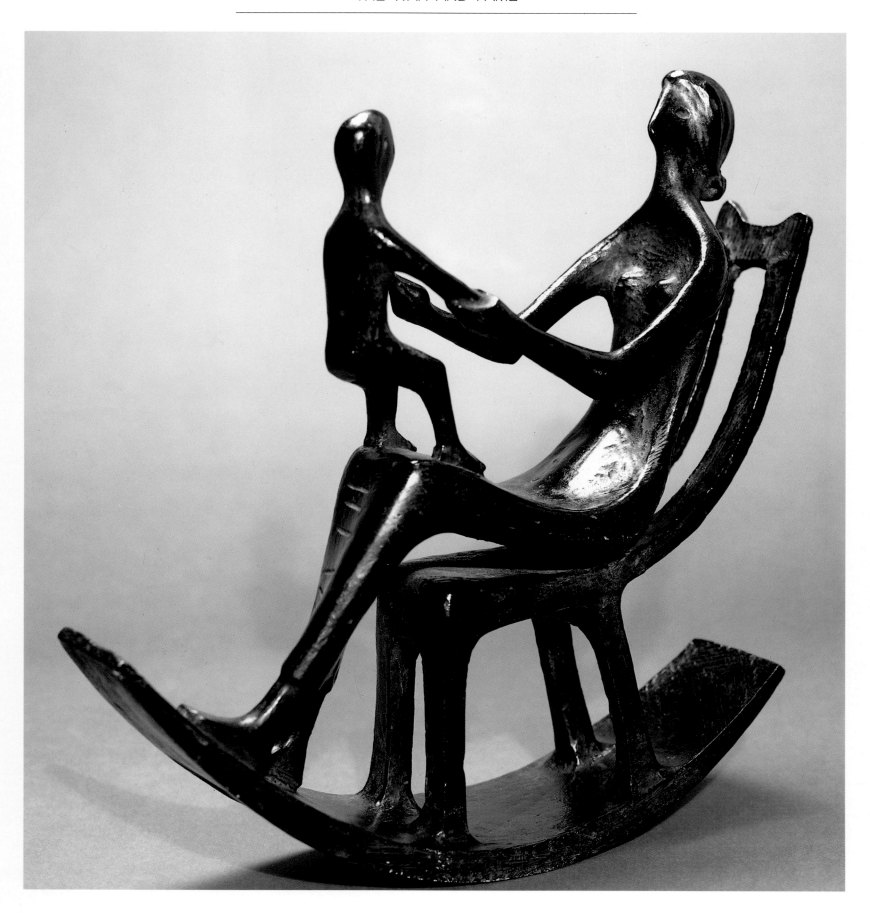

Rocking Chair No. 2, 1950
Bronze, h.11 inches (27.9 cm)
Private Collection, photo courtesy of the Henry Moore
Foundation

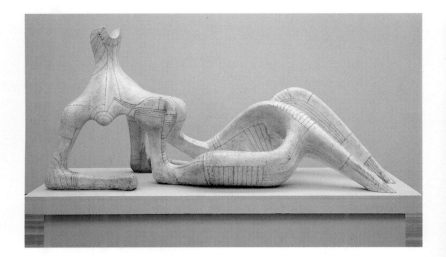

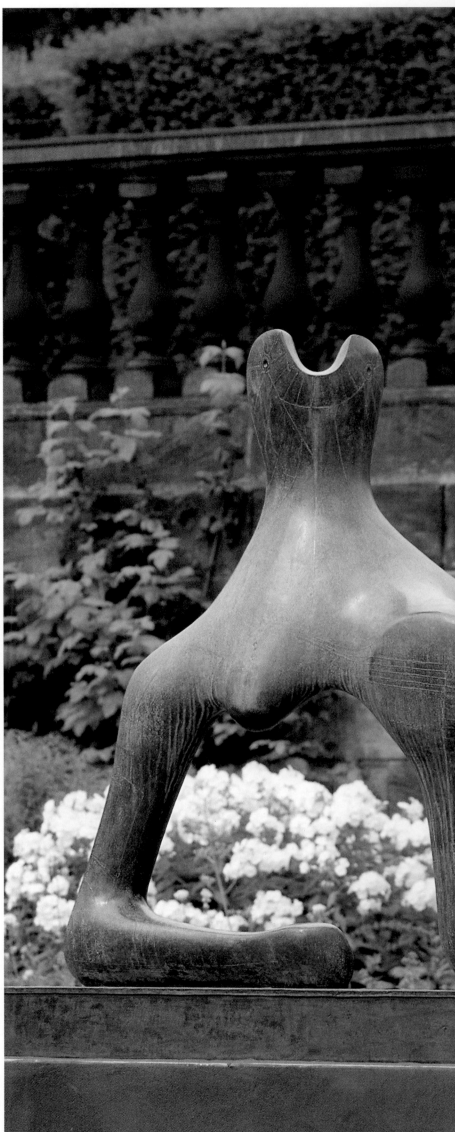

ABOVE:
Reclining Figure: Festival, 1951
Plaster, 1.89½ inches (227.3 cm)
Tate Gallery, London

RIGHT:
Reclining Figure: Festival, 1951
Bronze, 1.89 inches (229 cm)
Scottish National Gallery of Modern Art, Edinburgh, photo
Michel Muller, courtesy of the Henry Moore Foundation

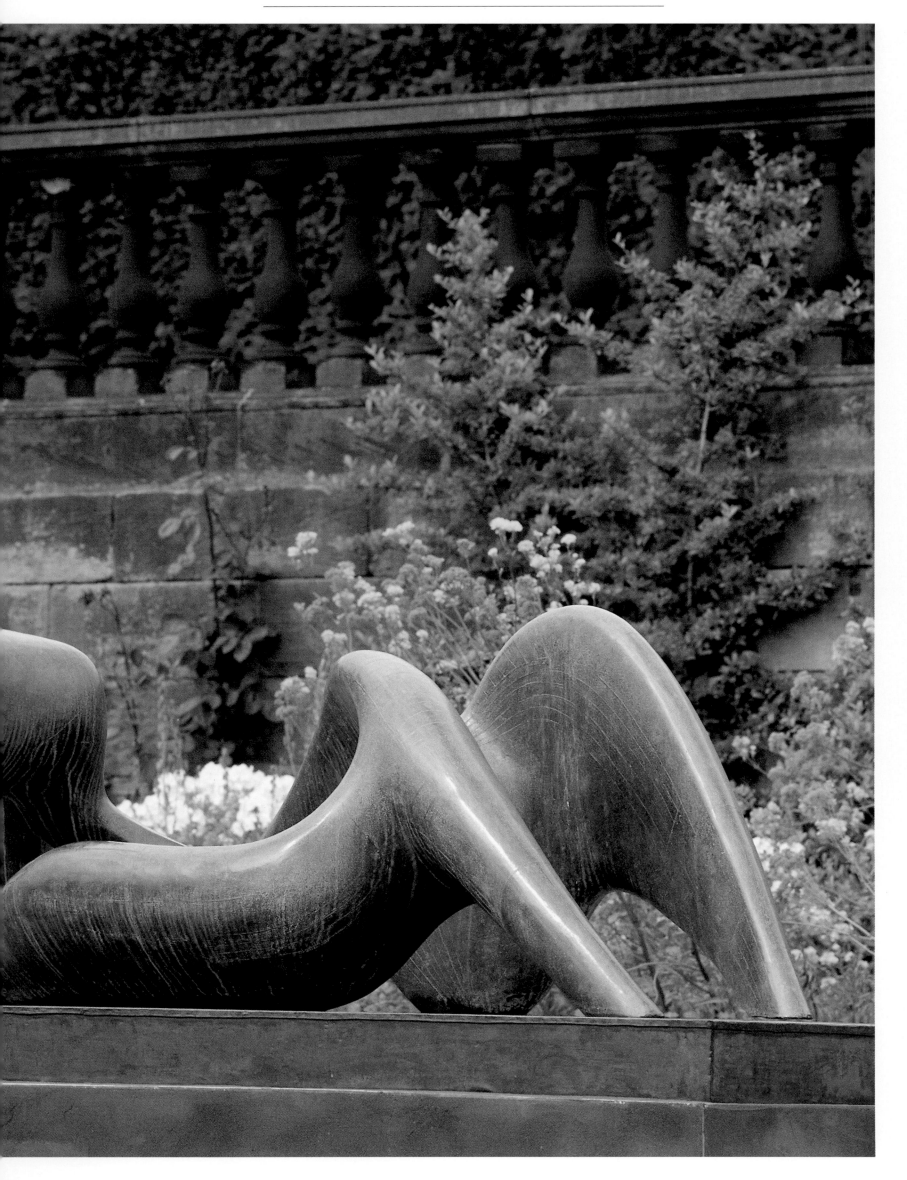

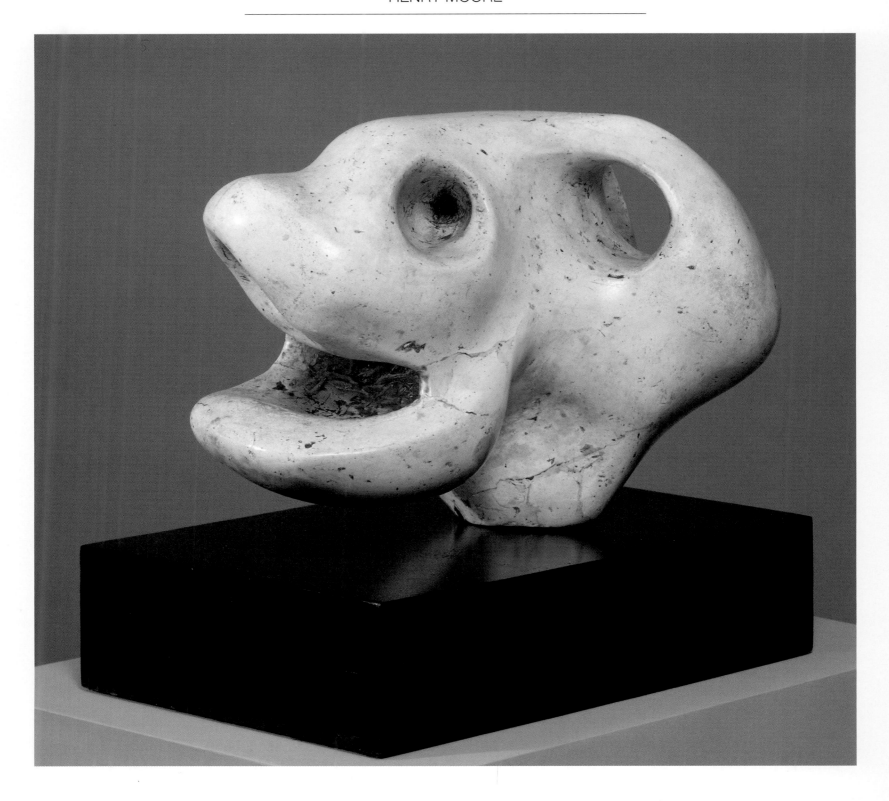

Animal Head, 1951
Plaster, l.12 inches (30.1 cm)
Tate Gallery, London

King and Queen, 1952-53
Bronze, h.64 inches (164 cm)
Courtesy of the Henry Moore Foundation

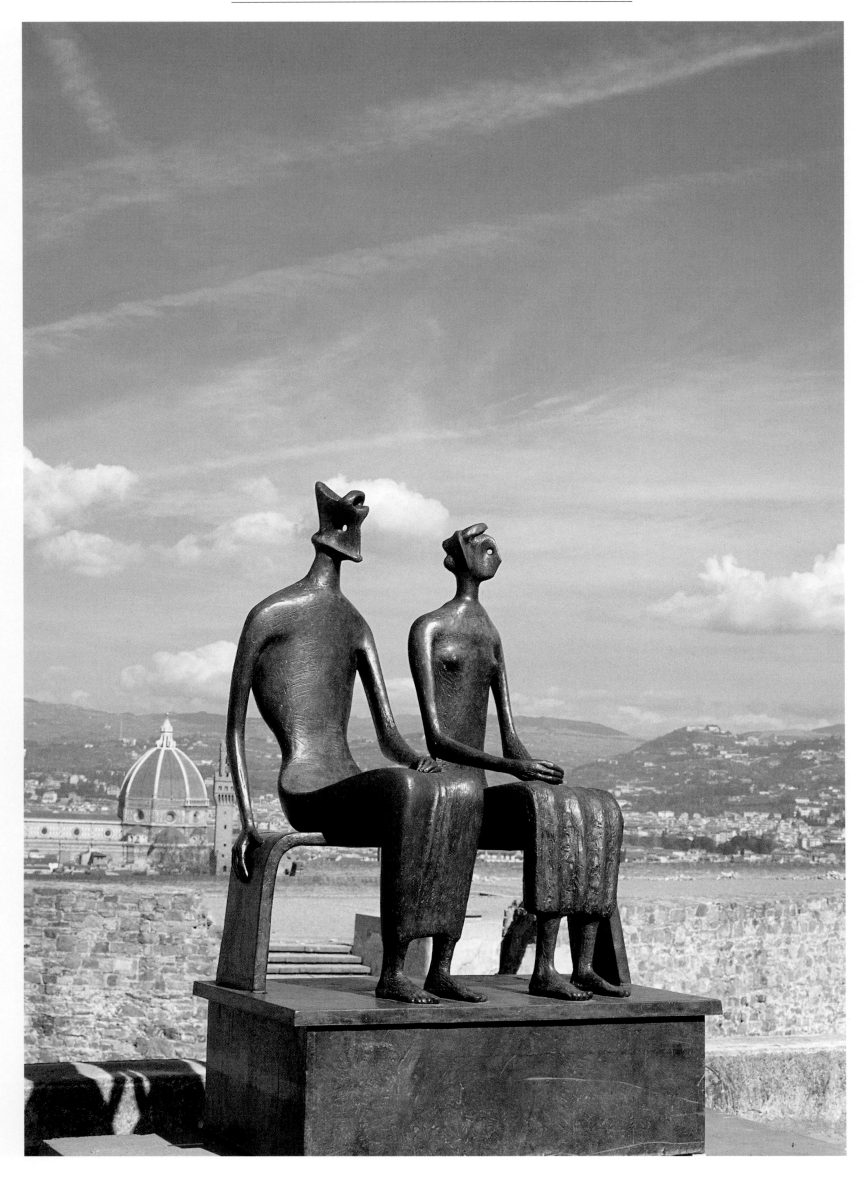

King and Queen, 1952-53
Bronze, h.64 inches (164 cm)
Courtesy of the Henry Moore
Foundation

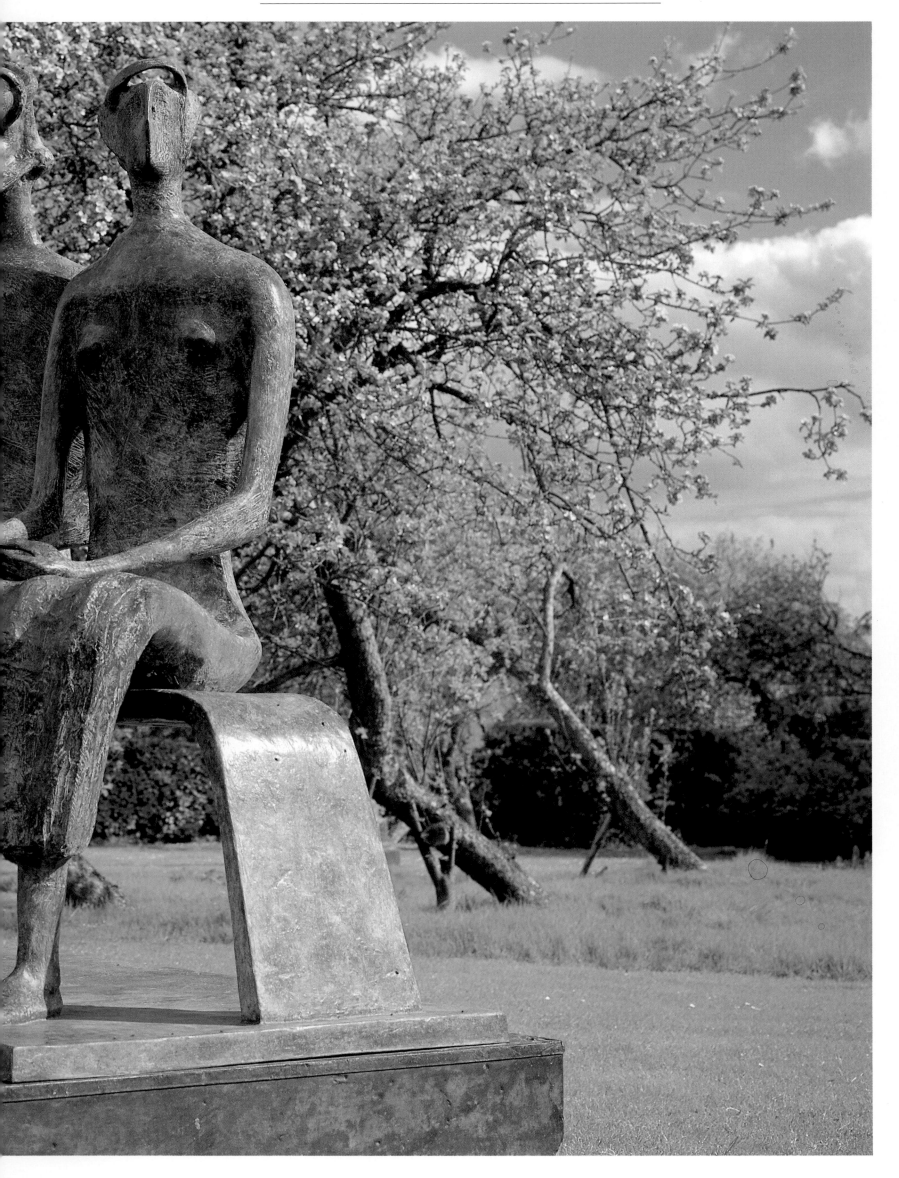

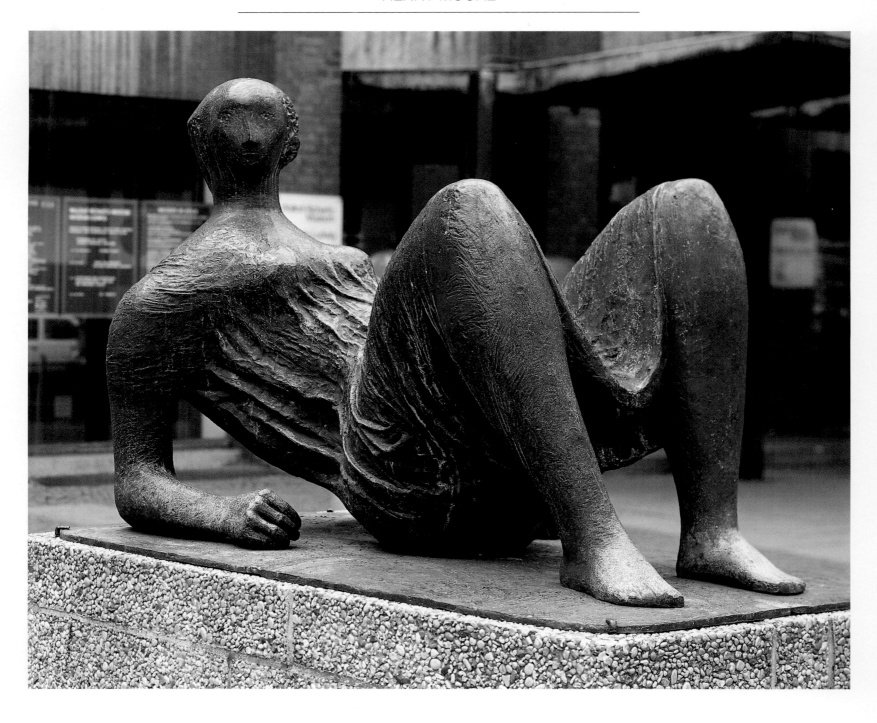

Draped Reclining Figure, 1952-53
Bronze, l.62 inches (157 cm)
Ludwig Rheinisches Bildarchiv, Cologne

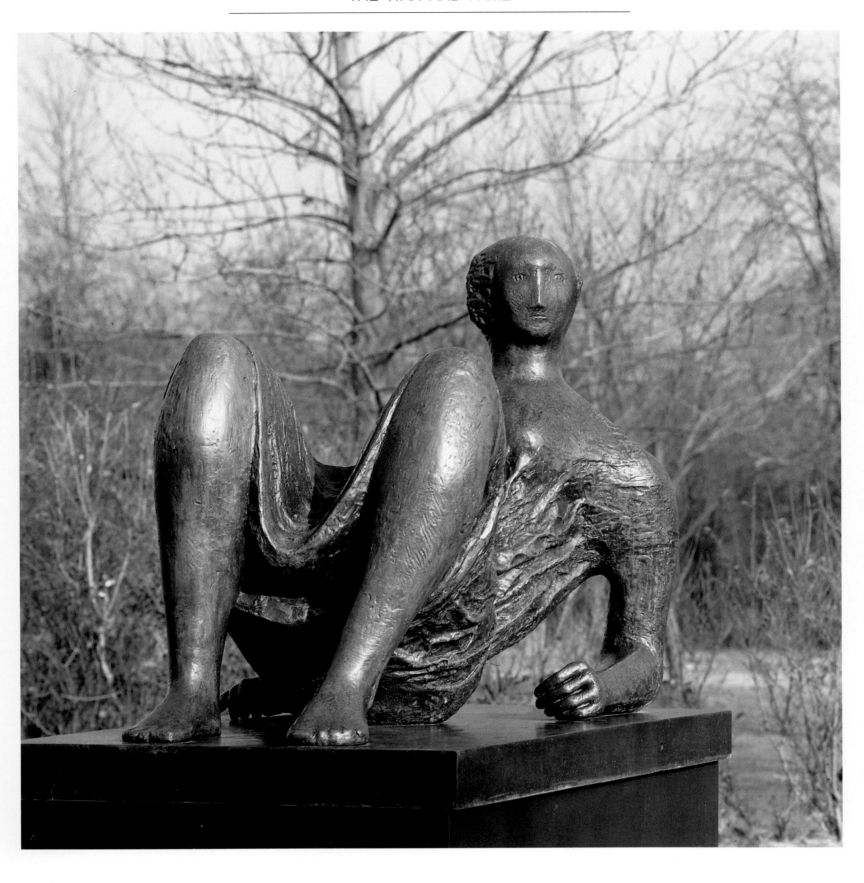

Draped Reclining Figure, 1952-53
Bronze, 1.62 inches (157 cm)
Courtesy of the Henry Moore Foundation

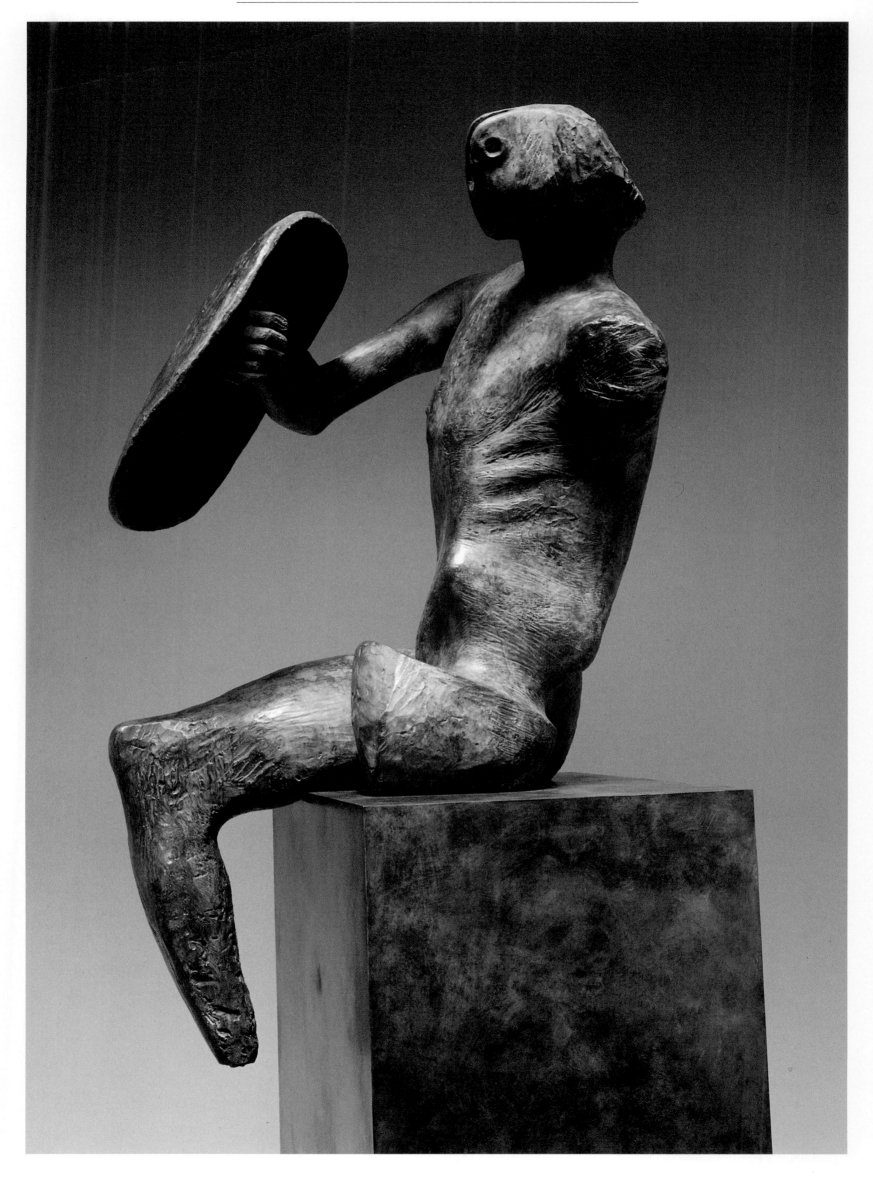

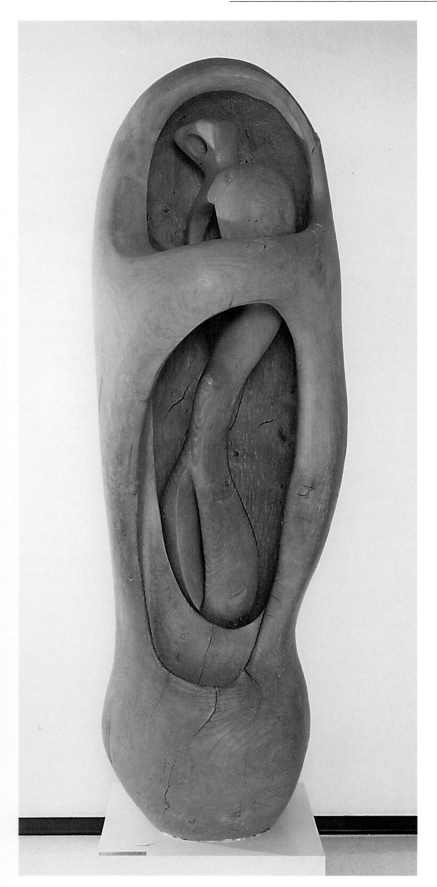

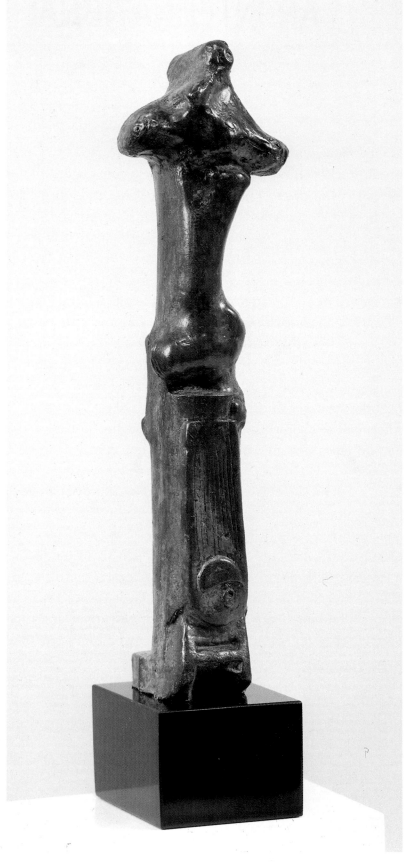

LEFT:
Warrior with Shield, 1953-54
Bronze, h.60 inches (155 cm)
Birmingham City Museum and
Art Gallery, photo courtesy of
the Henry Moore Foundation

ABOVE LEFT:
Upright Internal/External Form,
1953-54
Elmwood, h.103 inches
(264 cm)
Albright-Knox Art Gallery,
Buffalo, General Purchase
Funds, 1955

ABOVE RIGHT:
Upright Motive: Maquette No.1,
1955
Bronze, h.12 inches (30.3 cm)
Hirshhorn Museum and
Sculpture Garden, Smithsonian
Institution, Gift of Joseph H.
Hirshhorn 1966

Moore's fame during the late 1950s was not confined to Great Britain. In 1956 he was commissioned to execute a figure for the outside of the UNESCO headquarters in Paris, to embody the ideals of the organization. When he first received the invitation Moore envisaged a work in bronze, but then decided to carve a huge reclining female figure, the largest he had yet made. Over 16 feet in length and weighing 39 tons, the figure was carved from Roman travertine marble taken from a quarry used by Michelangelo, and is related to Moore's other female archetypes from this stage in his career, such as the large draped seated and reclining female figures in bronze, and the family groups and representations of mothers with children. Moore's reclining figures of this period are perhaps his best known work. The analogies between the reclining female form and the natural landscape are stressed to a greater degree than ever before.

In one of his sketchbooks of this period he wrote of his desire to 'combine sculptural form (POWER)/ with human sensitivity and meaning/ i.e. to try to keep Primitive Power with humanist content.' This perhaps can be seen most clearly in the monumental *Reclining Figure* (1963-65) for the exterior of the Lincoln Center for the Performing Arts in New York. This huge bronze was Moore's largest essay to date in the urban landscape idiom. Set in a pool, the two-piece form combines rock-like formations with their mirror images in the water. The massive curved forms are accentuated by the background of rectilinear buildings and demand that the viewer walk round the sculpture, in order to gain unexpected insights which are not available from a single viewpoint. Moore explained that 'if a statue is in two pieces, there's a bigger surprise, you have more unexpected views . . . Sculpture is like a journey. You have a different view as you return.'

In 1963, now aged 65 and already loaded with honors of every description both at home and abroad, Moore received the highest British accolade of all, the Order of Merit. Two years later he bought a small villa near the Carrara quarries at Forte dei Marmi, where such large pieces as the UNESCO figure had been carved, in order that he could work there in the summer. The ready supply of quality marble and the tradition of fine craftsmanship in the Henraux workshops, where the UNESCO figure had been carved, enabled Moore to return to his first major vehicle of communication as a sculptor, and in 1967 a new group of stone carvings was exhibited in London.

Moore's major work of the period, however, consisted of a series of large bronzes. These were much concerned with the exploration of upright motives, as in the *Glenkiln Cross* of 1955/56, which Moore described as 'a kind of worn-down body and a cross merged into one.' A perpendicular form such as this could be regarded as the antithesis of the several reclining figures of the period, but Moore had always experimented with oppositional motives. From his very earliest work he had been preoccupied with dichotomies: the reclining figure/ upright figure; hollow forms/ solid forms; open forms/ closed forms; passive motives/ active motives. This concern with primary oppositional forms was to remain a fundamental part of Moore's working practice for the rest of his long life.

RIGHT:
Draped Seated Woman, 1957-58
Bronze, h. 73 inches (185 cm)
Hebrew University, Jerusalem

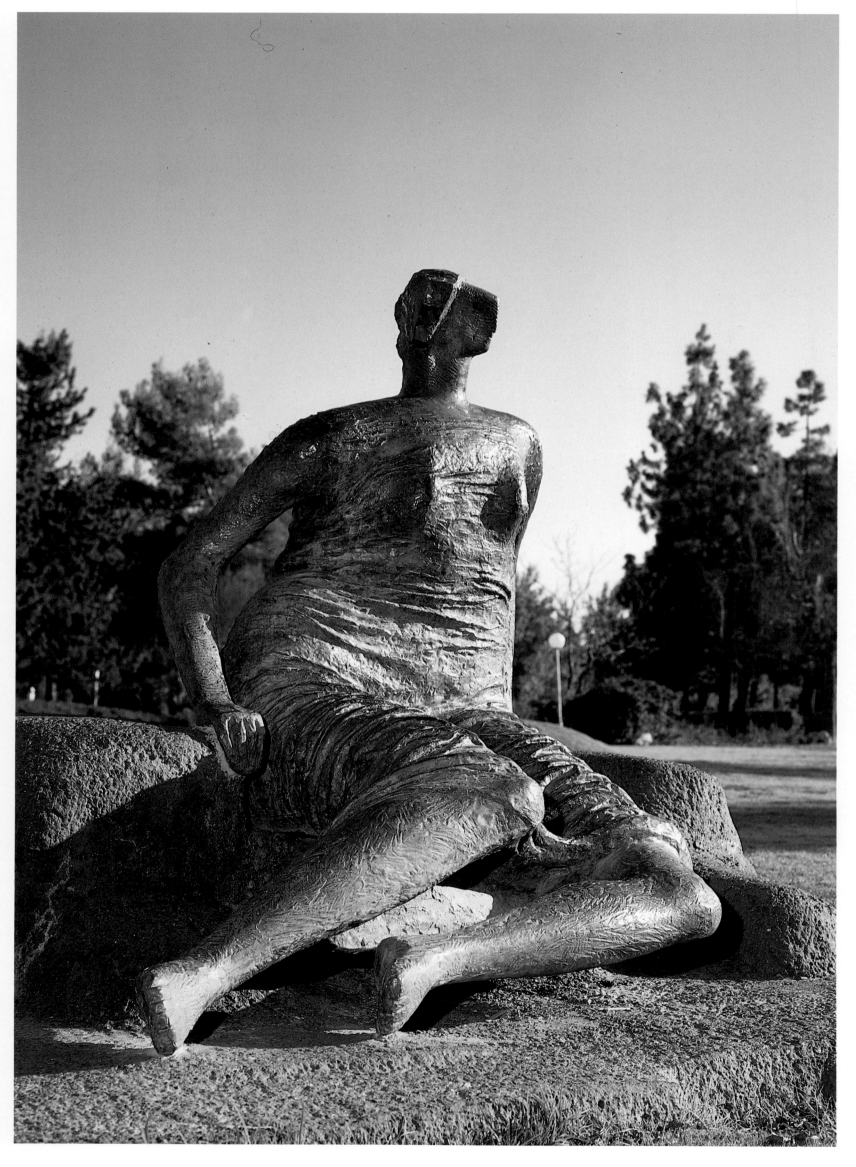

Reclining Figure, 1956
Bronze, l.96 inches (244 cm)
Pepsico Inc., Purchase, NY

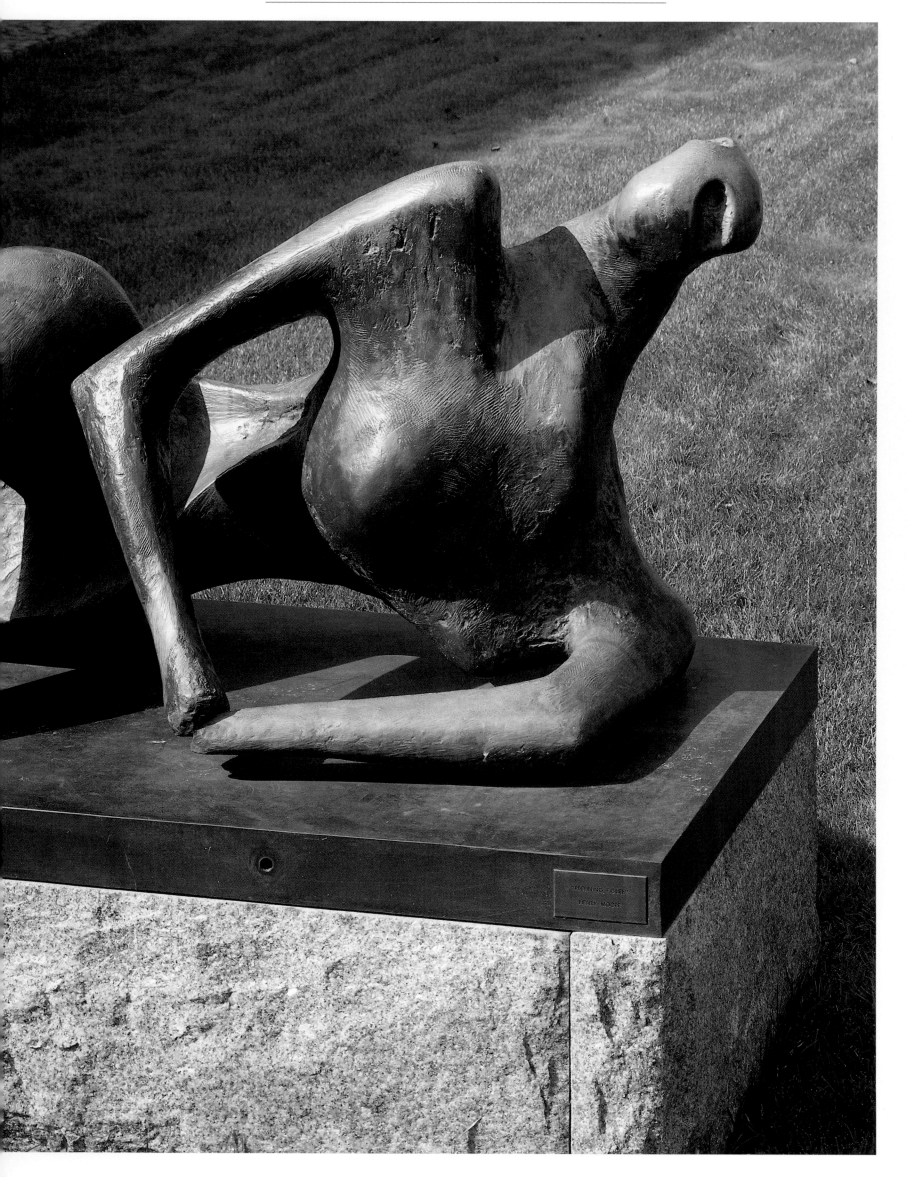

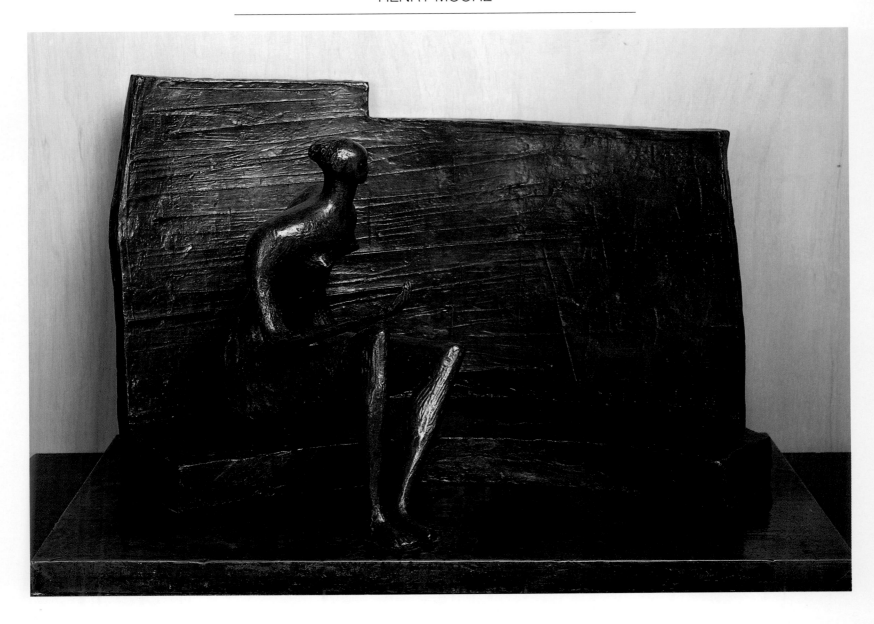

ABOVE AND RIGHT:
Seated Figure against Curved Wall, 1956-57
Bronze, l.32 inches (81.5 cm)
Arts Council, on loan to Doncaster City Art Gallery

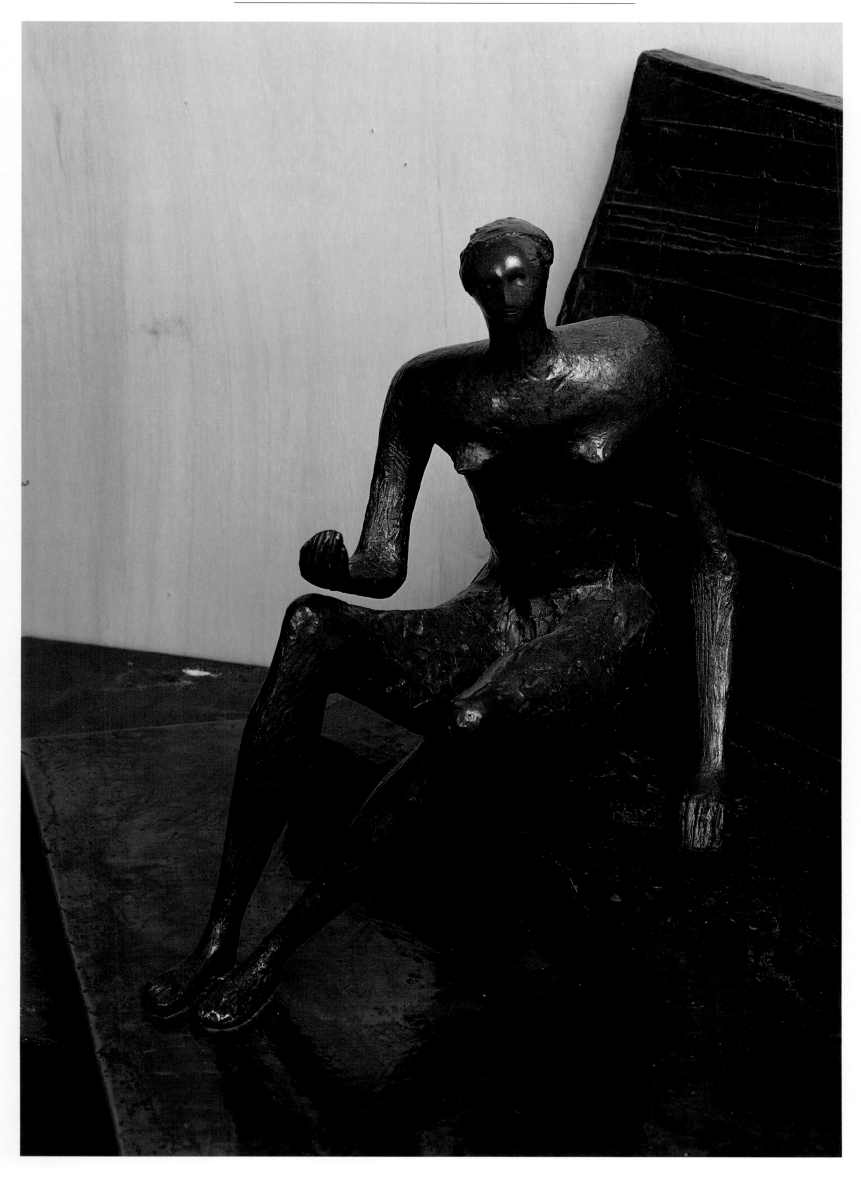

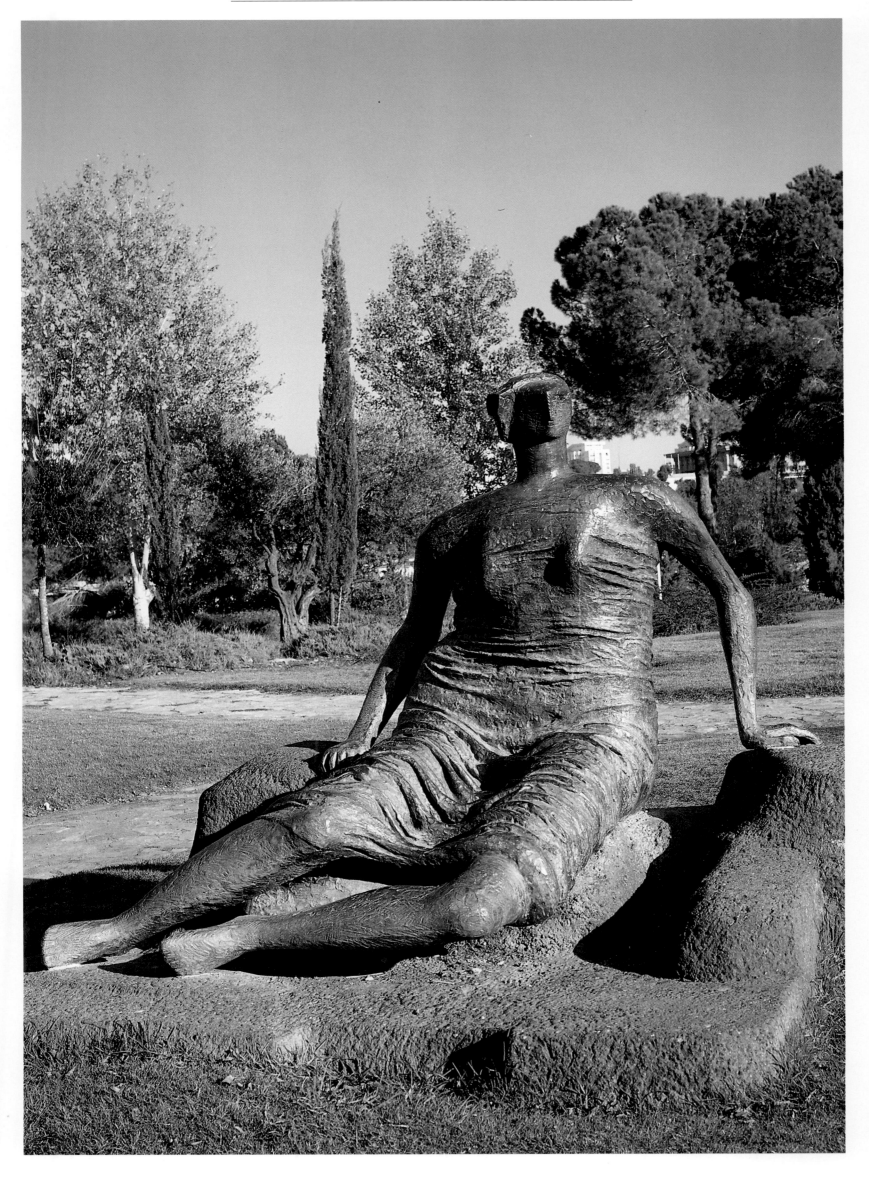

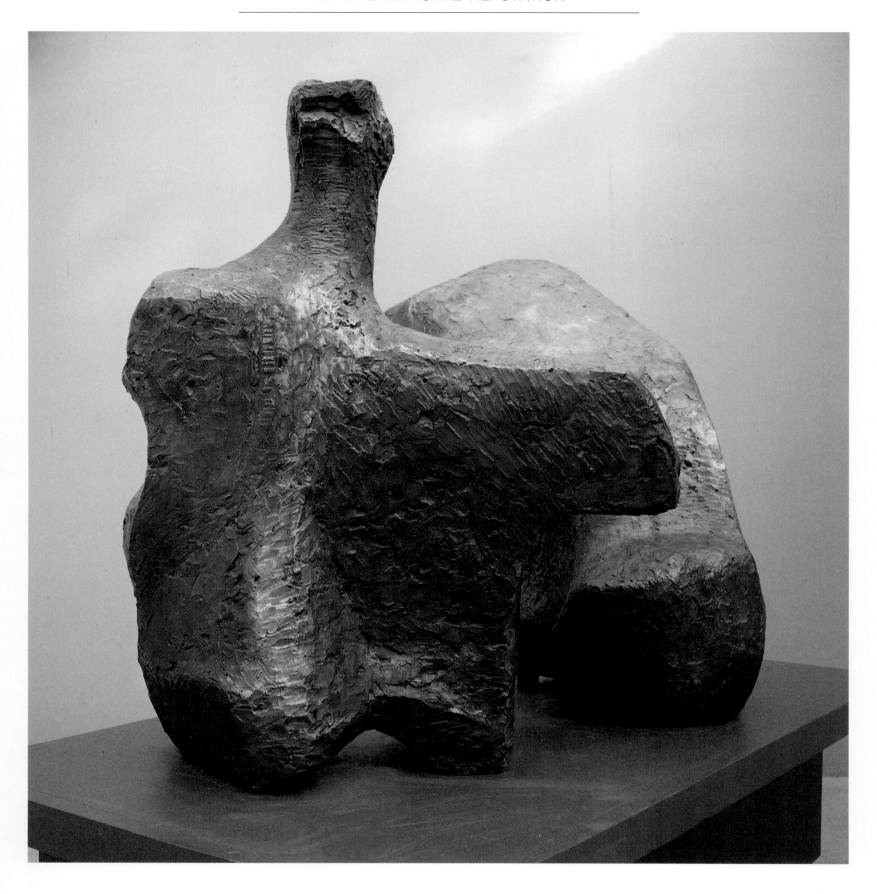

LEFT:
Draped Seated Woman, 1957-58
Bronze, h.73 inches (185 cm)
Hebrew University, Jerusalem

ABOVE:
Two Piece Reclining Figure No.1, 1959
Bronze, l.76 inches (194 cm)
Chelsea School of Art, photo courtesy of the Henry Moore
Foundation

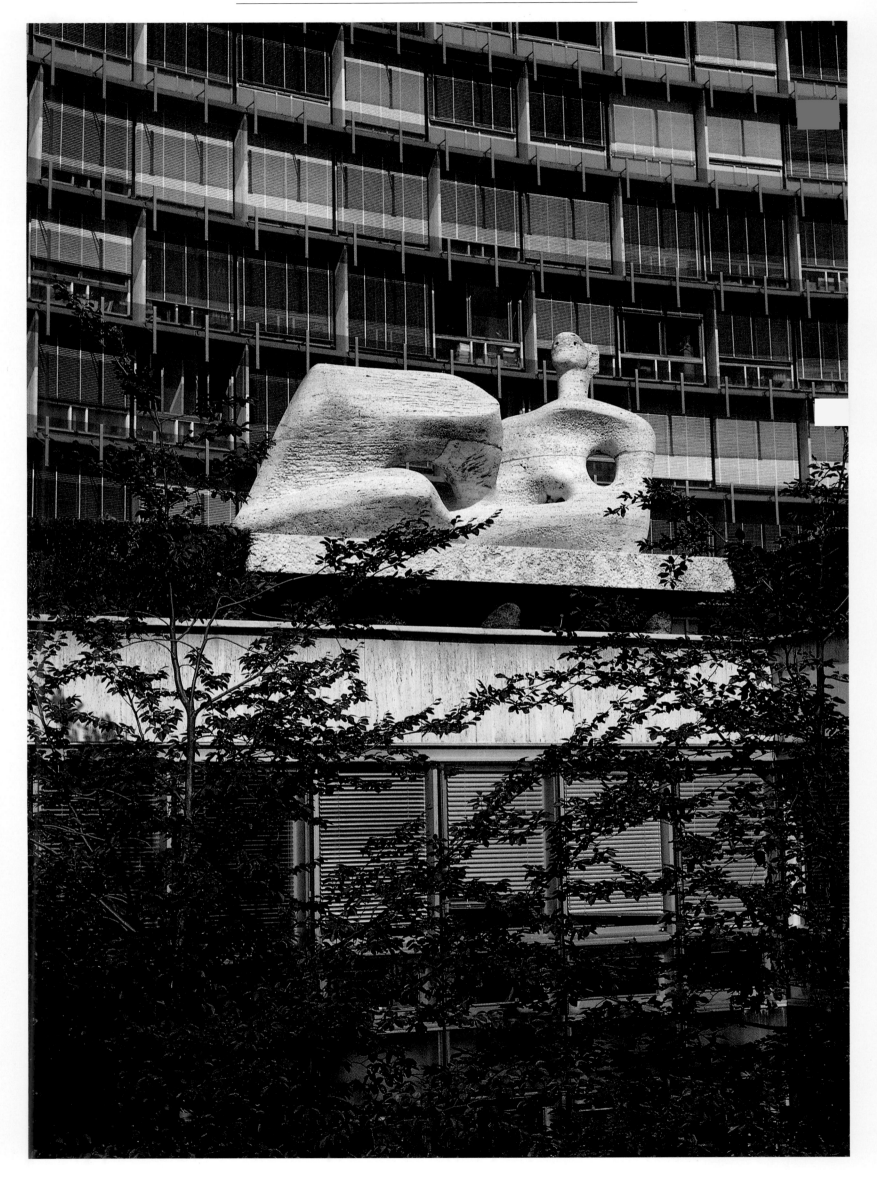

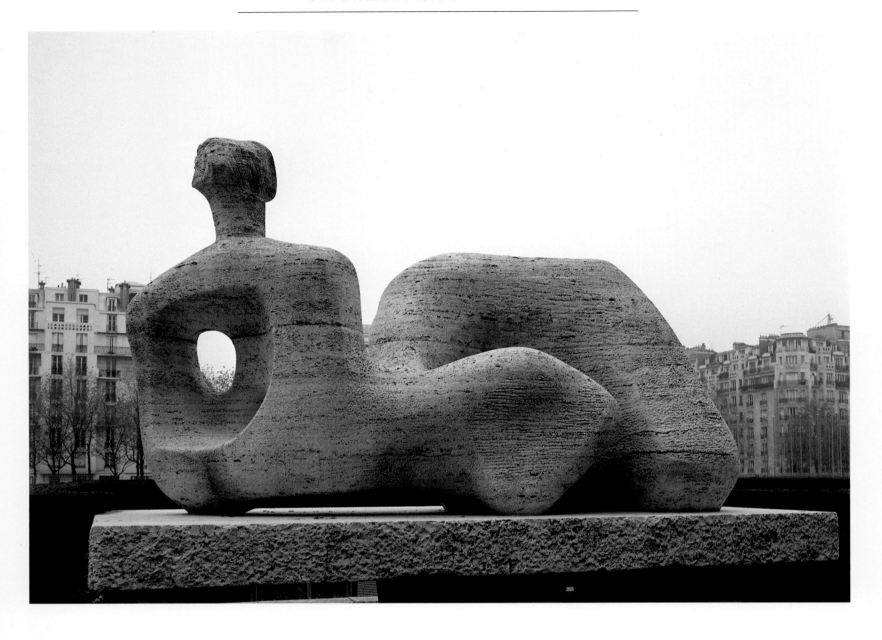

LEFT AND ABOVE:
Reclining Figure, 1957-58
Roman travertine marble, 1.200 inches (500 cm)
UNESCO headquarters, Paris

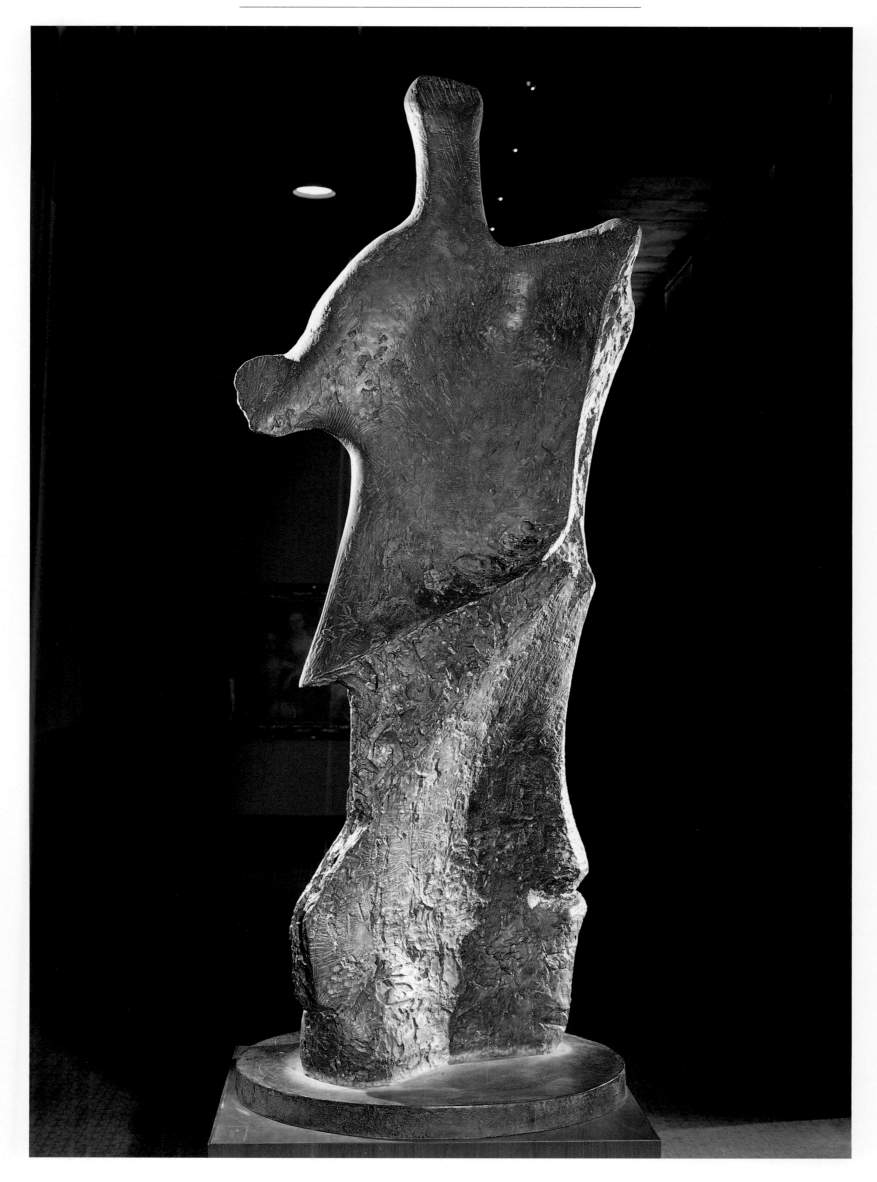

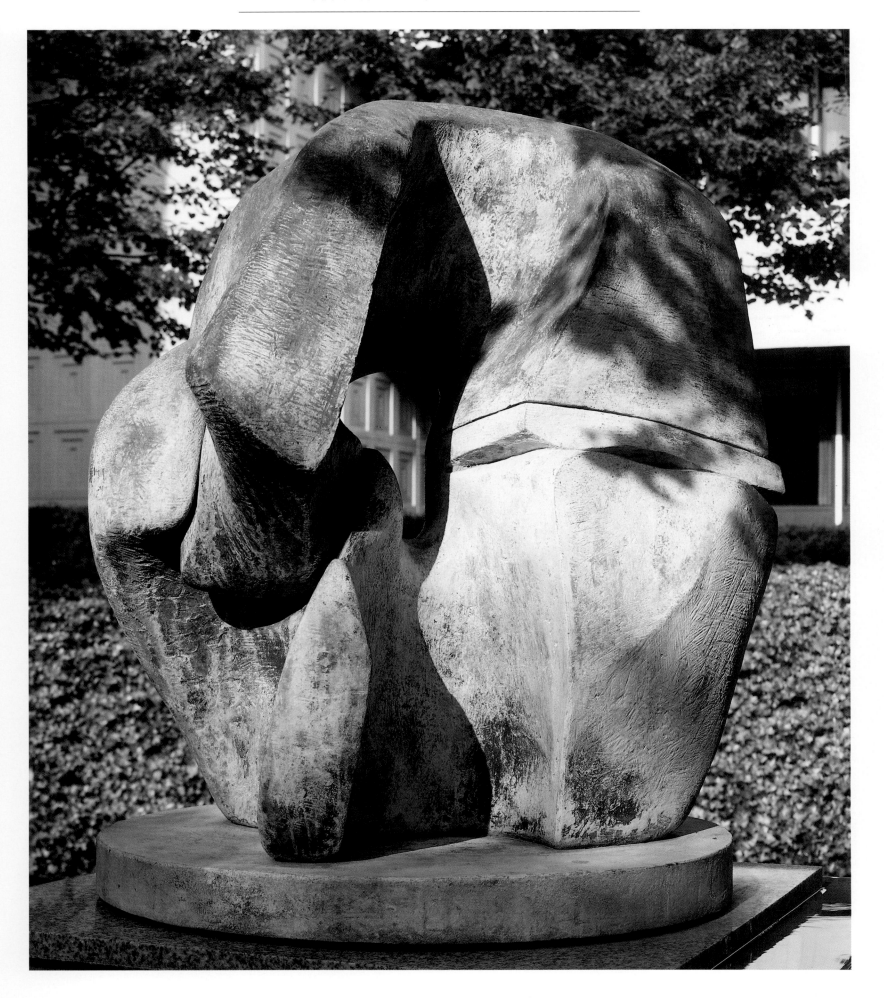

LEFT:
Standing Figure: Knife Edge, 1961
Bronze, h.112 inches (287 cm)
Norton Simon Art Foundation

ABOVE:
Working Model for Locking Piece, 1962
Bronze, h.41¼ inches (105.5 cm)
Pepsico Inc., Purchase, NY

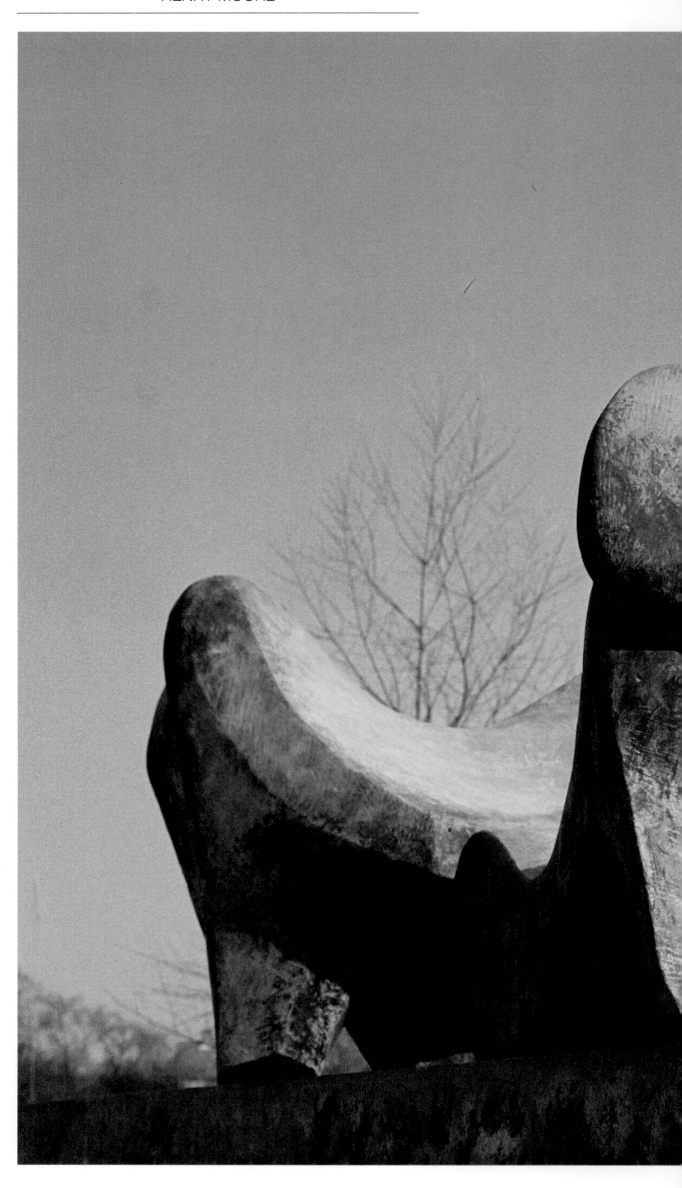

Three Piece Reclining Figure
No. 2: Bridge Prop, 1963
Bronze, 1.99 inches (251 cm)
City Art Gallery, Leeds, photo
courtesy of the Henry Moore
Foundation

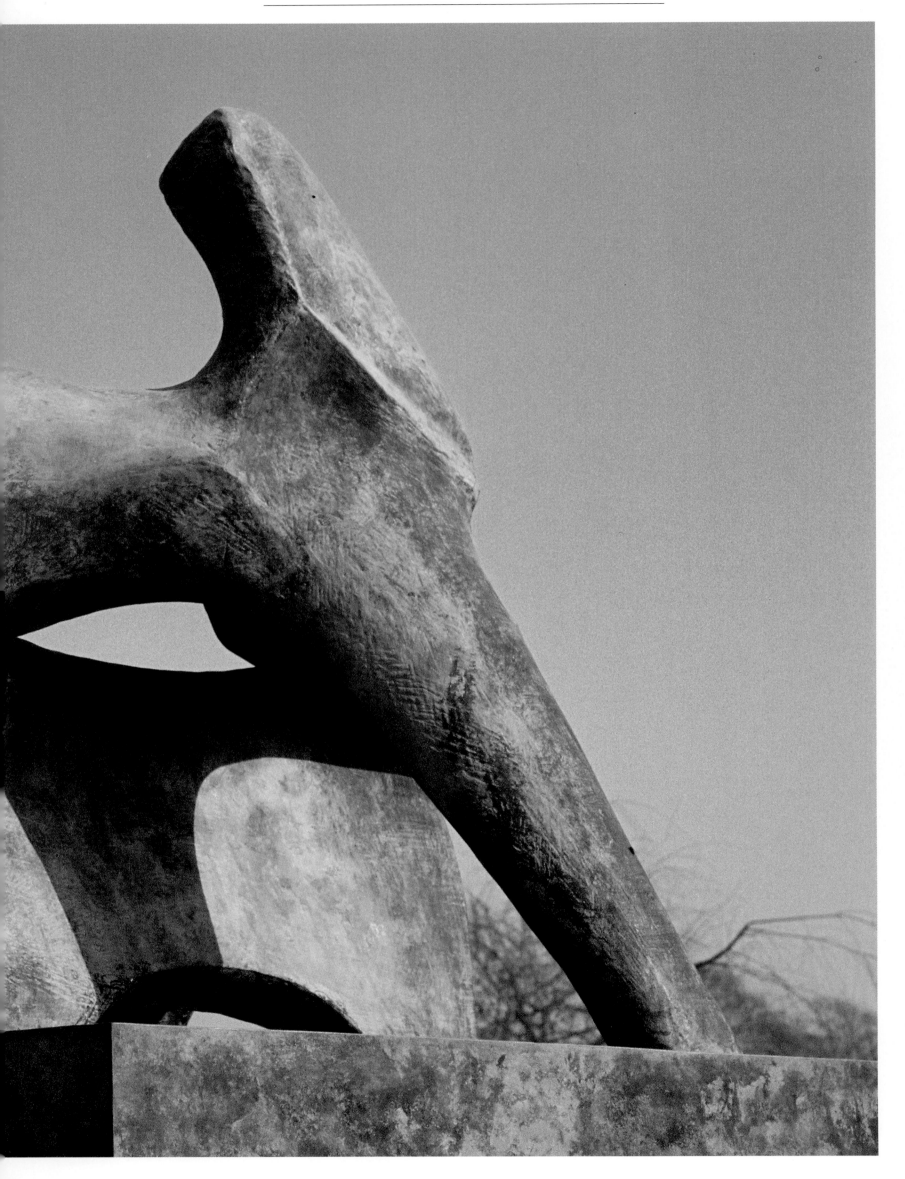

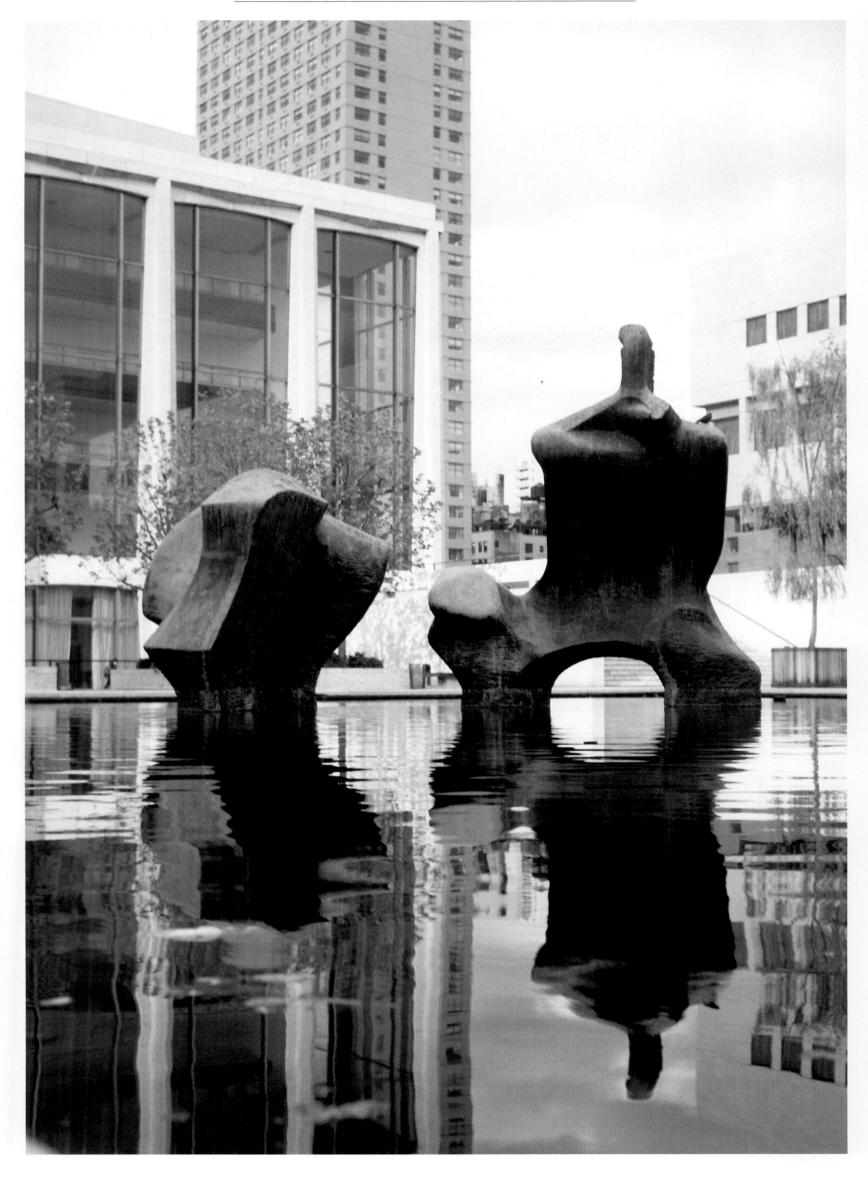

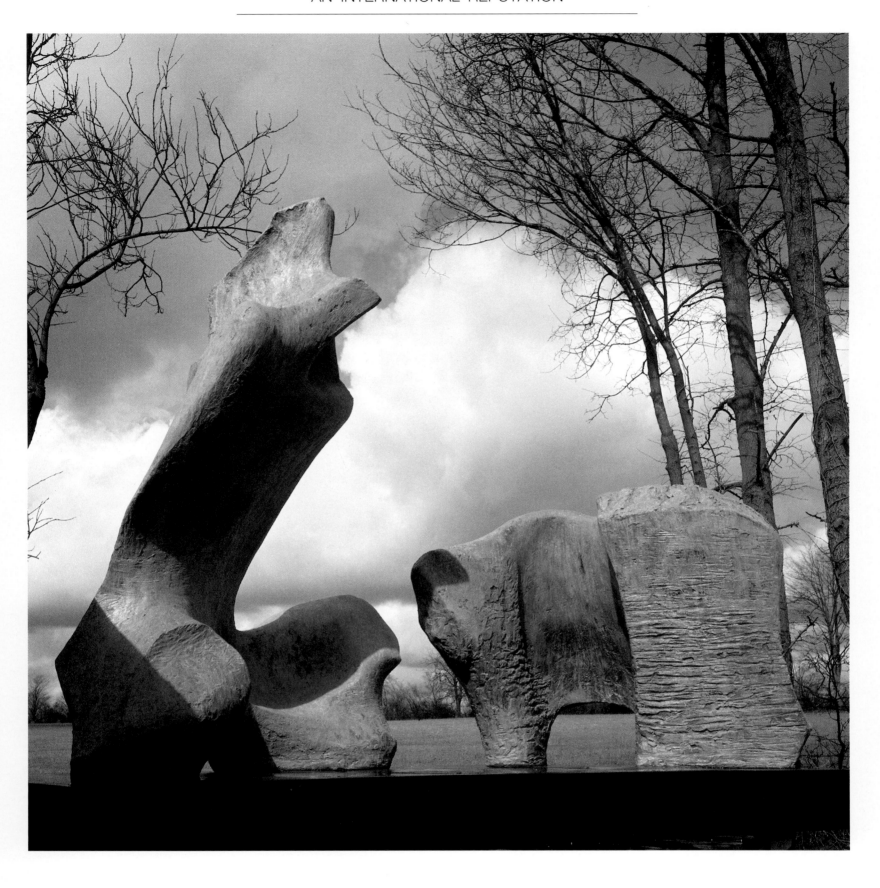

LEFT AND ABOVE:
Reclining Figure, 1963-65
Bronze, 1.168 inches (427 cm)
Lincoln Center for the Performing Arts, New York, photo
courtesy of the Henry Moore Foundation

APOTHEOSIS: THE FINAL YEARS, 1964-83

Moore's large bronze sculptures of his last years continue the themes that had preoccupied him throughout his long working life. To the upright motives that he had always explored, he added new forms with sharp angular edges, such as the *Knife Edge Two Piece* (1962-65), drawn from a source that had long interested him. He explained his fascination with bones from his days as a student, when he had drawn them, 'studied them in the Natural History Museum, found them on sea-shores and saved them out of the stew pot.' The land surrounding Moore's studio at Much Hadham had once been the site of a butcher's business and old bones were often dug up there, providing new sources of inspiration. In *Knife Edge* and other works of the period such as *Three Forms: Vertebrae* (1971), Moore was interested not only in the suggestive qualities of the bone forms, and the manner in which such natural forms had often been transformed by Surrealist painters and sculptors, but also, as he later explained, in their

Many structural and sculptural principles . . . Some bones, such as the breast-bones of birds, have the lightweight fineness of a knife-blade.'

In 1961 Moore used this sharp-edged thinness to produce a whole figure, *Standing Figure: Knife Edge*, the inspiration for which was a small piece of blade bone. The original form of the bone can still be seen, and Moore was pleased by the suggestion that the sculpture might also be entitled *Winged Figure*, as it bore certain resemblances to the classical *Winged Victory of Samothrace* in the Louvre. Comparisons such as this, which place Moore's work firmly in the long history of European

sculpture, are indicative of his standing as an artist at the time.

During the 1970s the classical tradition, which had always focused on the portrayal of the human figure, was perhaps the inspiration for the bronze *Goslar Warrior* (1973-74), named after the German city in which the first cast was sited. This evokes memories of the Parthenon sculptures in the British Museum, especially the series of warriors with similar circular shields in very high relief from the metopes of the Parthenon. A male figure is rare in Moore's work from any period, and this fallen warrior seems to hover between life and death.

During the last 20 years of Moore's working life, he continued to receive international commissions of major significance. Chief among these was the commission from the University of Chicago for a large bronze, to commemorate the 25th anniversary of the first controled nuclear chain reaction, which took place in a laboratory on the campus in 1942. *Nuclear Energy* (at first called *Atom Piece*) is related to an earlier series of helmet heads reflecting Moore's ideas about the atomic bomb in the immediate post-war period. The 12-foot bronze's dome-like form evokes both a mushroom cloud and the human skull.

In 1972 Moore was given the honor of a retrospective exhibition in Florence, a city he felt to be his 'artistic home.' The works were shown in the magnificent setting of the Forte di Belvedere, overlooking the city and the great Renaissance dome of the Cathedral. Such monumental curving forms as *The Arch* (1963-69) and *Hill Arches* (1973) achieved a new and exciting resonance in such an historic context, in a city to which Moore had first come as a student nearly half a century before.

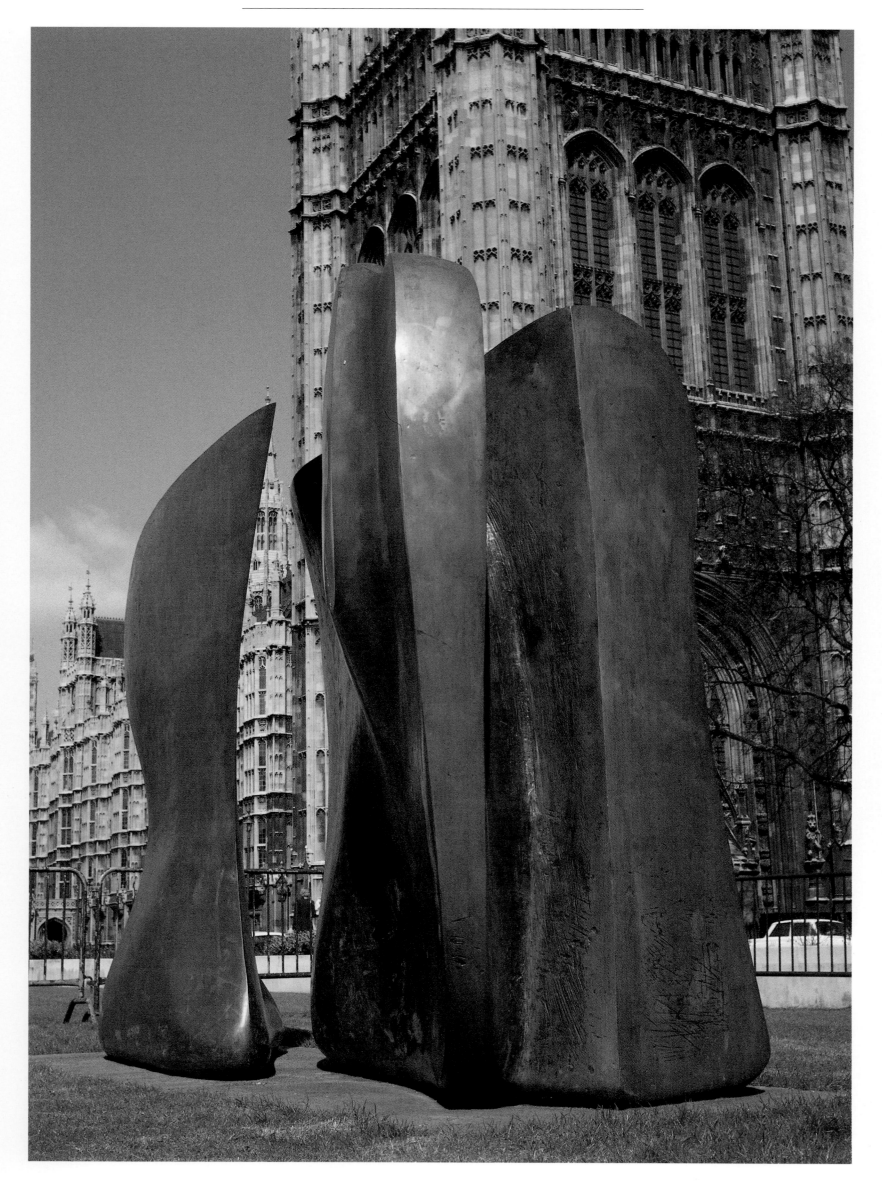

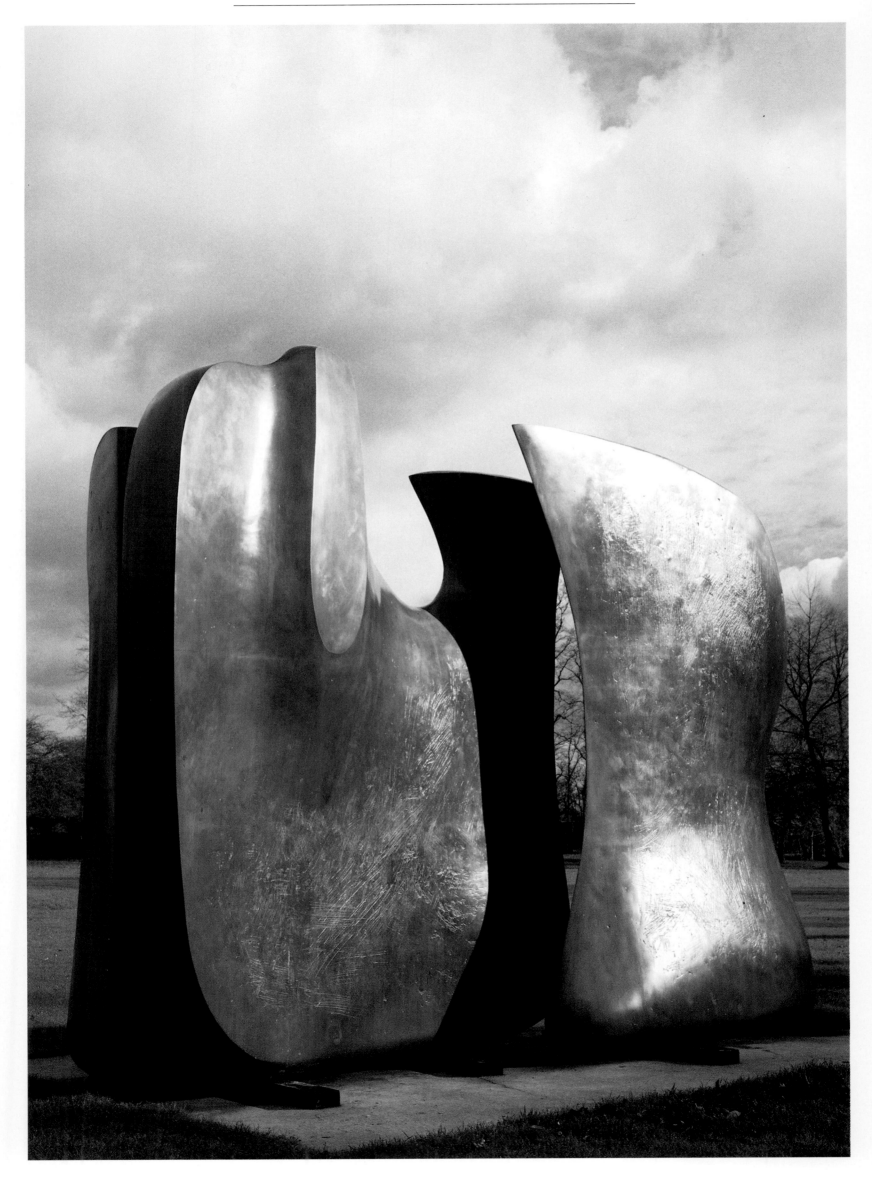

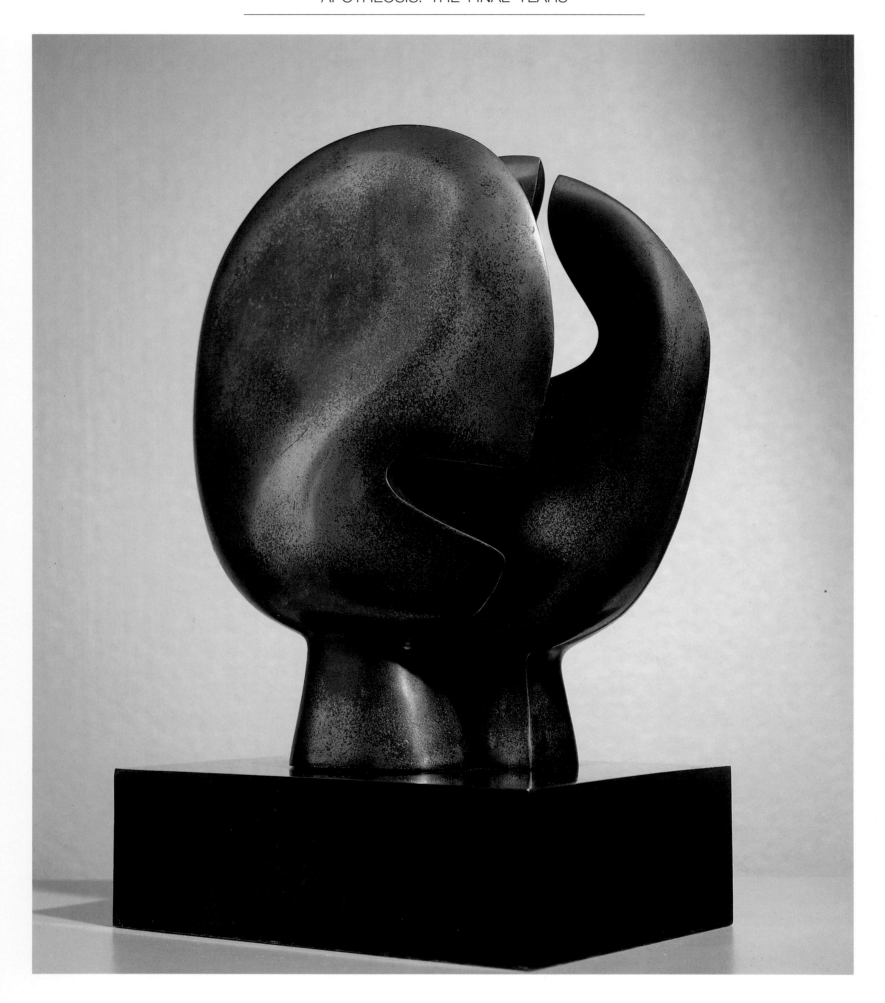

LEFT:
Knife Edge Two Piece, 1962-65
Bronze, 1.144 inches (365 cm)
Courtesy of the Henry Moore Foundation

ABOVE:
Moon Head, 1964
Bronze, h.22½ inches (57 cm)
Tate Gallery, London

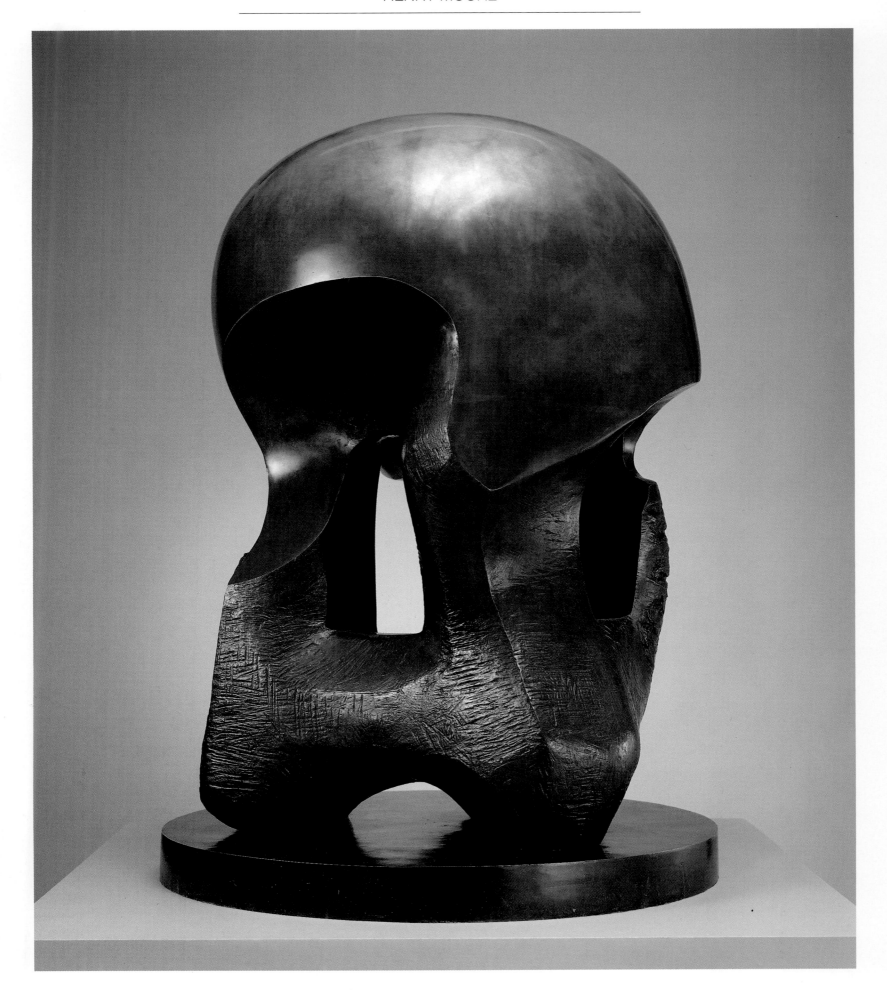

Atom Piece, 1964-65
Bronze, h.47 inches (119 cm)
Tate Gallery, London

Nuclear Energy, 1964-66
Bronze, h.144 inches (368 cm)
University of Chicago, Ill

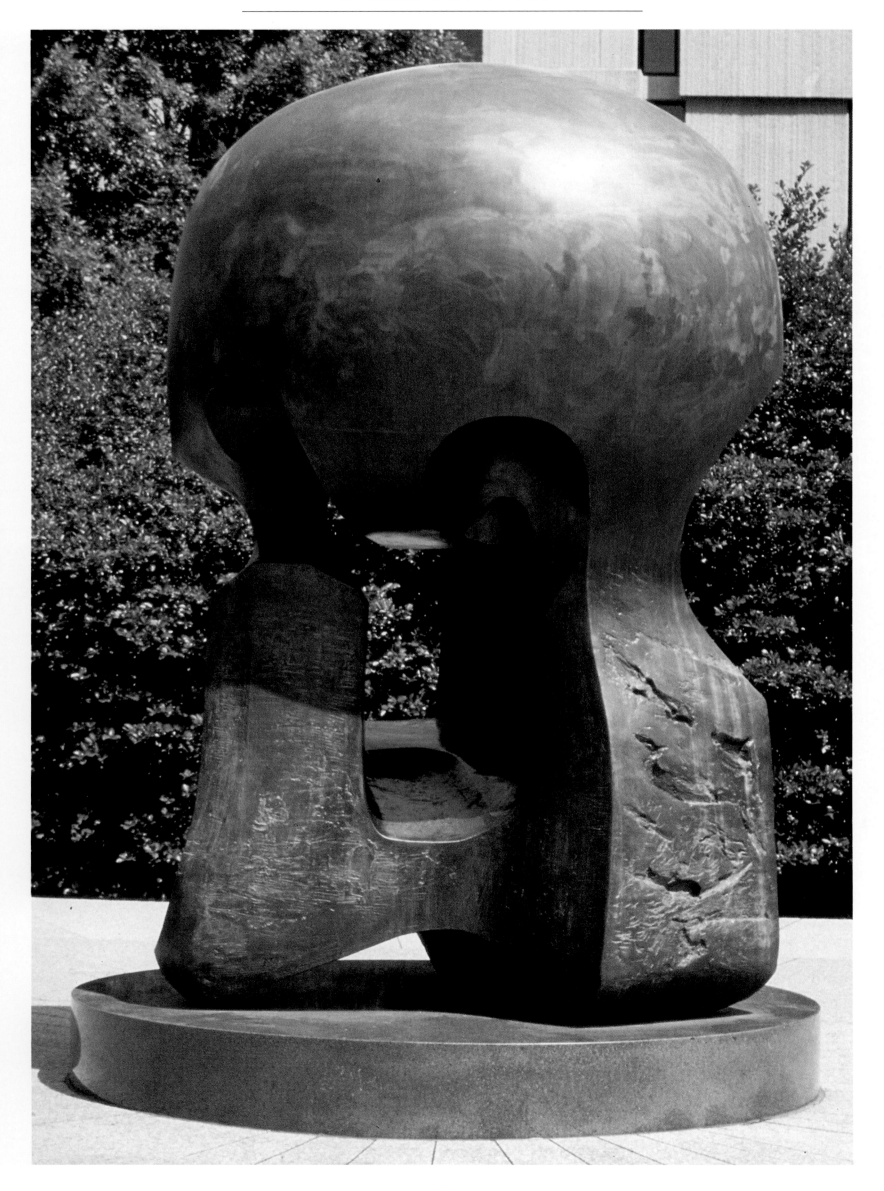

Double Oval, 1966
Bronze, l.216 inches (550 cm)
Pepsico Inc., Purchase, NY

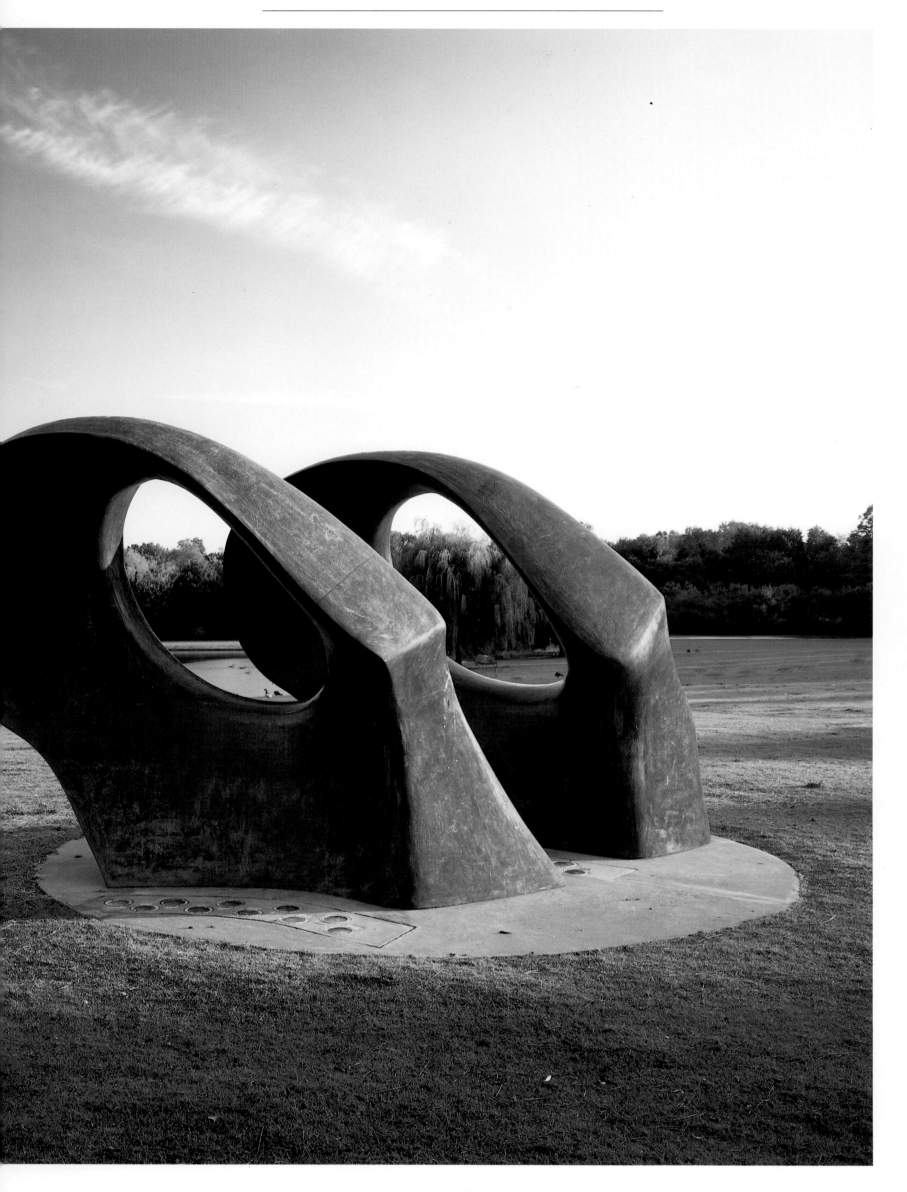

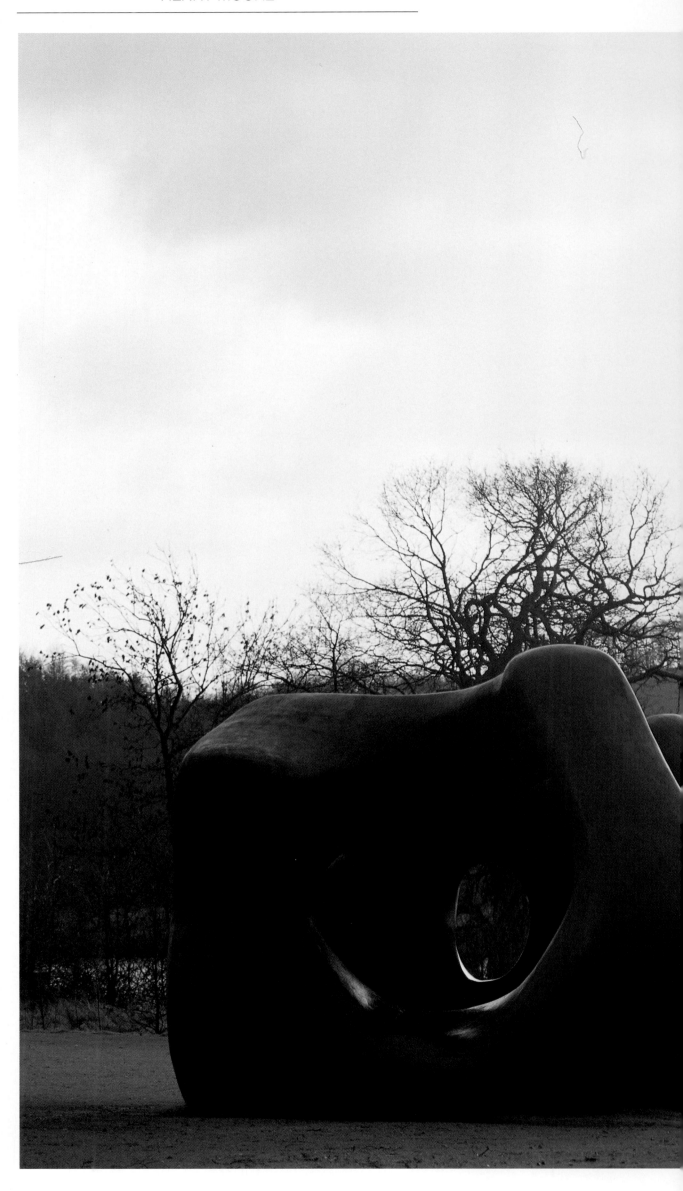

Large Two Forms, 1966-69
Bronze, l.238 inches (610 cm)
Yorkshire Sculpture Park,
Wakefield, West Yorks

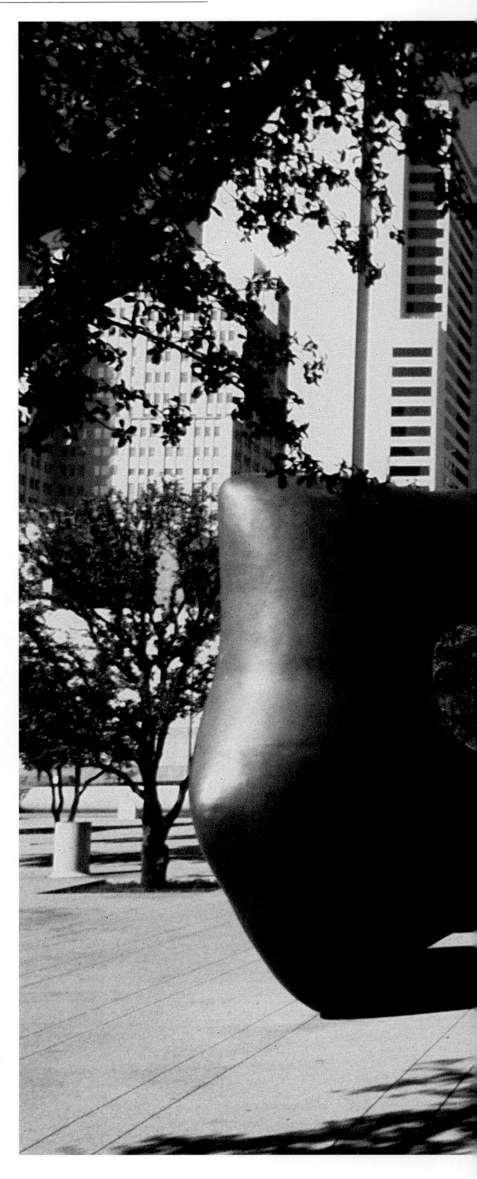

Three Piece Sculpture: Vertebrae, 1968-69
Bronze, l.280 inches (711 cm)
Courtesy of the City of Dallas Office of Cultural Affairs, Texas

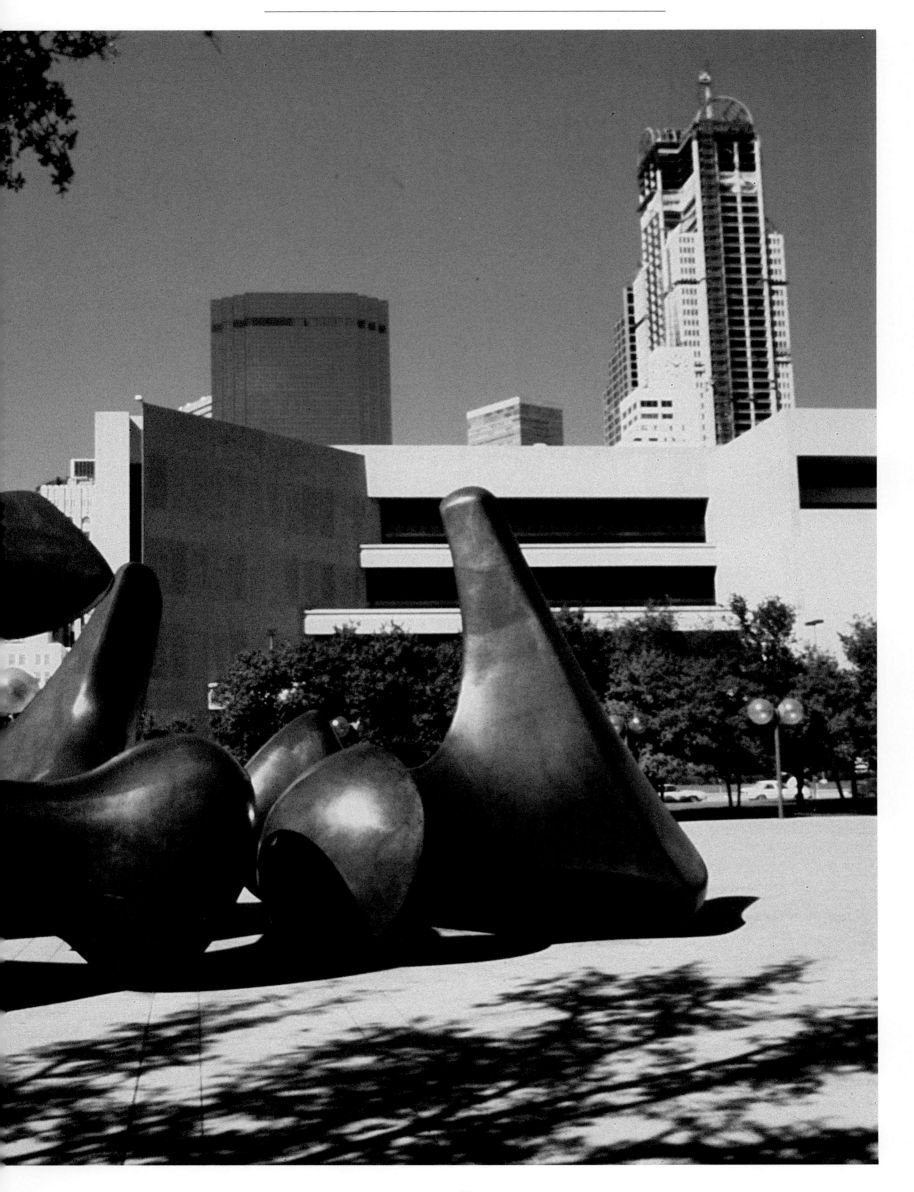

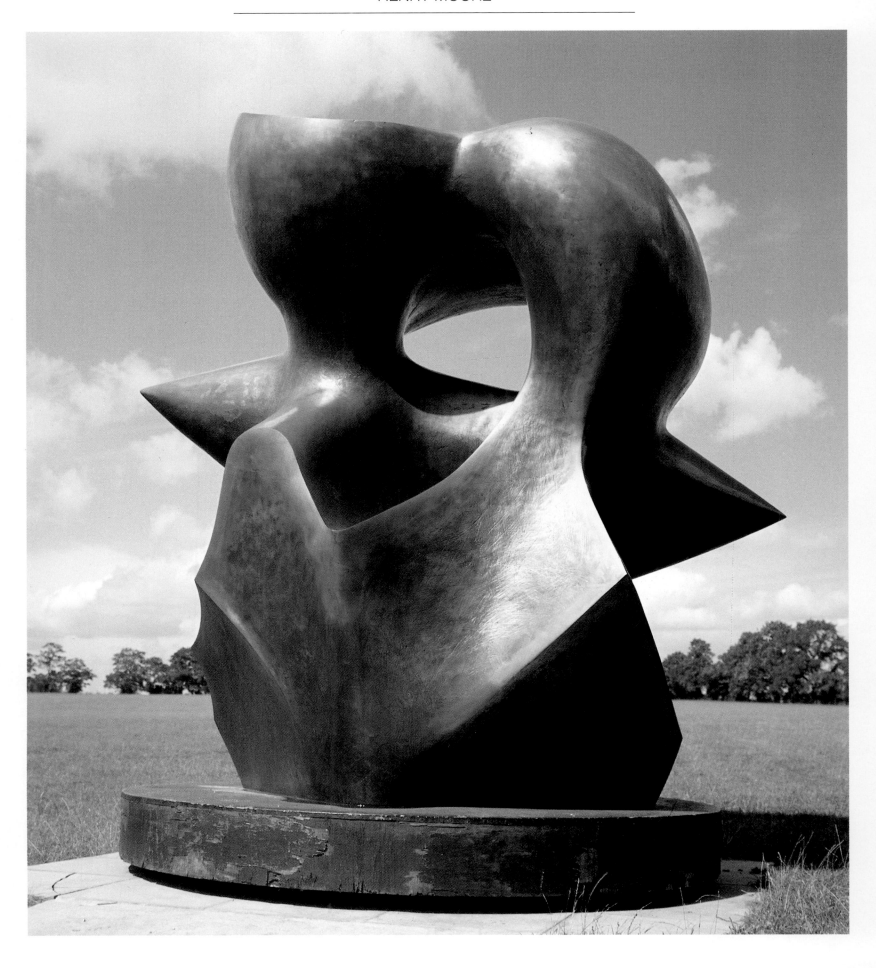

Large Spindle Piece, 1968-69
Bronze, l.130½ inches (327 cm)
Courtesy of the Henry Moore Foundation

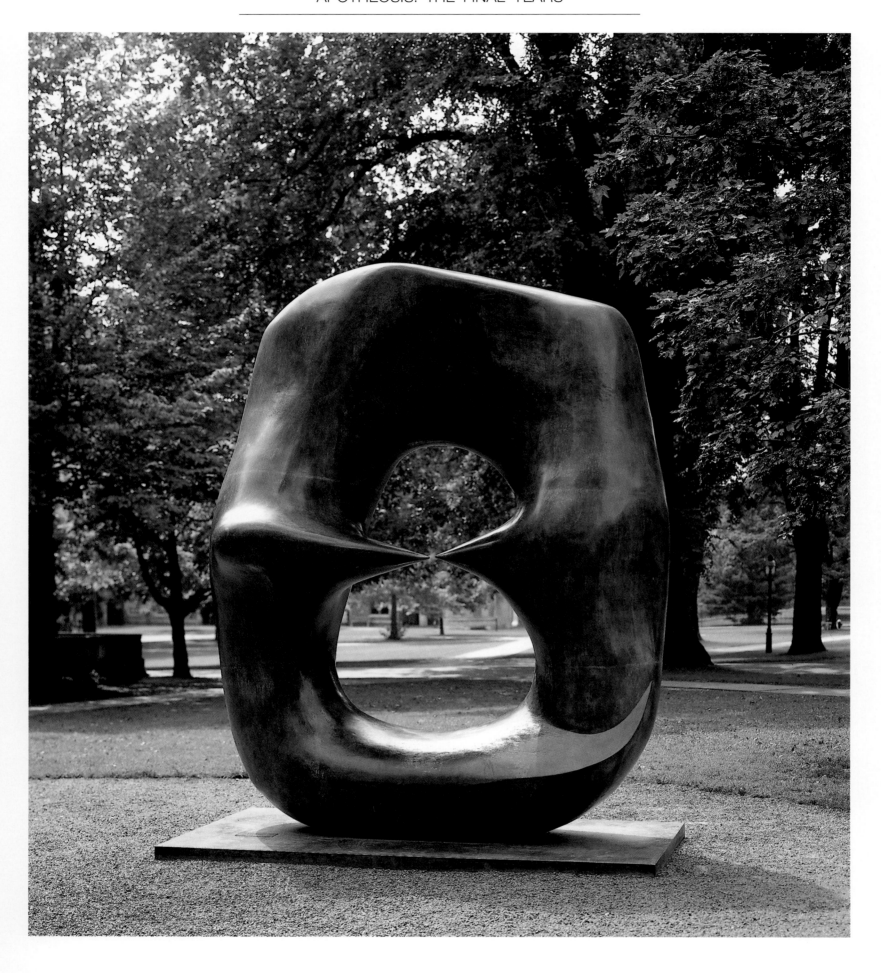

Oval with Points, 1969
Bronze, h.132 inches (330 cm)
The John B. Putnam Jr. Memorial Collection, Princeton
University

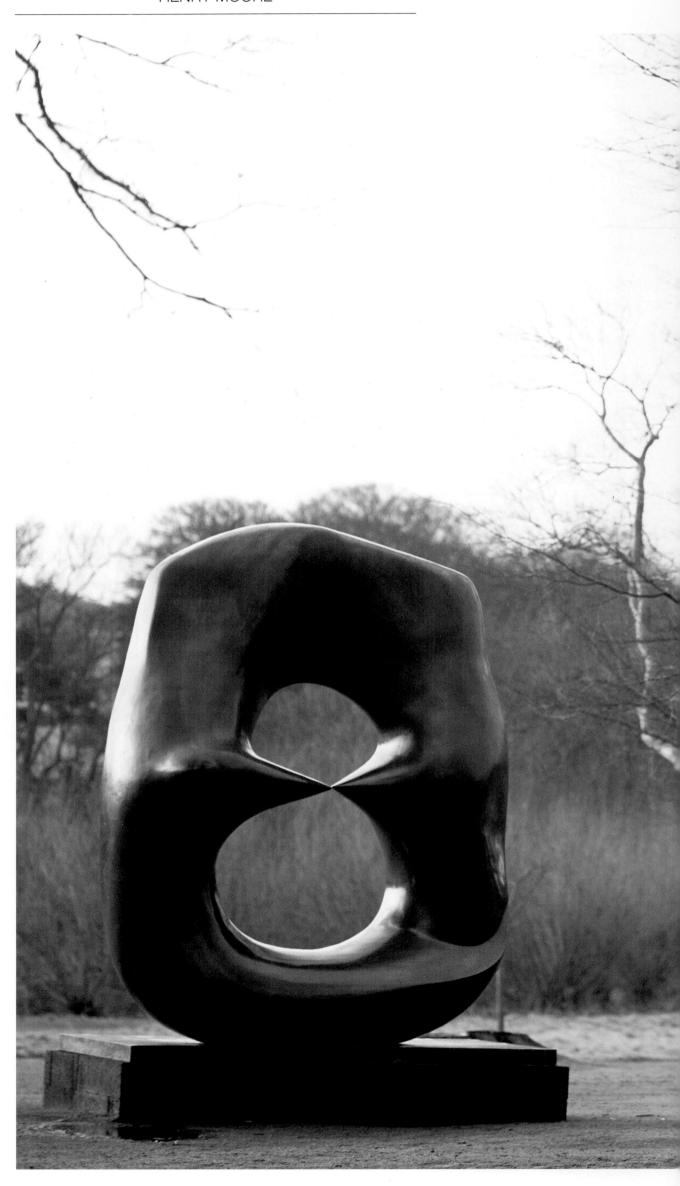

Oval with Points, 1968-70
Bronze, h.132 inches (330 cm)
Yorkshire Sculpture Park,
Wakefield, West Yorks

94

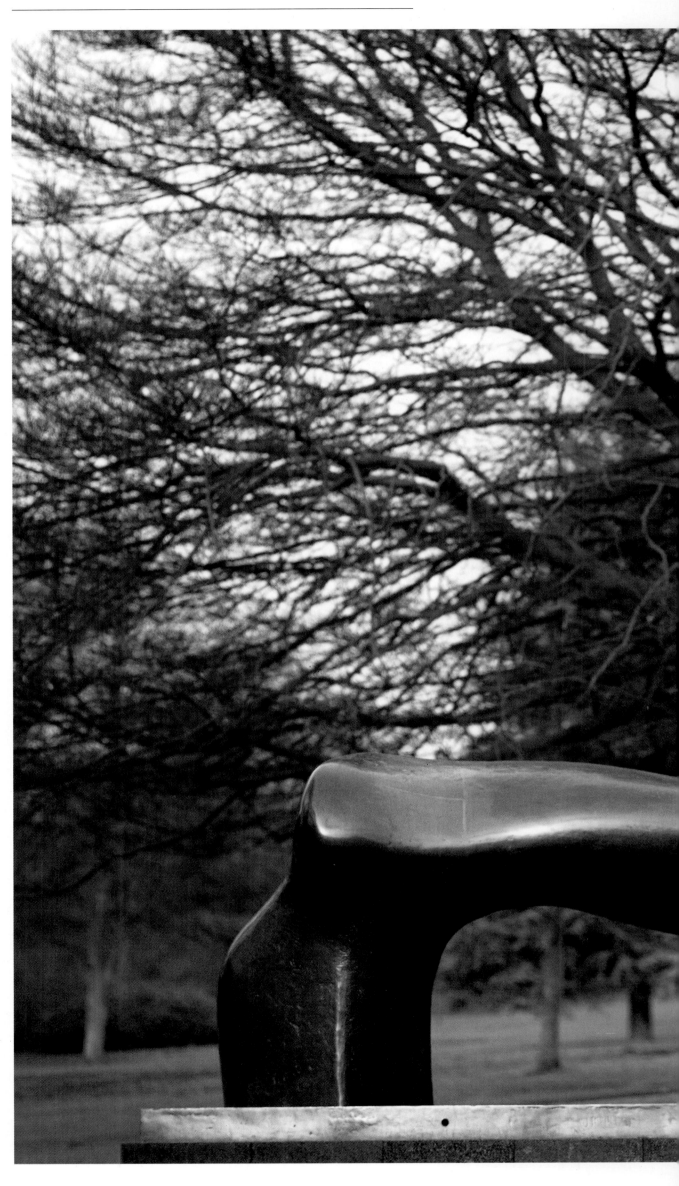

Reclining Figure: Arch Leg,
1969-70
Bronze, 174 inches (442 cm)
Yorkshire Sculpture Park,
Wakefield, West Yorks

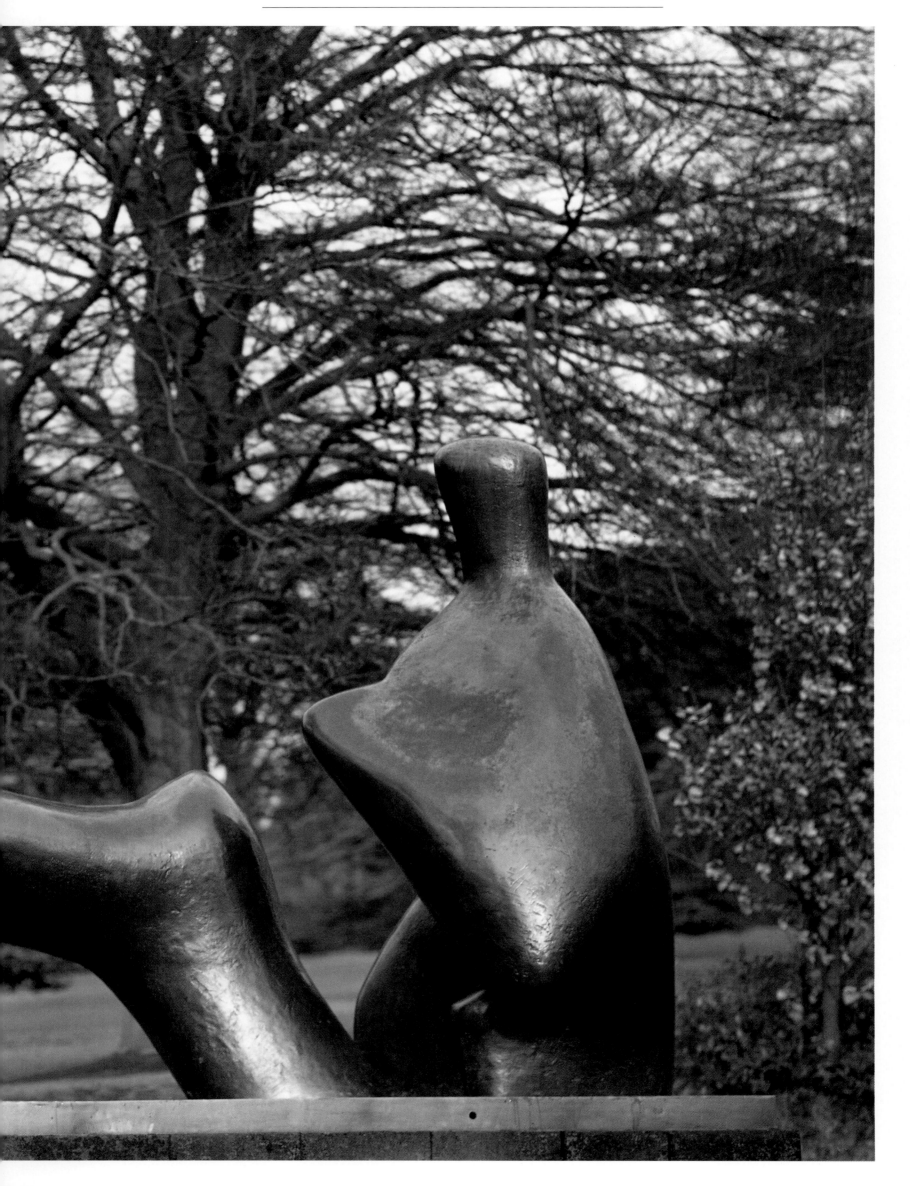

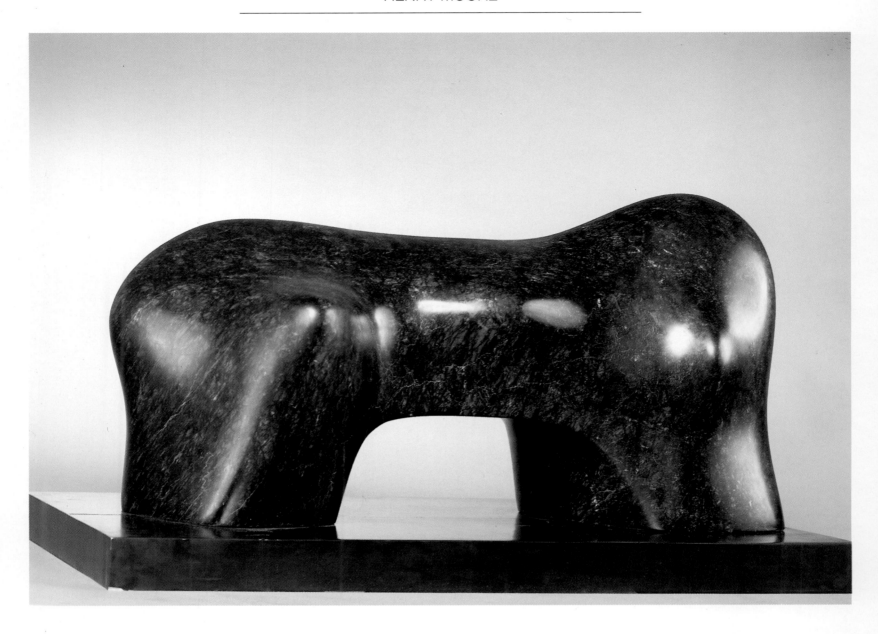

Bridge Form, 1971
Black Abyssinian marble, l. 27¾ inches (70.5 cm)
Private Collection
Photo Malcolm Varon

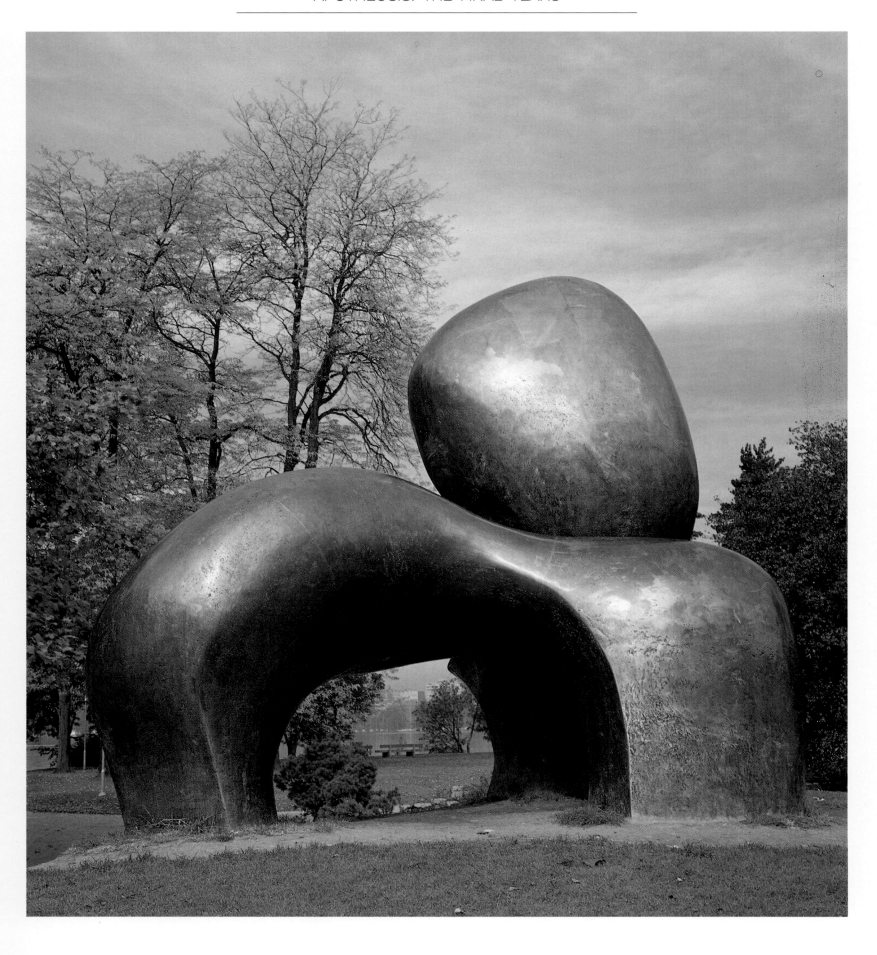

Sheep Piece, 1971-72
Bronze, 1.228 inches (579 cm)
Courtesy of the Henry Moore Foundation

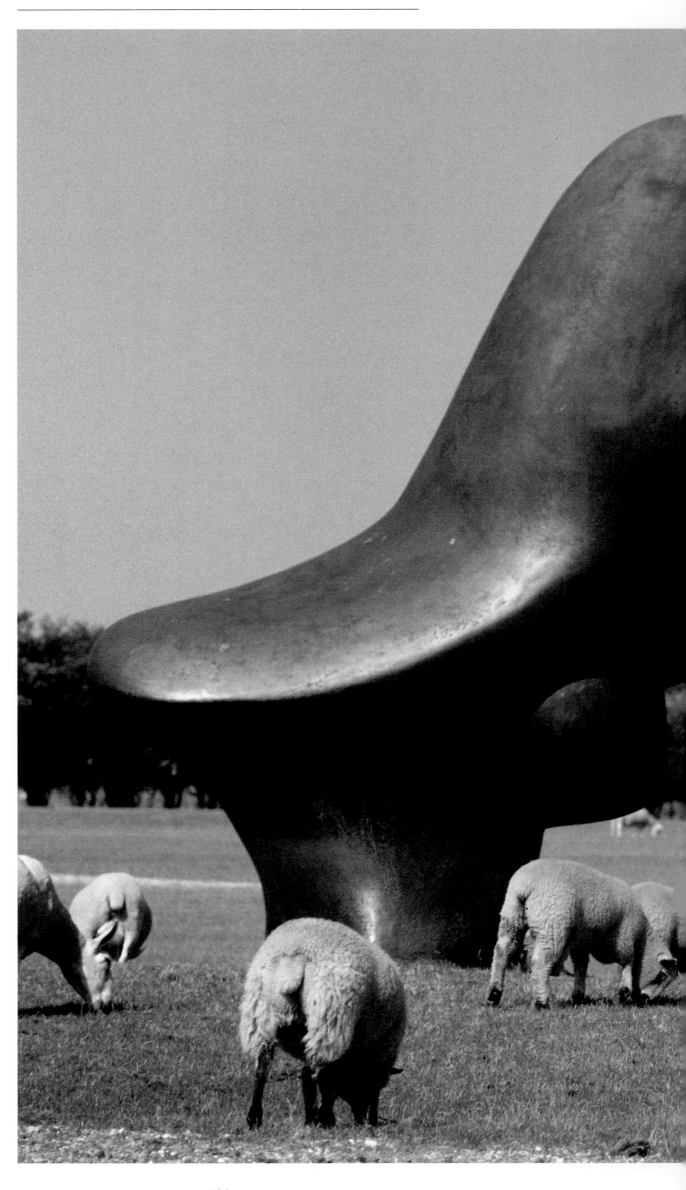

Sheep Piece, 1971-72
Bronze, 1.228 inches (579 cm)
Courtesy of the Henry Moore
Foundation

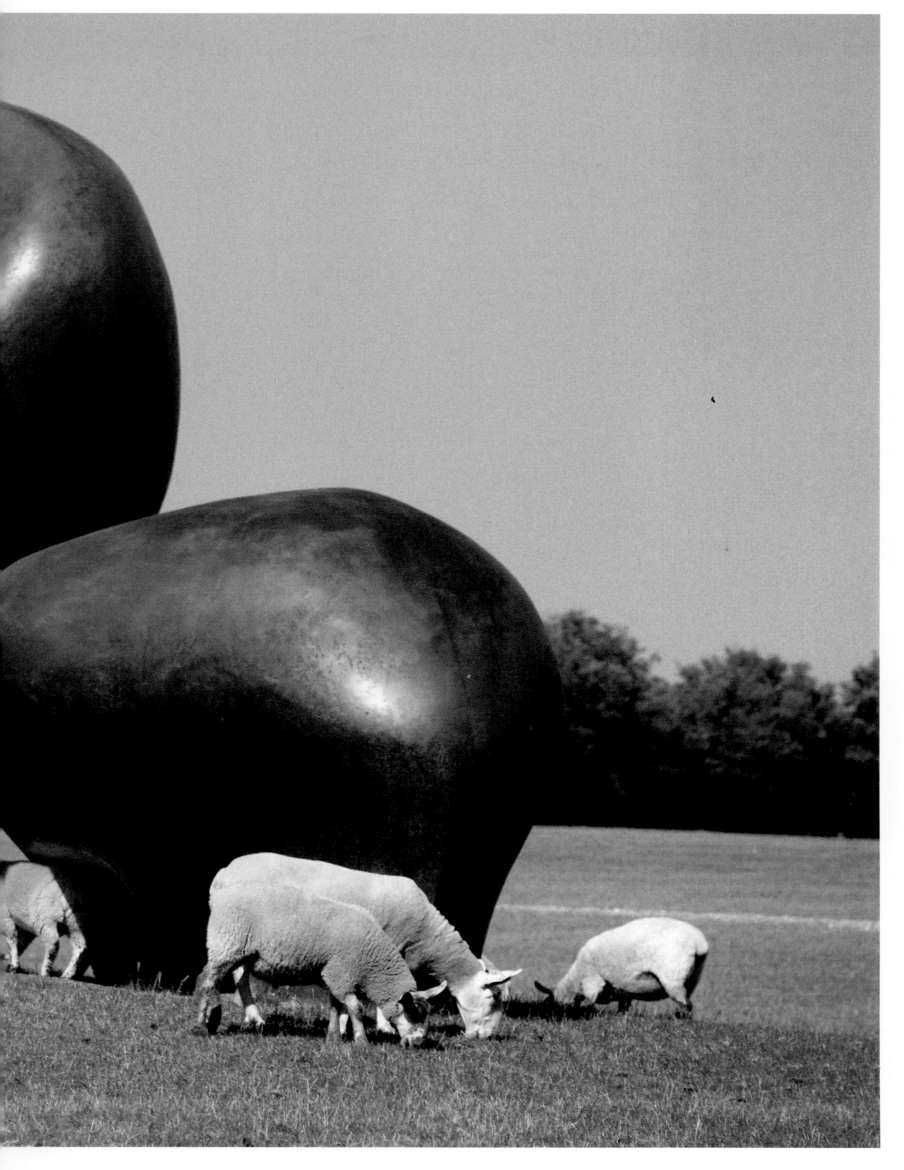

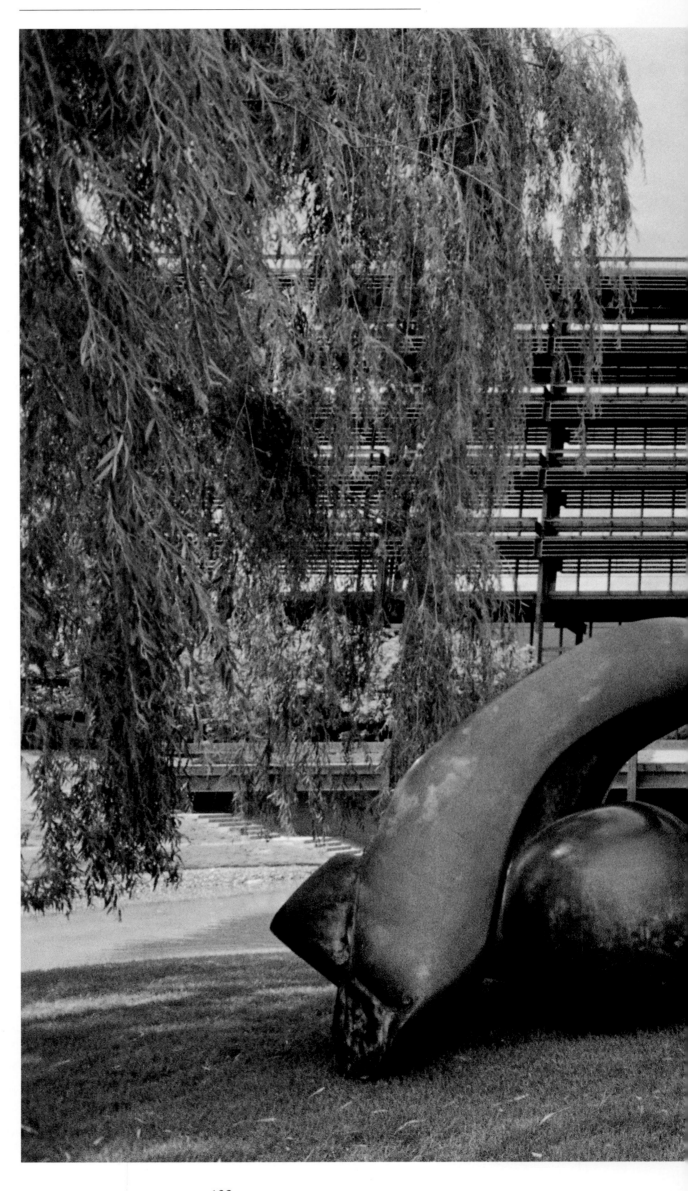

Hill Arches, 1973
Bronze, l.216 inches (550 cm)
Deere & Co, Moline, Illinois

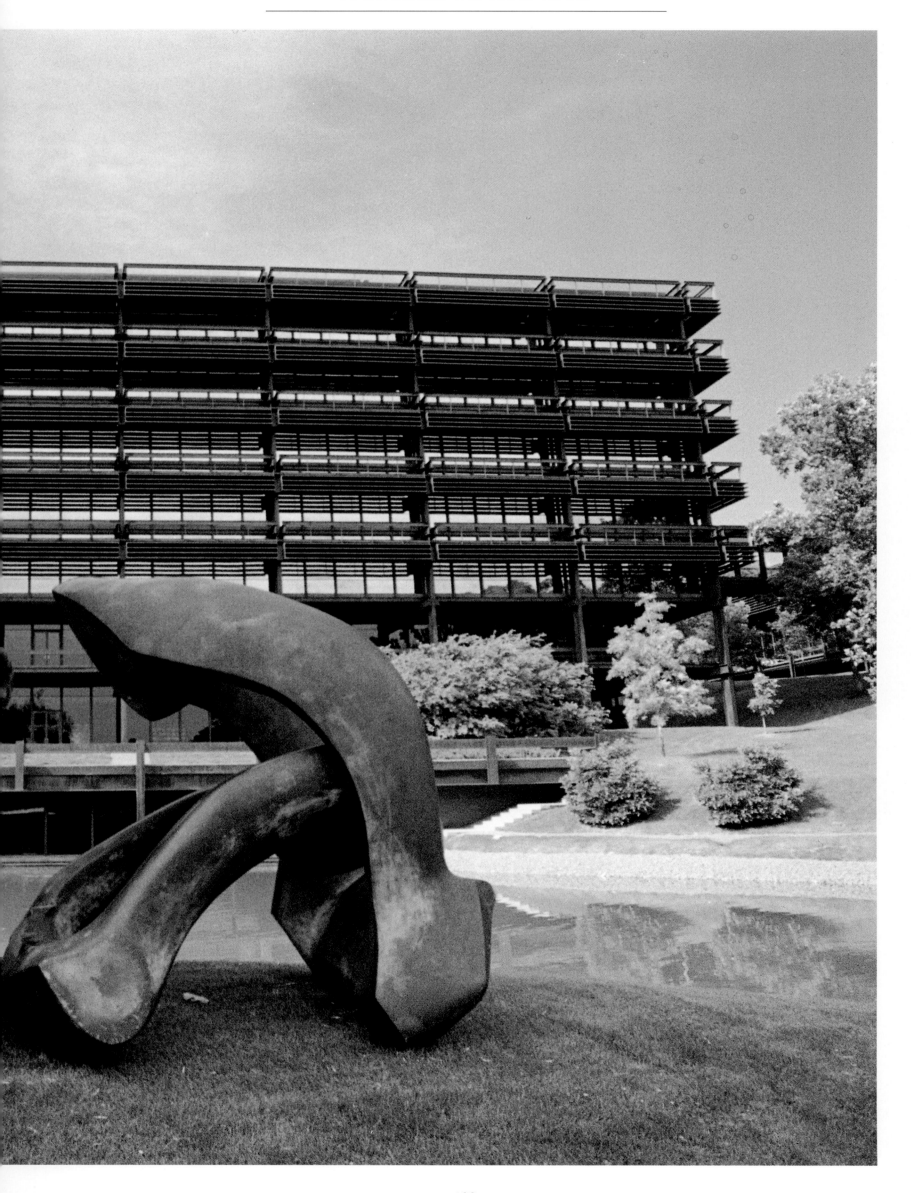

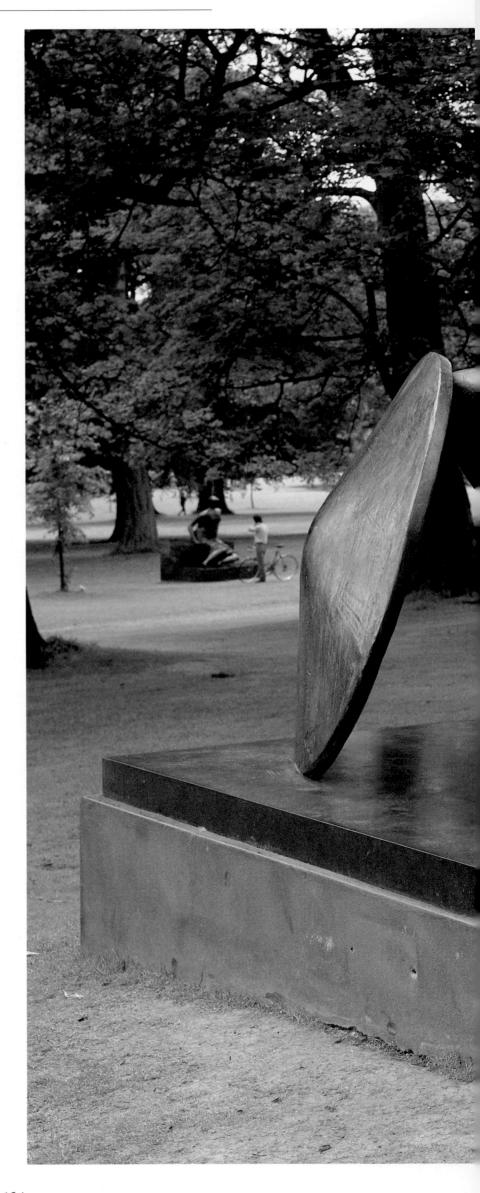

Goslar Warrior, 1973-74
Bronze, 1.98 inches (249 cm)
Courtesy of the Henry Moore Foundation

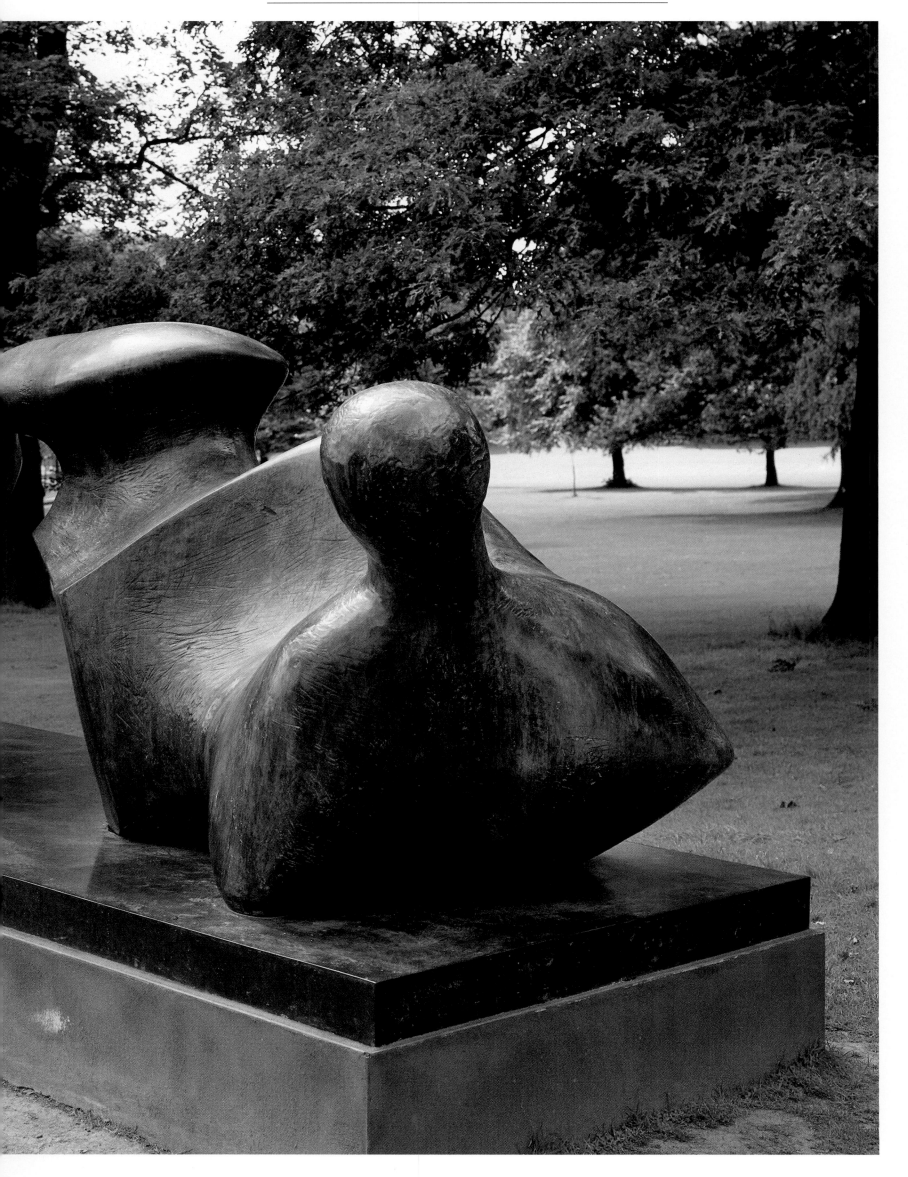

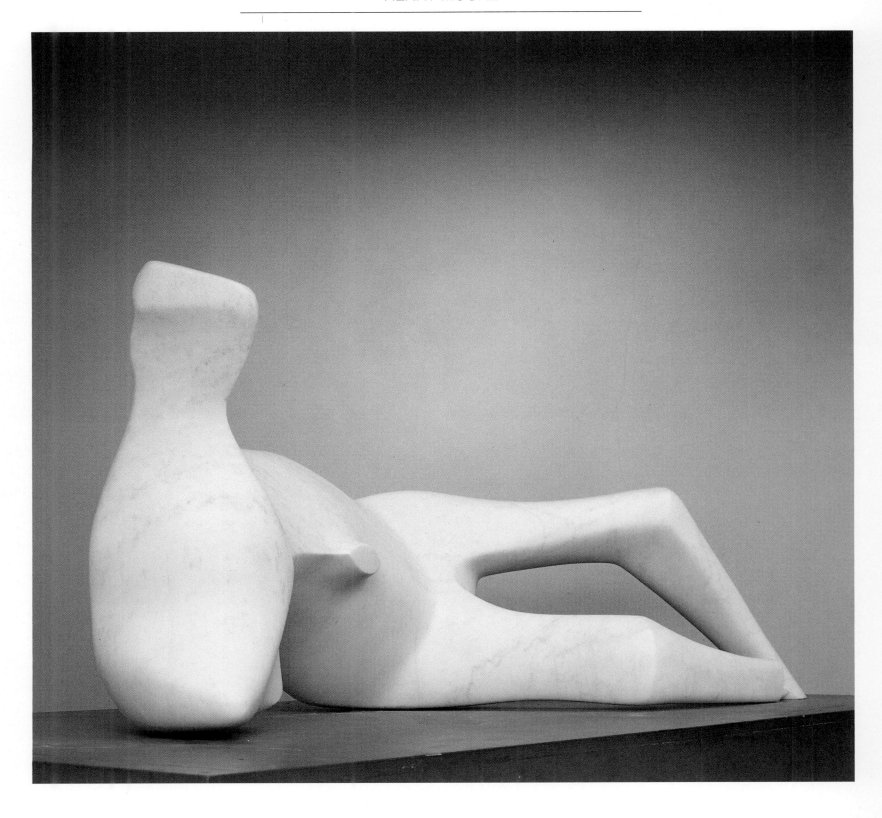

Thin Reclining Figure, 1979-80
White marble, 1.76½ inches (196 cm)
Courtesy of the Henry Moore Foundation

106

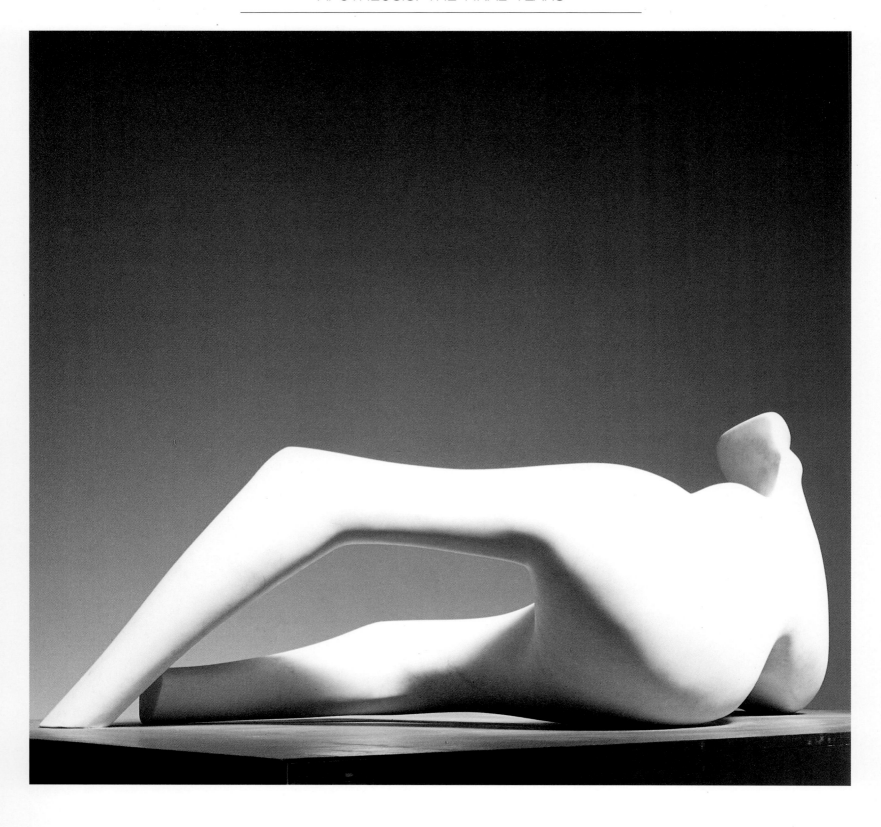

Thin Reclining Figure, 1979-80
White marble, 1.76 inches (196 cm)
Courtesy of the Henry Moore Foundation

Large Interior Form, 1982
Bronze, h.199½ inches (510.5 cm)
Art Institute of Chicago, Gift of Henry Moore

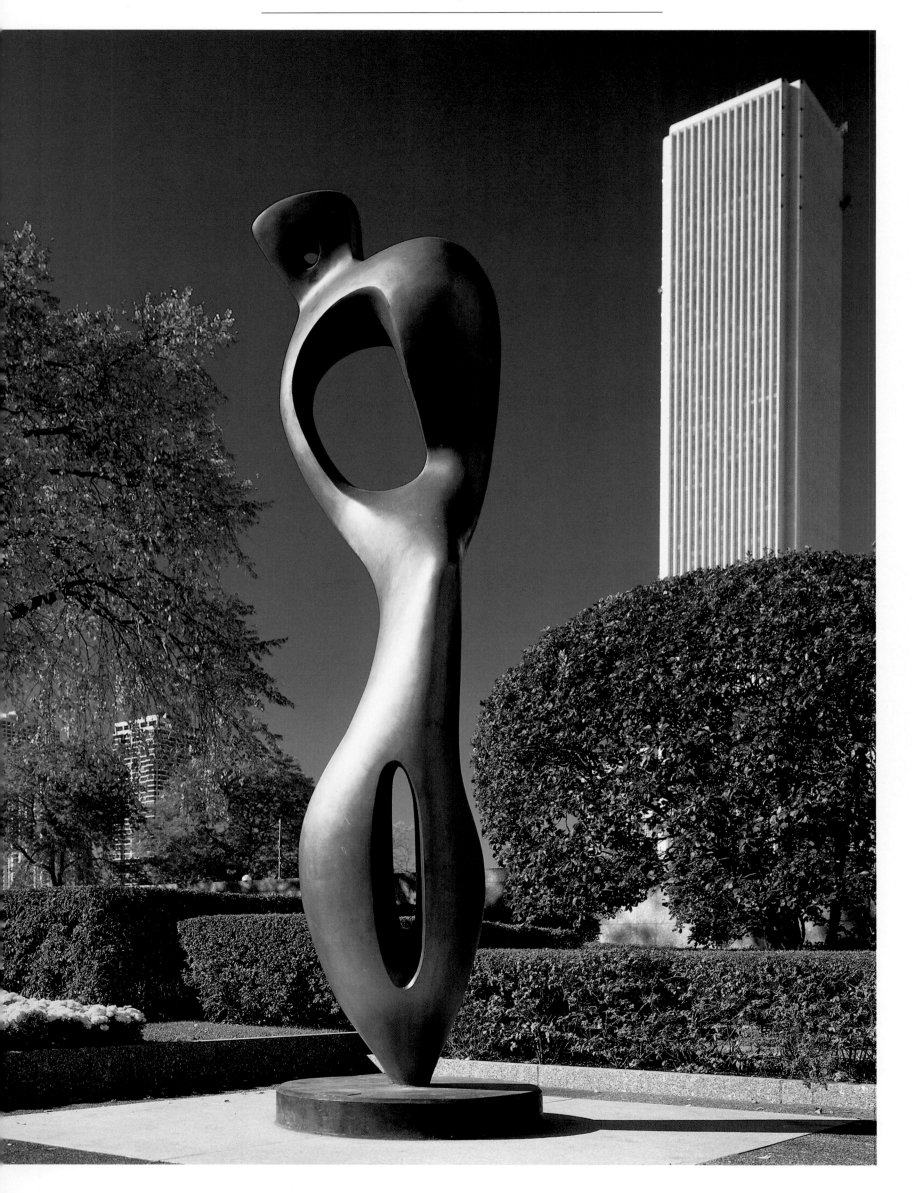

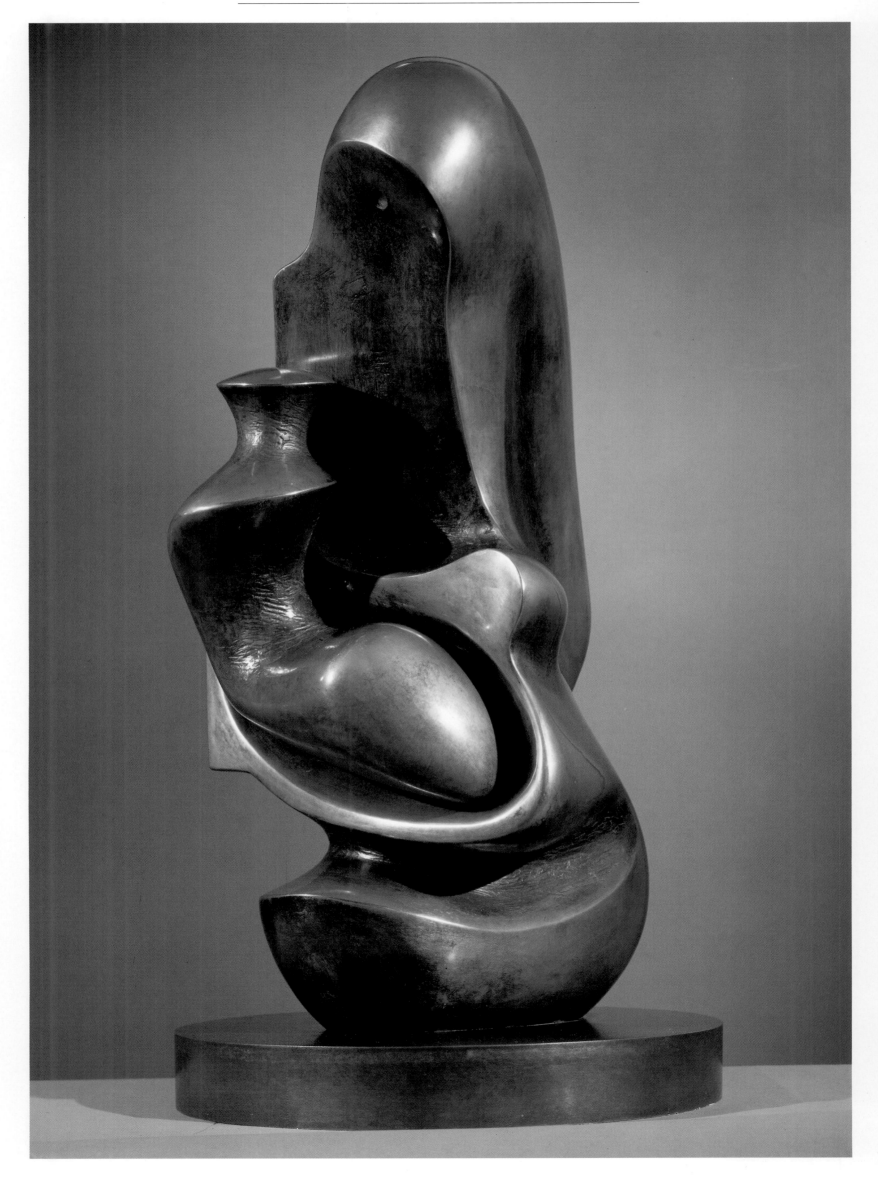

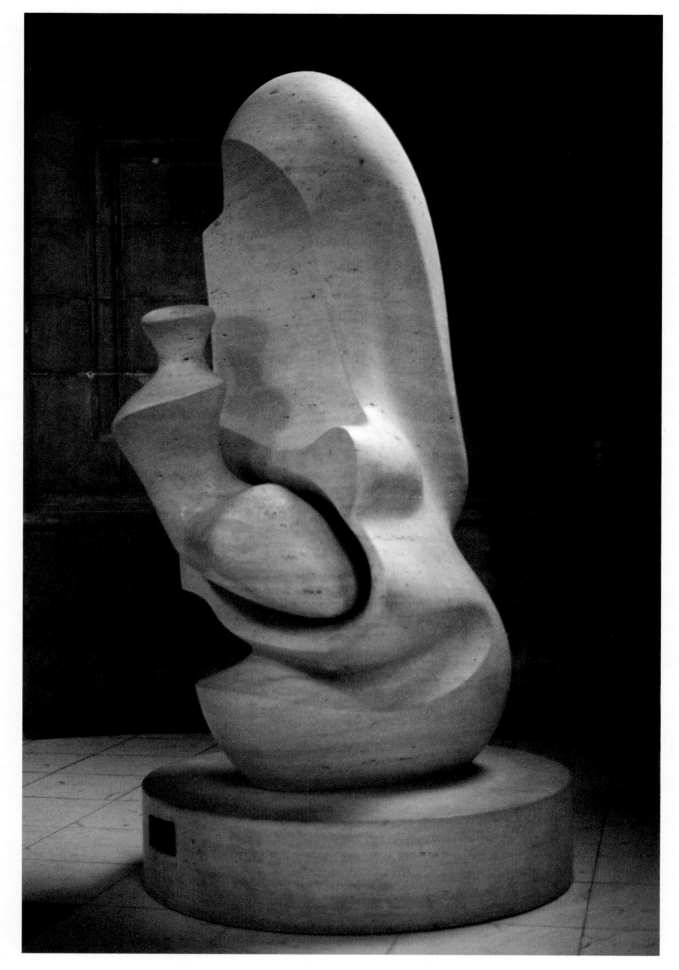

LEFT:
Maquette for Mother and Child: Hood, 1982
Bronze, h. 30 inches (76 cm)
Courtesy of the Henry Moore Foundation

ABOVE:
Mother and Child: Hood, 1983
Travertine marble, h. 71½ inches (183 cm)
St Paul's Cathedral, photo courtesy of the Henry Moore
Foundation

ACKNOWLEDGMENTS

The publisher would like to thank Martin Bristow, who designed this book; Susan Brown, production manager; Suzanne O'Farrell and Rita Longabucco, picture researchers; Jessica Hodge, editor; and Angela Dyer of the Henry Moore Foundation, for all her assistance. We should also like to thank the following individuals, agencies and institutions for the loan of photographic material.

Albright-Knox Art Gallery, Buffalo, NY: pages 36 (Room of Contemporary Art fund, 1939), 63 (left) (General Purchase Funds, 1955)

Art Gallery of Ontario, Toronto: pages 14 (Gift of the Contemporary Art Society, 1951, photo Larry Ostrom), 16 (Gift of Henry Moore, 1974, photo AGO), 19 (Gift of Mrs Mary R Jackman, 1988, photo AGO Brenda Dereniuk)

Art Institute of Chicago: pages 108-109 (Gift of Henry Moore, 1983.208 in situ, photo Thomas Cinoman)

City of Dallas Office of Cultural Affairs, Dallas City Center, Texas: pages 90-91

Collection: The Arts Council of Great Britain: pages 12, 68 (on loan to Doncaster City Art Gallery), 69 (on loan to Doncaster City Art Gallery)

Collection of the Henry Moore Foundation: pages 2, 4-5, 6, 7 (both), 9, 10 (both), 11 (photo John Hedgecoe), 13 (both), 15, 20, 21, 22, 22-23, 27, 32 (left), 34, 44, 48, 49, 53, 54-55 (photo Michel Muller), 57, 58-59, 61 (photo Michel Muller), 62, 71, 73, 76-77, 78, 79, 81, 82, 92, 99, 100-101, 104-105, 106, 107, 110, 111

Dartington Hall, Totnes, photo Kate Mount: pages 46-47

Deere and Co, Moline, Ill: pages 102-103

Detroit Institute of Fine Arts, Founders Society: pages 31 (Purchase, Friends of Modern Art Fund, photo Malcolm Varon), 40-41 (Gift of the Dexter M Ferry Jr Trustee Corporation, photo Dirk Bakker)

Hebrew University, Jerusalem, photo Werner Braun: pages 65, 70

Hirshhorn Museum and Sculpture Garden, Smithsonian Institution, Washington DC: pages 63 (right) (Gift of Joseph H Hirshhorn, 1966, photo John Tennant)

The Hulton-Deutsch Collection: pages 8, 17, 18

Leeds City Art Galleries, Henry Moore Centre for the Study of Sculpture: pages 26, 29

Museo d'Arte Moderna, Ca'Pesaro, Venice: page 52

Museum Ludwig, Rheinisches Bildarchiv, Cologne: page 60

Norton Simon Art Foundation: page 74

Pepsico Inc, photo Malcolm Varon: pages 66-67, 75, 86-87

Philadelphia Museum of Art: page 37 (Gift of Mrs H Gates Lloyd, photo Malcolm Varon)

Photo Malcolm Varon: pages 1, 25, 28, 30, 50, 98

Princeton University: page 93 (The John B. Putnam Memorial Collection)

San Diego Museum of Art: page 45 (Bequest of Earle W. Grant)

Tate Gallery, London: pages 32 (right), 33, 35, 39, 43, 51, 54, 56, 83, 84

UNESCO, photo Michel Claude: page 72

University of Chicago, Ill, photo Keith Swinden: page 85

University of East Anglia, Robert and Lisa Sainsbury Collection: page 38

Yorkshire Sculpture Park, Wakefield, West Yorks, photo Jonty Wilde: pages 88-89, 94-95, 96-97

SELECTED BIBLIOGRAPHY

Henry Moore: Complete Drawings, Garrould, A., ed., vol. 5 1977-81, London, Lund Humphries in association with the Henry Moore Foundation, 1994 (vols. 1-4 and 6 forthcoming)

Henry Moore, Complete Sculpture, Bowness, A., ed., 6 vols., London, Lund Humphries, 1944-88

Grohmann, W., *The Art of Henry Moore*, London, Thames & Hudson; New York, Abrams, 1960

Hedgecoe, J., *Henry Spencer Moore*, photographed and edited by J. Hedgecoe, words by Henry Moore, London, Thomas Nelson, 1968

James, P., ed., *Henry Moore on Sculpture*, London, Macdonald, 1966; New York, Viking, 1967, revised and expanded, 1971; New York, Da Capo Press Inc., 1992

Lieberman, W., *Henry Moore, Sixty Years of His Art*, New York, Metropolitan Museum of Art, 1983; London, Thames and Hudson, 1983

Melville, R., *Henry Moore: Sculpture and Drawings 1921-1969*, London, Thames & Hudson, 1970

Packer, W., *Henry Moore: An Illustrated Biography*, London, Weidenfeld and Nicholson, 1985

Read, H., *Henry Moore: Sculpture and Drawings 1921-44*, London, Lund Humphries, 1944; revised edition, A. D. B. Sylvester, ed., 1949 and reprints

Read, H., *Henry Moore: A Study of His Life and Work*, London, Thames and Hudson, 1965

Royal Academy of Arts, London, *Henry Moore*, London, 1988, exhibition catalogue published in association with Weidenfeld and Nicolson

Russell, J., *Henry Moore*, London, Allen Lane, 1968; New York, Putnam, 1968; revised edition, Harmondsworth, Penguin, 1973

Spender, S., *In Irina's Garden, with Henry Moore's Sculpture*, London, Thames and Hudson, 1986

Sylvester, A. D. B., *Henry Moore*, London, The Arts Council, 1968